PHOTOGRAPHIC
ENLARGING
IN PRACTICE

PHOTOGRAPHIC ENLARGING IN PRACTICE

Sidney Ray & Jack Taylor

DAVID & CHARLES
Newton Abbot London

An Element technical publication
Conceived, designed and edited by
Paul Petzold Limited, London

First published in 1985

British Library Cataloguing in Publication Data
Ray, Sidney F.
　Photographic enlarging in practice
　1. Photography———Enlarging
　I. Title　　II. Taylor, Jack, *1943—*
　770′.28′3　　　TR475

　ISBN 0-7153-8408-2

Designer Roger Kohn
Illustrator Janos Marffy

Typeset by ABM Typographics Limited, Hull
and printed in Great Britain
by Butler and Tanner Ltd, Frome
and Edwin Snell Printers, Yeovil
for David & Charles (Publishers) Limited
Brunel House　Newton Abbot　Devon

CONTENTS

CONTENTS

1 PRINTING AT HOME

Enlarging, one of the most creative processes in photography, is fun to learn and immensely satisfying to do. Once you have mastered the techniques, you should obtain a higher quality from your photographs than you might have thought possible and will also have the skill to embellish, or even totally change, the original image. Following the clear and precise instructions given in this book, you can soon discover how easy it is to produce good prints in black-and-white or colour, and will then want to start applying this additional skill to the creation of more exciting images.

Advantages of printing at home
A major difficulty for the black-and-white photographer is that of finding a processing laboratory willing to print his negatives to a high standard, yet at a reasonable cost. A few monochrome printing houses produce prints of superb quality, but they are very expensive and used almost exclusively by professional photographers requiring prints for exhibition or commercial assignments. The average developing and printing (D&P) house is not interested in black-and-white work, preferring instead to develop and print the millions of colour snaps taken each year

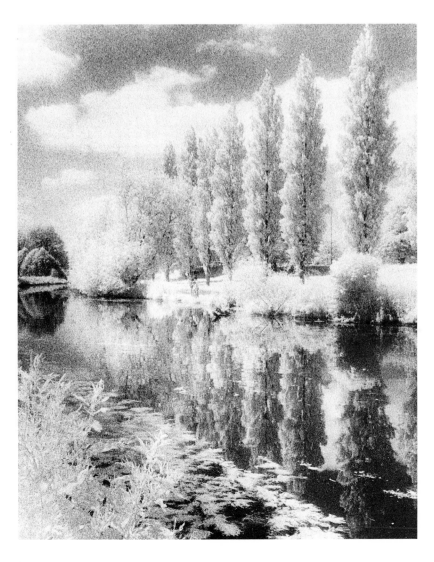

1 To have total control of how the print looks, the photographer must be involved in all stages of production, especially the most critical stage of enlarging. This river scene was photographed on infrared (IR) black-and-white film and carefully printed to give a full range of tones, paying special attention to highlight details.

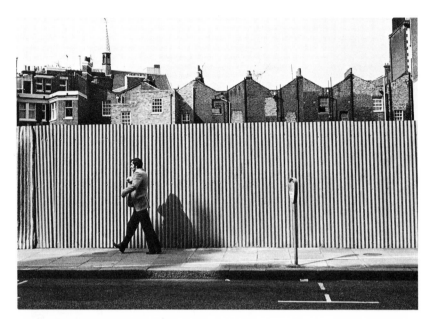

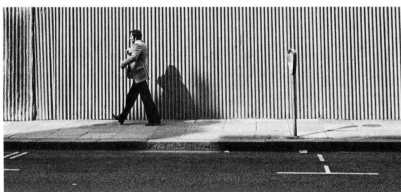

2-3 If these two prints are examined separately by covering over one while viewing the other, you will notice that they have quite a different impact – it is a matter of personal taste which is preferred. The two prints have been made from the same negative. However, the bottom one has been 'cropped' to isolate the main subject and give a more graphic image and print format.

by the general public.

Photographic enlarging gives the enthusiast a chance to produce high quality prints of any size at a very reasonable cost, while for the more serious photographer, there is simply no way of printing black-and-white pictures exactly as he wants them other than by working in his own darkroom. Only this approach offers total creative control over such important variables as image content (by cropping, etc), image density (local or general), contrast, tonal range, size and presentation.

Photofinishing is now such a competitive trade that it is perfectly possible to get your colour negatives and slides printed at a relatively low cost. In fact, if you allow for the cost of your own time spent in the darkroom, it becomes cheaper to send your films out for developing and printing.

The snag is that the results are not always very good, and many inexperienced photographers are consequently misled into blaming themselves for the poor quality colour prints they receive. In short, unless you print your own films or use an expensive professional colour laboratory, you may never know just how good a photographer you actually are.

Printing at home, in colour or black-and-white, means that you can produce exactly the photographs you want. Creatively, you cannot be in full control of your work unless you command both the camera and the printing exposure, and as your confidence as a photographer grows you will find any restrictions on these frustrating.

With greater confidence also comes the desire to produce large colour prints (which are prohibitively expensive when done by the process-

ing laboratory) and to experiment with more adventurous uses of photographic materials (see Chapter 11).

But apart from all these excellent practical reasons for doing your own printing, it is an immensely satisfying and creative hobby.

It's all so simple

There was a time when black-and-white printing was a lengthy process involving endless washing, and colour printing involved complicated and tedious processing cycles – indeed, you were lucky to produce more than a couple of prints after a long evening's work! But today's printing could hardly be more simple and straightforward.

It is now perfectly possible to produce a finished, dry, black-and-white print in less than five minutes, due largely to the introduction of resin (ie plastic)-coated paper. All you need for this is a small darkroom (temporary or permanent) which is equipped with an enlarger and a few inexpensive processing tools.

Modern colour printing is almost as easy as black-and-white, and can be done with the addition of a few extra items of equipment.

Chapter-by-chapter guide

This book is a practical manual on enlarging, and gives only the essential information to enable you to become a proficient black-and-white and colour printer – as quickly as possible. It can be read chapter by chapter as a complete introduction to the subject or for selective reference only.

Chapter 2 covers all the requirements for a darkroom, including design and layout, water and electrical supplies, as well as safety considerations.

All you need to know about enlargers is dealt with in Chapter 3, together with accessories such as masking frames, filters for colour printing, and timers. This section is essential reading for anyone who needs advice before buying an enlarger or other equipment.

Chapter 4 discusses exposure aids, including equipment such as enlarging exposure meters which, although not essential, are well worth considering for colour printing. The fifth chapter deals specifically with print processing equipment, and compares the relative merits of the different processing systems, including automatic processors.

The range of photographic papers and processing chemicals is vast and represents something

4 Subjects which have to be photographed very quickly before the incident or composition is lost, often produce less than ideal negatives. In this example, the print was achieved by cropping out unwanted surrounding detail on the negative and by darkening the bottom right corner to minimise the impression made by the girl.

of a maze to the beginner; Chapter 6 compares the choices and gives advice on their use. In the seventh chapter we give step-by-step procedures for black-and-white printing. This chapter can be used as a 'cookbook' while you are at work in the darkroom. The eighth chapter discusses more refined printing controls. In a similar manner, in Chapters 9 and 10 we take the reader through colour printing, and cover everything necessary to produce high quality prints.

Once you are familiar with the techniques needed to produce prints, you can begin to explore the many exciting possibilities described in Chapter 11, taking you beyond 'straight' photographs into the experimental area. Techniques for both black-and-white and colour 'derivations' are described in detail through their various stages. The twelfth chapter includes post-darkroom techniques and advice on the best presentation of your photographs.

2 DARKROOMS

A darkroom is any working space from which actinic light can be excluded, temporarily or permanently, so that photographic processes involving developing or printing can be carried out in safety. This may mean complete darkness or a low level of coloured lighting that is 'safe' for the materials being handled out of their light-proof wrappings.

The usual operations in a darkroom are the loading of film spirals or paper drums for daylight tank development, development in deep tanks without light traps, open dish development and printing with the aid of an enlarger.

A darkroom also serves to store all the equipment and materials related to such activities and to provide shelf-space for books, prints and camera equipment.

It is also a place where the photographer can work on his ideas alone, meditate while performing the mechanical actions of processing and have the pleasure of seeing pre-visualised ideas materialise as prints.

Makeshift and temporary arrangements

Due to family pressures on available living space few people have the luxury of a permanent darkroom. Fortunately, it is possible to set up a makeshift darkroom of more than one kind (fig 2.1).

Because a water supply is certainly helpful, though not essential, rooms such as bathrooms, kitchens and toilets are commonly modified for a printing session – albeit with the reluctant co-operation of other members of the household.

The primary need for blackout arrangements can be met in various ways. Windows may be covered with pieces of special heavy-duty opaque plastic sheeting, held in place by a low tack adhesive tape that is suitable for subsequent removal. Alternatively, more cumbersome sheets of hardboard may be cut to size, then slotted into grooved pieces of wood positioned around the window frame and held in place by turn buckles. A real luxury is a permanently installed pull-down blind with light-trapped edges.

Before use, wait for a few minutes in the dark-

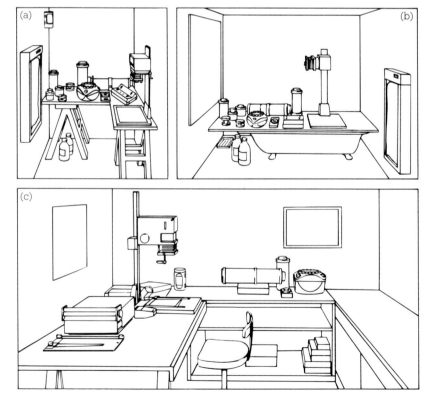

2.1 Darkroom arrangements. A In a cupboard B In a bathroom C Permanent set-up, with dry bench area at the left. For safety reasons, in all cases, the water supply and electrical facilities should be as far apart as possible.

ened room to allow the eyes to adapt to the conditions and see whether there are any chinks of light which could cause accidental fogging of materials. As a guide, if after 5 min you cannot detect your hand before you, the room is fully safe for all work. If you can *just* detect the outline of your fingers then it is still safe for printing. Any improvement in visibility means an unsafe darkroom!

The effectiveness of the blackout arrangements depends to some extent on the light conditions outside. Night-time (alone, or street lighting) allows less demanding light-proofing. Summer sunshine falling on a window requires truly opaque blinds or shutters and effective light trapping round the edges. Incidentally, the blackouts usually act as very effective radiators to heat up a room when they are being warmed up by the sun outside. An external layer of metal foil, such as that used for cooking, may be needed to reflect the sunlight and reduce such heating effects.

Beware also of various existing ventilation arrangements in the room; most tend to leak light and must be covered in order to exclude light but still allow an essential flow of air into the room.

A door may be light-proofed by temporary black tape around the frame, by a black curtain on a rail, draught-proofing strips and so on. A simple catch or bolt, preferably of the lavatory door type which can, in an emergency, be opened from outside, will prevent accidental opening of the door whilst working.

Other parts of a house which present no problems with windows, such as a large cupboard, below-stairs region or the loft, may, when converted for darkroom use, need some form of insulation to be added to the walls to retain a reasonable working temperature through the seasons. Various forms of wall insulation are available from hardware stores and they also serve to exclude dust from loft or under-stair areas. Be careful not to choose an insulation method that actually introduces dust, particles, chips or strands of material!

Take particular care with the electrical arrangements. Building regulations forbid power sockets in bathrooms so a temporary extension socket on a lead, suitably fused and earthed, may have to be run from an adjacent room. Most kitchens have adequate power units while a loft or cupboard may have a suitable power outlet installed permanently.

It is possible to have your enlarger mounted on a purpose-built trolley, complete with storage for dishes and paper beneath the base, which can be wheeled into the temporary darkroom. More commonly, the enlarger can be placed on a convenient table, cupboard or work-top to serve as a dry bench. Provided that the arrangement offers a convenient working height and a horizontal and stable baseboard, this is satisfactory.

Processing arrangements are more problematic. Considerable bench space is needed to take three or four dishes in a row. To accommodate the dishes, it is possible to buy a moulded plastic sink that fits on top of a bath, or to construct one from wood. Hinged flaps that can be folded flat against a wall when not in use are another alternative. One space-saving device is a tray-stacking arrangement where the dishes are staggered vertically and you work through the processing stages from top to bottom of the stack. Such alternatives as processing machines or drums require very little bench space but may need semi-permanent plumbing arrangements.

For darkroom sessions of a few hours' duration, in the absence of running water, some other provision may be necessary. Except for the archival washing of fibre based paper, modern materials, especially of the resin-coated variety, require only small amounts of water per print.

Sufficient water can be supplied from say, a 23-litre (5-gallon) container fitted with a suitable tap, standing on a sturdy shelf above the work bench. Waste water from a process may be poured into a bucket nearby for later disposal or can be drained into another container. With due care, a heated water bath for drum processors need not spill over and used drums may be carefully rinsed out to avoid problems with water splashes.

Other darkroom arrangements that have been found to work include enclosing the enlarger and dishes in a tent made of transparent red or yellow acetate safelight material or of black cloth. To carry out operations you stand outside and insert your arms through elasticated openings.

A portion of a large room may be partitioned off by means of an opaque curtain with a light-trapped pelmet and a weighted bottom, forming a temporary darkroom. If you have a space problem rather than a shortage of cash, you may purchase proprietary collapsible or fold-away darkrooms featuring built-in benches, drawers and cupboards, the walls folding up rather like a cardboard carton when not in use.

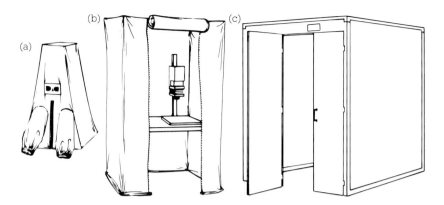

Complete self-contained darkrooms may also be purchased for local assembly but are semi-permanent rather than collapsible (fig 2.2).

Perhaps the ultimate in darkrooms is the 'coffee table' type, a totally enclosed portable device of small suitcase size for printing colour slides on to diffusion transfer reversal papers, such as Agfachrome Speed, with integral processing arrangements.

Garden sheds are a favourite choice for conversion into darkrooms, as are sections of garages. Indeed, there are few such places that cannot be adapted in some way.

But if all else fails or say, renting agreements forbid such adaptations, then a darkroom can usually be rented by the day or hour. Membership of a camera club often gives access to a club darkroom or to a cooperative arrangement with other members.

Permanent darkrooms

A permanent darkroom is a luxury few people possess but the arrangements described elsewhere, if not disturbed by packing away each time after use, may be considered permanent.

But assuming that an ideal darkroom is to be designed and fitted out, a few general comments are offered here. Remember, even a space measuring as little as 1 x 2m (4 x 6ft) can allow a pleasant working environment.

Design and layout

The basic layout is for a *dry bench* and a *wet bench*, as far apart as possible, where the printing and processing operations respectively, are carried out.

The enlarger may be free-standing, wall-mounted or stand on a *dry bench* (fig 2.1C). The working surface, the easel, should be at a comfortable height to avoid stooping and consequent backache. A stool, for seated operation is even better.

The ceiling height should be at least 2m (7ft), the greater part above the enlarger to allow clearance for the enlarger head to be raised for larger print sizes.

Any space below the dry bench can be used to store paper, dishes and equipment. Open shelves tend to collect dust so cupboard arrangements are better. Any free wall space should be exploited to accommodate shelves, pin board or racks to hold accessories such as dodgers (shaders), spare enlarger lenses, alternative negative carriers and so on.

To minimise fatigue, the floor could be covered with cushioned rubber material which is also easily washed after any accidental chemical spillage. Older surfaces such as duckboards can be used, especially on concrete floors. For the careful worker or where a processing machine is used, the floor could even be carpeted.

A major enemy is dust and regular cleaning

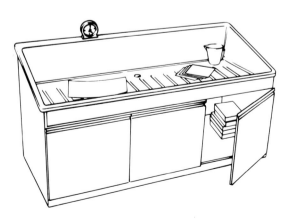

2.3 Darkroom processing sink.

helps reduce deposits which can cause white spots on prints. The enlarger should be fitted with a dust cover when not in use and accessories kept in a drawer. In any case, all optical surfaces, negative carriers and negatives should be dusted before use.

Compressed air or gas from a dispenser, anti-static cloths and liquids and electrostatic devices can be used to remove dust.

The *wet bench* bears the dishes, tanks or processor in use. An ideal arrangement is a shallow sink in which operations take place and spillages or waste chemicals drain away. Such sinks can be purchased in various sizes and feature an integral splash-back.

Home-made arrangements involve constructions of wood or sheet plastic. Metal is best avoided due to the corrosive properties of the chemicals used and problems such as rusting.

A flat surface to take dishes etc should be at a comfortable working height and have a shallow protective lip round the edge to prevent chemicals from running off on to the floor. A cove to carry the working surface continuously up the

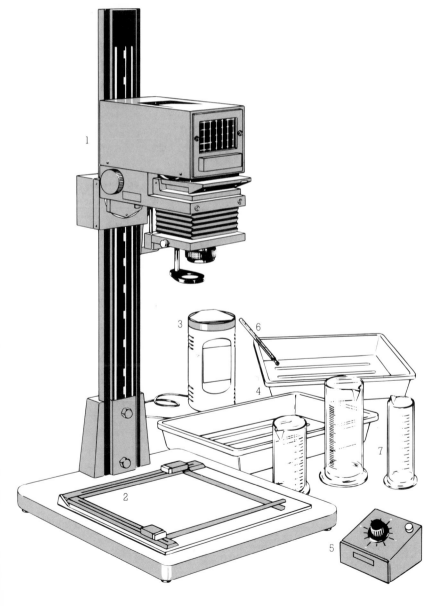

2.4 Basic darkroom equipment. For black-and-white printing all that is required are 1 Enlarger, 2 Masking frame, 3 Safelight, 4 Dishes, 5 Timer, 6 Thermometer, 7 Measures.

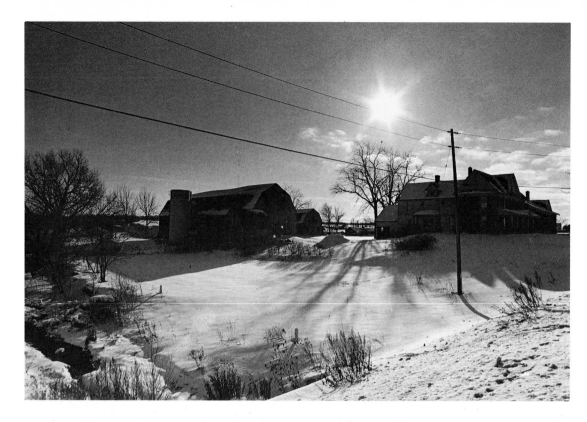

wall as a splash guard is useful. If appearance is important remember that many plastic coverings will stain from contact with chemicals and wood treated with polyurethane varnish may be preferable.

If a water supply is available, especially both hot and cold, a *water mixing valve* may provide water at the temperature required for colour processing. Cold water may be piped in by means of PVC plumbing fitments and pipes, needing only cold working adhesives for jointing. A darkroom in the loft space will generally be without water, being above the storage tank level unless the mains cold water inlet is suitably branched off.

Waste pipes from the darkroom must follow other pipes and not be routed down the front of a property, but the rear. Sometimes, the water supply needs to be filtered to remove suspended particles that would find their way on to films and prints, causing a number of problems.

Various such water-filters are available, mainly with cleanable filter elements, but remember that the flow rate must be reduced to permit effective filtration.

Environmental improvements
A darkroom should be a pleasant place in which to work and thereby foster creativity. Emerging

5 To ensure that scenes which have important but subtle highlight details, such as the snow texture in this landscape, are fully reproduced in the print, it is essential to maintain the temperature of the print developer at 18°C or above – a dishwarmer is the usual method of achieving this.

from a stuffy, humid, cramped, gloomy darkroom with an aching back, chemical-stained clothing, a raging headache and wasted print material does not encourage printing as a leisure activity.

Arrange matters to involve minimal walking about or stretching. Ensure that the heating and ventilation give a pleasant temperature with enough air changes to combat humidity and remove the unpleasant fumes that arise from stop bath and fixer. An air-freshener tablet or spray is helpful. Although quite an expensive item, a device to provide an atmosphere rich in negative ions, which seems to promote pleasant working conditions, may help people who are prone to hayfever or asthma and do not particularly relish enclosed areas.

It is important that the darkroom be kept free from gases or fumes which may attack photographic materials and cause fogging. Sulphurous gases are dangerous to humans also.

Vibration can be a problem, especially where there is a busy road nearby or subterranean

trains. Enlargers can be isolated from this by fitting rubber mats beneath the baseboard.

Many people find that they work best with background music from a radio or tape-recorder. Extension speakers may be run from the hi-fi in an adjacent room, if required.

A common mistake is to paint a darkroom black. This is not needed, except around door frames and window edges where light may get in. The walls are best left smooth to minimise dust build-up, and finished in light coloured paint. White is preferable, but pastel yellows and orange, all safelight colours, may be used. Remember that a safelight reflected from a white wall is still 'safe'.

The only areas where black serves any purpose is immediately adjacent to the enlarger, on the wall behind it, and on the ceiling above, to minimise reflectance which may affect print contrast.

Heating and ventilation

A darkroom should be maintained at about 15 to 20°C (60 to 68°F) for comfortable working. For black-and-white printing, optimum results are obtained at solution temperatures of 20°C – indeed, some developers work poorly at temperatures below 15°C. Other solutions are less critical.

6 Where a subject has large areas of similar tone, such as the sky in this example, the control of print exposure and development must be accurate – any unevenness is easily noticed in the print. The illumination system of the enlarger needs to be carefully set up and then checked from time to time.

Dishes of developer may be made up using temperature-adjusted water to provide an initial 20°C which is then maintained by means of a heating pad or a *dish warmer* on which the tray stands. This should not be regarded as a luxury, at least in the British climate.

Heating the darkroom is aided by suitable insulation of the walls and ceiling. A central heating radiator with thermostat is ideal for consistency and as a safe source. Do not use an electric fire, with its attendant dangers of contact in a confined space, the presence of liquids and as a source of unsafe red light. Storage heaters tend to be overpowering for a small darkroom. A fan-type heater, which can also provide cool air flow in a hot darkroom, may also blow dust about, if present. A gas fire too, is best avoided.

Humidity can build up in a darkroom both from the human body and by evaporation from dishes of chemicals or a water bath for a processor. Frequent air changes are essential. An extraction fan ventilator system is ideal if suitably baffled to prevent light leakage and if it does not cause dust problems. The darkroom should have a suitable inlet for air in such instances.

Safety considerations

It is obvious that a few sensible safety precautions are essential for working locked away in the dark in a confined space and in the presence of various chemicals, water, electrical supply and heating arrangements as well as preventing accidental fogging of sensitised materials.

Electrical safety is paramount, and the dangers of wet hands in contact with faulty equipment are well known! The power supply must be correctly earthed. Even better, a special ground fault interrupter socket may be fitted which instantly cuts off all power if it senses even a microscopically improper current leakage.

Each appliance should be earthed using 3-core cable for connection to a 3-pin plug fitted with a fuse of the correct rating. As several appliances are normally in use, avoid multi-socket adapters in a power outlet and, instead, use a multi-outlet fused distribution board which may be run on an extension lead to the wall near the dry bench. Four outlets should be adequate.

A single 13A fused outlet can handle about 3000W so ensure that the total power rating of the appliances in use does not exceed this value.

A regular inspection of appliances for loose connections, frayed or rotting cables, cracked

plugs and other hazards is recommended.

Never use the lighting circuit to supply power to appliances. The room light (white light) or print inspection light should be on a cord-pull switch for safe operation with wet hands, and to avoid accidentally switching it on in error for a safelight operated by a toggle or rocker switch.

Electrical wiring and connections should be neat and kept out of the way by cable clips.

As mentioned before, the darkroom door should have an inside catch to prevent accidental opening but be openable from outside if need be in case of emergency.

Few home darkrooms have the luxury of a light trap system of two doors and intervening space although this is the ideal arrangement.

Processing chemicals in the form of stock solutions or liquids of working strength need a few precautions. Storage in a *locked* cupboard is vital, preferably high on a wall so that small children cannot reach them. Made-up solutions should *never* be stored in proprietary containers such as lemonade or beer bottles in case of accidental consumption. All storage vessels should be marked and labelled unambiguously.

Handling chemicals can cause skin irritations or chest problems to those sensitive to such materials. A simple precaution is to wear rubber or plastic gloves and use print tongs as necessary. Avoid breathing in dust from powder chemicals; a simple face mask and eye goggles may seem extreme precautions, but it is better to be safe than sorry. Adequate room ventilation removes objectionable fumes. For disposal of used chemicals, follow the manufacturers' instructions and in any case dilute with water as well.

A simple overall or apron (special impervious darkroom types are available) serves to protect clothing from splashes or spillage. For any skin contact with chemicals, rinse with water and dry. This applies to hands used to manipulate or pull prints from the fixer and avoids the risk of finger marks on the next print.

Chemical spills should be wiped up immediately to prevent them from drying into piles of dust which blow about and contaminate the environment.

For working in total darkness, avoid sharp or projecting edges on benches or appliances, low ceilings, uneven floors or trailing wires. Switches may be identified by stick-on luminous markers which do not fog materials.

Ensure that someone knows your whereabouts

7 Many prints rely on strong sparkling highlights to be successful. If these light areas often appear degraded and 'flat', the safelights should be checked to ensure that they are not fogging the paper – this is more likely to occur with variable contrast papers. To heighten interest, this Mediterranean wall has been printed upside down deliberately.

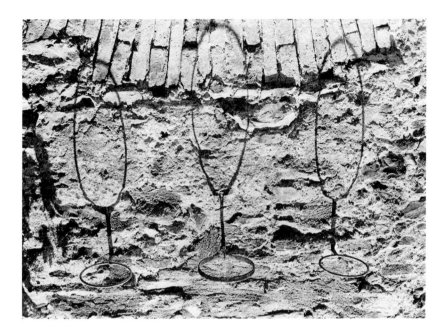

when you disappear into the darkroom for a printing session. He or she can not only prevent interruptions, but also check occasionally on your well being. In general, avoid consuming food or drink in a darkroom, and if you smoke – never do so in a darkroom.

Water supply

Water is required in a darkroom to make up processing solutions, for rinsing hands, to provide water baths for temperature control and for washing prints.

While a filtered, hot and cold dual supply with a mixing valve is ideal, it is by no means essential. Solutions can be made up elsewhere and taken into the darkroom. Do not attempt to carry a full dish of developer from one room to another, spillage is almost inevitable!

A stop bath used between developer and fixer avoids the need for a water rinse at this stage and a fourth dish containing water used after the fixer can act as a 'holding' tray until a few prints can be ferried out of the darkroom to be washed thoroughly elsewhere with the correct frequency of water changes. Even a bucket or washing-up bowl of water can serve to hold these prints.

A plastic container of the 'wine-bucket' type with a lower drain cock, located on a sturdy shelf above the wet bench and holding 9–23 litres (2 to 5 gallons) of fresh water may be used as a water supply. Waste water may drain into a similar container on the floor beneath a dry sink.

The water bath in which tanks of solutions stand or a bath for a drum processor should be fitted with a floating lid to reduce evaporation and temperature fluctuations and minimise contamination. This water bath needs occasional topping-up and replacement.

A thermometer and measuring vessels are necessary accessories for any darkroom.

Electrical needs

Several or all of the following electrical appliances may be in use in a darkroom: Enlarger, colour analyser, safelight, print viewing light, processor, dish warmer, electric timer, radio/tape recorder, ventilator fan, room heater.

In the UK, a single 3-pin power socket outlet from a ring main takes a fused plug, the fuse rating being up to 13A. The maximum power that can be handled by a circuit can be worked out from the formula

volts x amperes = power (watts)

So for 240V mains and a 13A fuse, a total of 3120W is possible.

Each appliance should have an attached plate stating its electrical needs and power consumption in watts. Most are modest, and the rating will seldom be exceeded unless a 2kW heater is included as well. A better arrangement is for each appliance to be fused individually to a distribution board, itself fused to 13A.

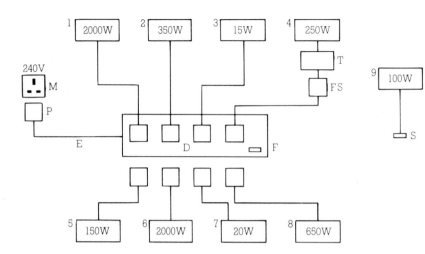

2.5 Electrical needs in the darkroom. Electrical supply arrangements and power consumption of typical appliances and equipment. M Mains power socket outlet, P Fused plug, E Extension lead, D Distribution board, F Fuse, S Pull switch, FS Foot switch, T Timer. 1 Fan heater, 2 Paper processor, 3 Safelight, 4 Enlarger, 5 Dish warmer, 6 Glazer/drier, 7 Colour analyser, 8 Print drier, 9 Room light.

A vital requirement for colour printing, but not for black-and-white, is that of a stable voltage supply to the enlarger lamp. A voltage change of 1 per cent produces a colour shift equivalent to a filter change of about 10 units as the lamp output alters in colour quality. A conventional enlarger modified for colour printing will need a *constant voltage transformer* to remove voltage fluctuations.

Purpose built enlargers incorporate such arrangements in their control gear. A step-down transformer may also be needed to provide the 25V commonly used for enlarger light sources.

Various light sources in the darkroom may be interlinked so that, for instance, switching on the enlarger may switch off any safelight in use to facilitate focusing. Likewise for the room light or 'white light'.

An enlarger timer has to be wired into the supply correctly to provide both a by-pass supply for focusing and a separate one controlled by the timer. A foot-operated switch is a great convenience for printing manipulations.

Additional wiring or alterations should be done in accordance with current legislation using approved products and carried out or checked by a qualified electrician. The consequences of ignoring this advice could be fatal.

Safelights

A darkroom is not always used in total darkness. Not all photographic materials are sensitive to light of all wavelengths. Some may be handled for periods of time in illumination to which they have negligible or reduced sensitivity. Such illumination is termed *safelighting* but it must never be

regarded as completely safe and frequent checks are essential.

The major classifications of spectral sensitivity of photographic materials are: 'ordinary', 'orthochromatic' and 'panchromatic', being blue sensitive only, insensitive to red only and sensitive to all colours, respectively. In general, a yellow safelight is used with blue sensitive materials, which category includes conventional bromide paper. A red one is used for orthochromatic materials such as lith or line film and no safelight with panchromatic materials such as most camera film and colour paper (figs 2.6 and 2.7).

The idea of safelighting dates back to the early days when materials were always developed by inspection of the image as it became visible under the dim coloured lighting. Processing by standardised time, temperature and agitation conditions was gradually introduced and is now practised universally. The convenience of developing by inspection has, however, been retained for printing, as it avoids much blundering about in the dark.

Even panchromatic materials may have a reduced sensitivity in a narrow spectral region and a safelight colour specific to this zone may be

2.6 Kodak safelight filters

Identification number	Colour	Materials
00	Light yellow	Slow, blue sensitive
0A	Greenish yellow	Fast, blue sensitive
0C	Light amber	Contact paper
1	Red	Slow, orthochromatic
1A	Light red	Kodalith
13	Amber	Ektacolor paper (neg-pos)

2.7 Properties of safelights.
A Black-and-white
materials. Graphs of
wavelength λ in nanometres
against log sensitivity of the
material L and safelight
filter density D. (I) Blue
sensitive paper B, and
yellow or brown, Y-B,
safelight. (II) Orthochromatic
material O, and dark red,
DR, safelight. (III) Pan
chromatic material P, and
dark green filter DG.
B Colour print materials.
(IV) Spectral intensity I, of an
LED safelight in the gap
between sensitivities of
paper layers.
(V) Dichroic filter with a
sodium lamp transmits in
the same gap.

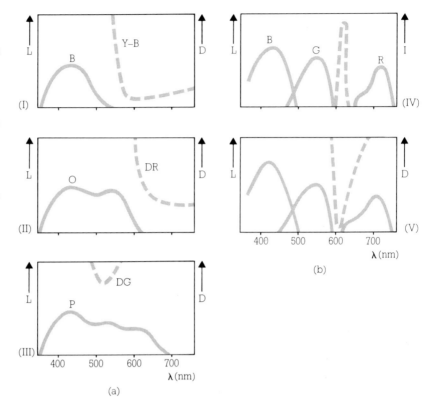

used. Examples are X-ray and infra-red films, but most of these are nowadays machine-processed.

Colour paper, by virtue of its function, must be panchromatic and is also very sensitive to ultra-violet and infra-red radiation too. With this, only very dark safelights can be used. As a general warning, the speed or sensitivity of modern colour papers is such that it is wise not to use a safelight but instead to become accustomed to working in the dark. Illuminated filter dials in colour enlarger heads should be switched off before removing colour paper from the box.

Safelights are available in various forms and may be free-standing, wall- or ceiling-mounted. Usually, the support allows a choice of direct or indirect lighting by swivelling the housing in the desired direction. The filters may be inter-changeable or a complete, coloured housing or dome may be removed and replaced by others. A rotating filter turret may give a choice of white or coloured light at the turn of a control wheel.

Various types of safelight are in common use. The traditional variety uses a conventional low wattage, mains voltage tungsten filament lamp plus a colour filter and diffuser. The filter may be made of dyed gelatin or acetate sheet mounted between glass, or dyed translucent plastic. Both varieties are prone to fading with time and lamp intensity, and are a potential source of unsafe light to cause fogging or veiled highlights.

For direct illumination, the safelight should be at least 1.2m (4ft) away with a 7.5–15W bulb and exposure should not exceed 2 to 3 min with the appropriate filter. Filter colours range from light yellow to a very dark amber.

To illuminate a large darkroom, a *sodium vapour discharge source* of the SOX type may be used, giving the strong yellow monochromatic light typical of street lighting, but still used with a yellow filter and diffusers. The filter may be the heat-resistant dichroic type but is still prone to thermal cracking. The necessary electrical control gear for this type of lamp necessitates a 10 min warm-up time and a restart period of some 20 min. A little-known side effect is that the infra-red radiation emitted may affect readings from negative analysers used for exposure.

Another variety of safelight is an *electro-luminescent* type using a steel plate coated with a ceramic mixture of phosphors which fluoresce when a voltage is applied. The spectral emission is too broad for real control and the devices are

in any case generally rather expensive.

Conventional fluorescent tubular light fittings can be used with a special filter layer applied to give the required safelight colour. They are suitable once again for large darkrooms where widely distributed illumination is necessary.

The most modern type of safelight is that using light-emitting diodes (LEDs), which are solid state devices tailored to emit suitable light of a very narrow band width to take advantage of the reduced sensitivity of colour paper at around 600nm.

Even colour reversal paper, normally best handled in complete darkness, may be used in safelight conditions. Further, by pulsing the LEDs at a suitable frequency, visual performance is unaffected but the effect on sensitised materials is reduced for greater safety.

Such safelights consist of arrays of LEDs numbering from a dozen to hundreds, of suitable colour and powered by mains or battery, emitting a virtually cold light. A small battery-powered unit can be hung around the neck for local illumination as necessary. Power consumption is minimal at a few watts. Dimming is also possible. Interspersing different coloured LEDs with suitable switching gives a choice of safelighting as required.

In use, to facilitate focusing on the easel, it is often convenient to link the safelight to the on-off switch for the enlarger lamp, so that it switches off the safelight when the enlarger lamp is on.

A safelight should be tested after installation according to the manufacturer's instructions for the printing materials in use. Testing should be periodical to check for leakages, especially with the traditional designs.

The classic test is to place a coin on a sheet of printing paper, expose to the safelight only for various periods of time, develop, and see if a photogram image is visible as a light circular patch against a faint detectable background fog.

A much better, systematic test is to make a good quality print from a normal negative on to a grade 2 paper, allowing a generous border, with the safelight set up as instructed. Process as recommended. Expose another sheet of paper identically but with the safelight off. Place the exposed paper beneath the safelight and cover one-third of the sheet with black card. Switch on the safelight and expose the remainder of the sheet in steps of 1, 2 and 4 min. Develop this print in darkness, giving the same processing as before. Compare the two prints and they should show no difference in contrast or density. Some slight fogging at the 4-min exposure warns of the time limit on safelight exposure. If the first print handled by safelighting appears to have less contrast than the second, some fogging is occurring and the safelighting conditions need checking. Safelight fogging does not affect white borders or unexposed regions, only areas that have received some exposure, so safelight fog could go undetected unless a proper test is conducted.

To avoid tiresome unwrapping and rewrapping of printing paper to minimise safelight exposure, a light-tight box or drawer in a bench to serve as a *paper safe* or *dark drawer* may be found useful.

3 ENLARGERS AND ACCESSORIES

The majority of amateur photographs are taken with small or medium format cameras so that the resultant image size may be between 8 x 10 and 60 x 90mm.

In general, same-size contact prints are un-acceptable other than for initial evaluation or filing purposes. An enlarged image allows composition to be selected or adjusted and shows the fine detail given by the camera lens. A comparison may be made with the colour slide viewed by the unaided eye or when projected on to a screen.

An enlarger serves to produce a larger image to be recorded as a print, it has means to control exposure of this print and allows overall or local control and manipulation of the image.

Magnification

The comparative sizes of the original negative or slide and their enlarged images are related by *magnification*. This is the ratio of image size to subject size so that a 24 x 36mm negative enlarged full frame to give a print size of 120 x 180mm represents a magnification of $\frac{120}{24}$, that is, 5. This is usually expressed as X5. Note that this is a *linear magnification* denoted M, an increase in a given length.

3.1 Effect of print magnification on image illumination. At a given aperture, as print magnification increases to give a print of larger area, the amount of light received per unit area also decreases, requiring an increase in exposure time.

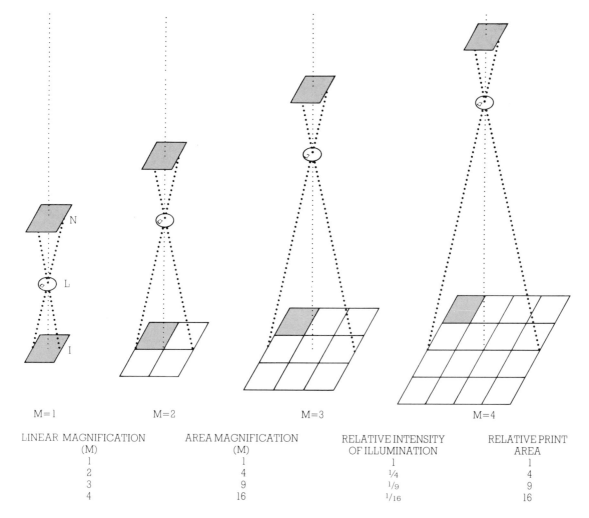

	M=1	M=2	M=3	M=4
LINEAR MAGNIFICATION (M)	AREA MAGNIFICATION (M)	RELATIVE INTENSITY OF ILLUMINATION	RELATIVE PRINT AREA	
1	1	1	1	
2	4	1/4	4	
3	9	1/9	9	
4	16	1/16	16	

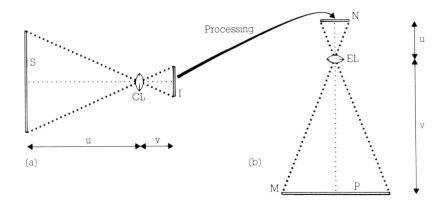

3.2 The camera and the enlarger. **A** The camera: an image I of the subject S is formed by the camera lens CL. Magnification m=v/u and is usually less than one. **B** The enlarger: the negative N of the subject produces a print image P in the plane of the masking frame M using enlarging lens EL. Magnification m=v/u and is usually greater than one.

The *area magnification* of the image is M^2, in this case 25.

To be useful, an enlarger should be capable of magnification in the range X2 to X8 at least, without modifications.

The enlarger operates in reverse mode to a camera (fig 3.2). The lens to image distance (v) is greater than the lens to subject (negative) distance (u). Linear magnification is given by

$$M = \frac{v}{u} \text{ and area magnification is} \quad \left(\frac{v}{u}\right)^2$$

For convenience and for assistance in calculation of exposure with change in magnification some enlargers are provided with magnification scales.

Basic requirements for an enlarger

For decades the enlarger has changed little in basic design. It is much like a vertically mounted slide projector in operation, but with more critical performance.

The basic components are the *head, column, baseboard* and *control gear*. The head contains the light source, an illumination system including filtration for the negative, a negative carrier and a lens in a focusing mount. These will be explained in detail but a few general comments are useful here.

The head must be light-tight to prevent accidental fogging of print material left uncovered or being exposed. Some form of convective or forced draught ventilation is needed for the head to remain cool externally. The latter system should not cause vibration or blow dust on the illumination system and negative.

The head should be easily attached and aligned on the column and locked securely in place. Any control knobs should be large, suitable for resetting or locking as required and be clearly labelled for use in dim light. Focusing knobs should be adjustable to take up any backlash or slackness from habitual use.

As the head rides up and down the column to give different magnifications make sure that the ceiling height allows sufficient clearance for maximum magnification.

The column itself should be heavy duty and rigid. Simple poles of circular section are not common now – complex girder shapes are preferred – but the former type do allow the head to be rotated round to project on to the floor for really big enlargements. Counterweights or springs can assist smooth movement of a heavy head.

A vertical column sometimes means that a really large image may encroach on the base of the column itself, if the lens axis to column distance is inadequate. A sloping column avoids this problem. Naturally, it must be possible to clamp the head securely.

The column should have a sturdy mount for attaching to the baseboard and be easily unclamped to allow rotation for projection on to the floor (fig 3.3).

A chrome or shiny column is a potential source of light reflection or flare on to paper lying on the baseboard, so a dark matt surface is preferable. Various scales or markings on the column can be useful to aid calculations of magnification changes, actual magnification or to reset a particular image size.

The baseboard should be as large as possible, to prevent the masking frame from projecting over the edge and thus being easily knocked out of position. Baseboard thickness adds mass and rigidity to the enlarger, making it less prone to vibration. The surface is usually white to allow the whole image to be inspected before selecting the final area to be recorded.

3.3 Big enlargements
A Wall mounted or free-standing enlarger with a drop baseboard
B Projection on to the floor
C Projection on to a wall
D Projection on to a wall via a mirror.

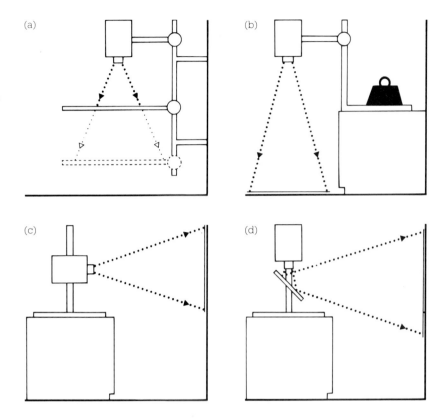

The control gear comprises the electrical supply to the light source, switches and timers.

Enlargers which have baseboard-mounted controls for enlargement and focusing are wonderfully easy to use.

Other useful features are to have the lamp easily accessible for replacement, an ample length of electrical supply cable, acceptance of short focal length lenses, a long focusing bellows extension and a choice of negative carrier types.

Most enlargers will give many years of use with only minimal maintenance before replacement seems necessary.

Enlarger types

There are several basic designs of enlarger, all of which fulfil the same primary role.

Most enlargers are of the small *bench-standing vertical* type, designed to be placed on a horizontal surface about 75cm (30in) in height and some 60cm (24in) wide and deep, but check on the space needed before purchase. This arrangement allows seated operation to save fatigue and for all controls to be easily reached for modest enlargements. Bigger enlargements usually involve stretching on tiptoe to operate the focus-

ing control. A great help for this are accessory extension rods fitted to the controls to allow close visual inspection of the baseboard image while operating. Baseboard-mounted controls are even more convenient.

A greater luxury still is a *motorised enlarger*, still uncommon in vertical designs, or an *autofocus enlarger* (fig 3.4).

A useful design is the *portable* or *folding* vertical enlarger which can be dismantled swiftly and packed into a small suitcase-sized container which may itself form the baseboard. This type is useful for taking to makeshift locations, for travelling demonstrations or where space is at a premium.

Horizontal enlargers are normally used for large scale enlargements made on a flat, vertical easel. They tend to be designed to handle large format materials only and have motorised controls for remote operation.

Another type of vertical enlarger is the *wall-mounted* type where the column is attached to a wall by suitable extension brackets and projects on to a table or bench of appropriate height. An exceptional magnification range is possible without time-consuming adjustments such as rotation

of the head about the column. The risk of vibration is also reduced but the alignment of the bench must be carefully checked.

An alternative is the *free-standing vertical enlarger*, whose very long, sturdy column on a heavy base carries both the head and the easel, which can both be moved independently. A large magnification range is possible and the relative heights and separation of head and easel can be selected for the operator's comfort.

Another variant of the free-standing type is the enlarger built into a sort of box framework to allow flexibility in positioning. The lower part can be used to store paper boxes and dishes (fig 3.5).

A very simple enlarger is the *fixed focus type* which gives only one degree of enlargement.

Some dealers and other outlets have special in-store combined enlargers and processors with zoom enlargement facilities operated as an over-the-counter service. The customer may approve the cropping before printing and have a finished print (usually making one print from another) delivered in a few minutes.

Devices for making prints from slides on to self-developing film may also be regarded as miniature self-contained enlargers.

Another primary classification for enlargers is into black-and-white or colour printing types. Any enlarger will allow black-and-white prints to be made and need only have the basic facilities described above. But for making colour enlargements some additional features are called for. These include a tungsten light source, preferably tungsten-halogen, a voltage-stabilised power supply, a timer and provision for colour filters to control print colour balance (fig 3.6).

Very often a basic enlarger may be upgraded or converted for colour work by means of an

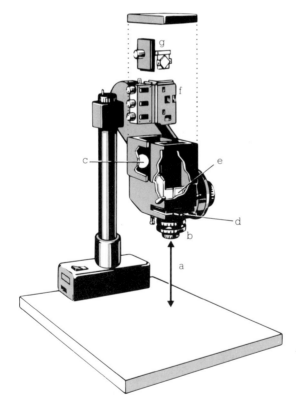

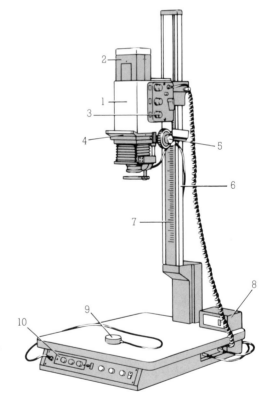

3.4 Advanced features of a 35mm professional enlarger. **A** Autofocus **B** Wide-angle lens **C** Low voltage lamp **D** Negative carrier for one format only **E** Low contrast diffusion box **F** Colour printing filter module **G** Variable contrast monochrome module.

3.5 Features of a colour enlarger of advanced design. **1** Colour head **2** Reversible illumination system for condenser or diffuse illumination **3** Colour filter controls **4** Negative carrier **5** Focus control **6** Vertical column with offset base **7** Scale **8** Transformer **9** Probe **10** Colour assessment system.

adapter kit, modified lamphouse or an alternative *colour head*.

Enlarger choice

There are many enlargers on the market and choice is dictated by several considerations. Usually price is foremost with additional features or flexibility being available only at a greater cost. The next consideration is the present needs of the user and also his future needs.

An enlarger with numerous unusual features may not be as good a choice as a simpler one which can be adapted in the future to allow colour printing. For example, for black-and-white printing only, a high quality make may be preferable to a colour model for a similar price. Due to its diffuse illumination system, a colour enlarger is normally less efficient for black-and-white printing than one designed for black-and-white only.

3.6 Advanced enlarger design. This unusual parallelogram arm arrangement needs only a short column. Automatic focusing is also possible over a wide magnification range.

The working height available in the darkroom may restrict the column length that can be accommodated. However, an enlarging lens of shorter focal length can give larger prints at the same column height.

The same applies if only small prints, not exceeding say 20.3 x 25.4cm (8 x 10in) are needed, with only very occasional larger ones. The bother of reversing the column may in this case be tolerable but an alternative is a shorter focal length lens.

You must also consider the maximum film format that the enlarger can handle. You may only use 24 x 36mm at present but you may change up to 60 x 60mm or even 60 x 70mm at a later date. In any case, you may be asked to make enlargements from large negatives belonging to other people. An enlarger taking 60 x 70mm negatives is a good choice.

Although costly, an autofocus type may be worth considering if a large amount of work is contemplated at various sizes – especially for those with eyesight problems and difficulties with focusing the image on the easel, or seeing in dim light.

A bench enlarger needs a permanent home. A wall-mounted enlarger takes up less space if the bench can be folded away against the wall. A free-standing enlarger requires little floor space and has much to recommend it, except cost.

Where possible, an enlarger should be inspected and evaluated in working circumstances. Before making a final choice, take any opportunity available to see equipment at a trade show or in a printing workshop. Matters such as vibration sensitivity, smooth movement of head up and down the column, top-heaviness, the feel of controls and their position relative to your physical size and hand dimensions, can all be checked. Look especially at the focusing control and the brightness of the image on the easel with the head set for maximum enlargement. Small features such as rear-illuminated filter dials can also be important.

The glassless type of negative carrier is essential for small negatives, to avoid problems with dust, but to keep larger negatives flat the glass variety is preferable. Built-in, independently moving masks to shade off areas of the negative are *essential*, not a luxury.

The provision of accessories in an *enlarger system* may be attractive and allow for future expansion of photographic activities.

Illumination system

The illumination system of an enlarger serves to make efficient use of the output of the light source and provide even illumination at the negative plane. As might be expected, there are various arrangements for this.

The light source on older enlargers is usually a mains voltage bulb of about 75 or 150W. This *opal* or *photopearl* bulb is double-sprayed white. It may be used with a simple *flashed opal diffuser*, which is inefficient but cheap and convenient, or an *optical condenser system*. This latter consists of one or two thick plano-convex glass elements of diameter equal to or greater than the diagonal of the film format. It focuses the incident light into the rear of the enlarger lens (actually into the entrance pupil), thus illuminating the negative.

To obtain even illumination, the lamp position may have to be adjusted while inspecting the easel image without a negative in the carrier. With condenser systems the position of a small light source is critical.

With black-and-white materials, but not with

8-9 The extra quality provided by larger formats can be very useful, especially when only a portion of the negative area is enlarged. These two prints were made from the same 6 x 6cm (2¼in sq) negative and show none of the quality loss (reduced definition and higher graininess) associated with great enlargements from 35mm negatives. Wherever possible, always use the slowest film that suits the subject and lighting conditions.

colour images, a *diffuser* system gives an image of lower contrast than a *condenser* system. This is due to the scattering of light by the silver particles in black-and-white film which does not occur with the image dye particles of colour materials. So, while black-and-white printing needs the choice of several contrast grades of paper to compensate for the illumination system, amongst other things, colour printing theoretically requires only one grade of paper.

For a condenser enlarger taking different sizes of negatives, the condenser arrangement has to be changed to suit. This can be done in various ways such as by changing the condensers completely, using two or three in different arrange-

ments, adding a supplementary condenser or by a 'zoom' system where the condenser separation is variable.

In every case the condensers must be kept scrupulously clean and should be of good optical quality and clarity.

Often, a *colour filter drawer* is available, positioned above or between the condensers. Being out of focus relative to the negative carrier, however, such filters can be of lower optical quality but more robust than filters designed for use below the lens where they form part of the *imaging system*.

The photopearl lamp has a long life, but must be voltage-stabilised for colour printing as even a 1 per cent change in supply can cause a colour shift of about 10 filter values.

As an emergency for large scale enlargements, a 275W *photoflood* lamp can be installed to increase light output. However, the enlarger head ventilation must be good.

The illumination system described above requires a lamphouse of considerable size and, consequently, a high ceiling in the darkroom. A more compact head is possible with a large plane mirror inclined at 45° between light source and condensers.

Large format enlargers may use more unusual light sources such as *pulsed xenon, mercury vapour* or *cold cathode (fluorescent)* types. These provide large areas of intense, highly actinic light but are unsuitable for colour printing.

The modern enlarger, especially of the *colour head type* (fig 3.9), uses a very small tungsten halogen light source (QI). This gives an intense light with a colour temperature of 3200K, eminently suited to colour printing. The lamp is usually 12V, requiring a transformer from mains voltage as well as voltage stabilisation, and of 75 to 250W output. Two, or three lamps are used in some designs.

The lamp often has an integral ellipsoid-shaped reflector to provide a near-collimated (parallel) light beam. This beam enters a *diffusion box* or *mixing chamber*, whose exit face is an opal plastic diffuser just above the negative. The result is to give even illumination.

These *integrating boxes* can be interchanged to suit different formats. The interior is lined with white polystyrene tiles. The entrance port is fitted

3.7 Enlarger illumination systems. **A** Condenser system using two plano-convex condenser lenses C1 and C2 to illuminate negative N in the carrier. **B** More compact design using a mirror M. **C** Design using offset diffusing chamber D **D** Provided that the condenser to negative carrier distance can be varied, negative formats N_1, N_2 and N_3 can be covered. **E** Using a smaller negative format wastes light **F** Smaller condensers utilise the light for a lens of shorter focal length.

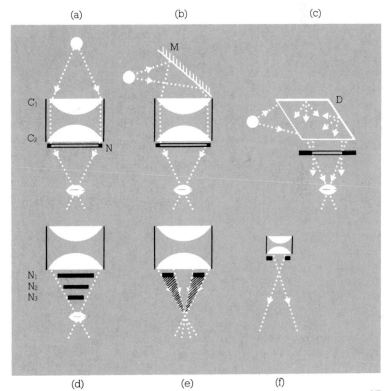

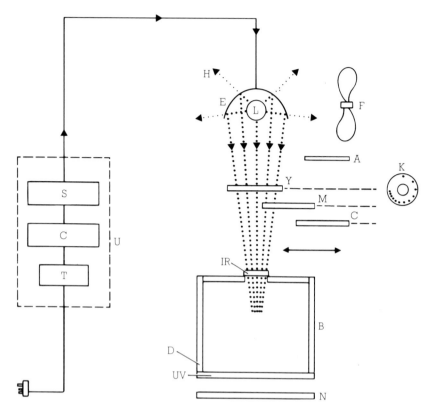

3.8 Colour head for an enlarger. T Timer, C Constant voltage transformer, S Step-down transformer, U Control unit, L Tungsten halogen lamp, E Ellipsoidal reflector (cold mirror), H Infra-red (heat), F Cooling fan, A Light attenuator, Y Yellow filter, M Magneta filter, C Cyan filter, K Filter control dial, IR Infra-red filter, B Integrating box, D Diffusing material, UV Perspex UV filter and diffuser, N Negative.

10 This dew-laiden scene was photographed early in the morning when the weather was overcast, thereby producing a negative of fairly low contrast. To ensure a 'lively' print it was necessary to use grade 4 paper and a condenser enlarger.

with an infra-red, *heat absorbing filter* and the opal plastic diffuser also acts as an *ultra-violet absorbing filter*. Colour paper is sensitive to both these forms of radiation, necessitating their removal.

The lamp/reflector assembly is located accurately in a mount. It is kept cool by a small impeller fan arrangement. The reflector surface has a multi-layer dichroic coating to form a 'cold mirror' which reflects white light but transmits harmful infra-red heat radiation.

Filters may be introduced into the light path. In the case of a twin-lamp head designed to print variable contrast papers such as Multigrade, yellow and magenta filters are used. A three-lamp head such as the Philips Tri-One system has fixed red, green and blue filters and the light outputs are varied before mixing.

Normally, for a single source, yellow, magenta or cyan filters are 'dialled in' and inserted progressively into the light path. A zero value is fully 'out', the maximum filter value is fully 'in' and there are intermediate values. The integrating box then serves to 'scramble' the light efficiently and give a uniform coloured output to the negative.

The light output of such an enlarger can be embarrassingly great so sometimes there is a 'HI-LO' filter arrangement to reduce output by a factor of 2 or 4. Because of heat problems and the need to keep colour temperature constant, a *wire gauze filter* serves as an efficient means of attenuating the light.

Enlarger lens

The lens fitted to an enlarger projects an image of the negative on to the easel. This is almost always an enlarged image, ie, its magnification is greater than one.

A simple, one-element lens is inadequate for photography due to the presence of various imperfections in image formation, known as *aberrations*. To correct for these, several elements are required, the additional elements giving improved performance. A complication in the design process is that camera lenses are 'optimised' or corrected for best results at a particular lens-to-subject distance (which is usually infinity unless it is a *macro lens*). But an enlarger lens always has the subject (the negative) at close range, normally between one and two focal lengths away. (The *focal length* is defined as the lens-to-image distance for a subject at infinity.)

As a consequence, enlarger lenses are of basically different design from camera lenses and are optimised for a particular magnification range, such as X3 to X10.

In general, poor results are obtained when a camera lens is used on an enlarger, although adapter lens panels may be available. There are operational difficulties too, such as lack of an illuminated iris diaphragm scale. Once removed from the camera body, lenses from modern SLR cameras may not allow manual operation of the aperture control.

So, given that an enlarger lens is designed for the job, what qualities should be expected? High on the list is a *flat image field* to coincide with the flat sheet of paper in the masking frame. An image that is saucer-shaped to give out-of-focus edges is of little use. The lens should have minimal *linear distortion* so that the shape of the subject is unchanged on printing. Lenses of *symmetrical construction* with equal numbers of similar shaped elements about the iris are best for this purpose.

On older lenses, *spherical aberration* was troublesome – a lens fault which gave a form of soft focus at full aperture, but disappeared on stopping down. Modern lenses are corrected for this and for astigmatism, too, and so are termed *anastigmats.*

The lens also needs to be 'colour corrected' to overcome the dispersion of light into colours by optical glass. An *achromatic* lens, which brings red and blue light into focus together is normal for colour printing. For very critical work, such as for colour separation, an *apochromatic* lens may be purchased. This is corrected for three colours.

The lens should be capable of imaging the smallest detail in the negative. This *resolving power* should be uniform over the field of the lens so that edge resolution matches that in the centre.

Some of these properties depend on the aperture setting of the enlarger lens. If present, they are more evident at full aperture than when closed down by two or three stops, which may give optimum results. The maximum aperture is often only suitable to give a bright image for ease of focusing.

Enlarger lenses are generally of *triplet, reversed Tessar* or *symmetrical* design (fig 3.10), with 3, 4 or 6 elements respectively, improving in performance and increasing in cost with the number of elements.

11 Where large areas of similar tone occur towards the corners of a negative it is especially important that the enlarger be correctly set up. Uneven enlarger illumination results in a decrease in exposure away from the centre of the image and therefore gives a print with corners which are too light in tone.

12 A high quality enlarging lens is essential for producing prints which have edge-to-edge clarity. A poor quality lens shows a fall off in definition from the centre outwards and this becomes most apparent in finely detailed subjects.

The lens elements have anti-reflection coatings to reduce flare which would adversely affect image contrast.

The maximum apertures of enlarging lenses are usually quite modest, in the range of $f/2.8$ to $f/5.6$. A large aperture is useful to help you focus at great magnifications with dense negatives, as the available illumination is spread over an increasingly large area (fig 3.1). But as *depth of focus* at the image plane is small, and field flatness not always perfect, it is sensible to stop down for the print exposure. The evenness of illumination will also improve although there will always be a measurable fall-off from centre to edge, due to

physical reasons and correctness of alignment in the illumination system.

The iris diaphragm usually has an equi-spaced, click-stop scale with a minimum value of about $f/22$. Occasionally, a scale of 1, 2, 4, 8, 16 is used, being *exposure factors* relative to 1 for the maximum aperture. An illuminated scale is very useful for confirming the setting by visual inspection. Some lenses offer a choice of either *click stops* or scales with continuous variation. The latter are useful in conjunction with a *colour analyser*.

The lens should be in a black anodised barrel to reduce risk of reflections.

The lens is mounted directly on to a fixed panel in the enlarger or on an interchangeable panel. Occasionally a *lens turret* for two or three lenses (for rapid interchange) is available as an accessory.

The majority of lenses whose physical size permits, use a 39mm diameter screw mount for attachment to the enlarger. This is the old Leica screw thread size and survives as a standard for enlargers.

As a general rule, the enlarging lens suitable

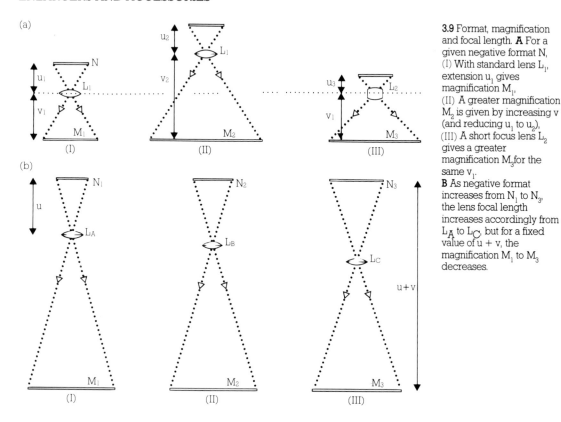

(a)

(I) (II) (III)

(b)

(I) (II) (III)

3.9 Format, magnification and focal length. A For a given negative format N, (I) With standard lens L_1, extension u_1 gives magnification M_1, (II) A greater magnification M_2 is given by increasing v (and reducing u_1 to u_2), (III) A short focus lens L_2 gives a greater magnification M_3 for the same v_1.
B As negative format increases from N_1 to N_3, the lens focal length increases accordingly from L_A to L_C, but for a fixed value of $u + v$, the magnification M_1 to M_3 decreases.

for a given format is one whose focal length is approximately the same as the diagonal of the format (fig 3.9). (A similar criterion applies to the *standard lens* for a camera.)

This focal length, plus the height of the column, determines the maximum enlargement possible without recourse to other methods. For instance, a 24 x 36mm negative used with a 50mm lens with a column height of 1 metre may give a linear magnification of X15, given that a lens-to-image distance of 800mm is physically possible.

With *wide-angle enlarging lenses* that have a short focal length but still cover the standard format, enlargements of greater size are possible with the same enlarger (fig 3.10). For example, a 40mm lens will give a 20 per cent increase in printing area compared with a 50mm lens or allow a shorter column to be used (ie in a darkroom with a low ceiling).

A very few *zoom enlarging lenses* are available. These are of two distinct types. One is a true zoom, used at a given lens-to-easel distance and retains focus as the zoom control varies the magnification. The other type is a *varifocal lens*. This, too, alters focal length to cover different negative formats, but requires refocusing with each

change. Both are expensive.

The choice of an enlarger lens requires various decisions to be made but it is generally advisable to buy the very best that you can afford. It is very unwise to pay dearly for camera lenses and then economise on the enlarger lens. If enlargements are to be made from several different film formats but only one lens can be purchased, select one of a focal length to cover the largest format. You must then accept that smaller negatives or slides can be enlarged to a more limited extent unless a longer throw from lens to easel can be provided, such as by a mirror or with the enlarger projecting on to the floor. Do not be too impressed by large apertures – f/2.8 to f/4 is quite adequate for small formats, f/5.6 for larger. Buy a lens with the common 39mm screw fitting.

To test a newly purchased lens, a few simple investigations are possible. First test for evenness of illumination. Ensure that the correct condensers and carriers are in the enlarger head. Focus the full area of a negative on to the masking frame. Remove the negative and, by means of a test strip, find the exposure time at full aperture to give a medium grey print density. Make corresponding exposures first at full aperture and then at succes-

3.10 Increasing degree of enlargement. **A** An intermediate setting, **B** A short focus enlarging lens, **C** A zoom enlarging lens, **D** Raising head up a long column or column extension increases enlargement, **E** The vertical column may cause loss of part of the image, **F** A sloping column allows maximum enlargements without loss.

(a)

(b)

(c)

(d)

(e)

(f)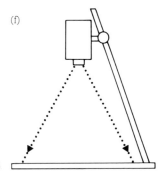

sively smaller apertures. Look for an even tone across the print, but do not be dismayed to see the corners a little lighter at full aperture. This effect should disappear at smaller apertures. A very uneven distribution of light could mean misalignment or incorrect condensers.

Insert a *focusing test negative* (page 38) with an overall fine pattern (or make one by photographing a page of newspaper text), focus carefully and make a print at full aperture and smaller values. Inspect the prints for unsharpness or loss of resolution at the corners. This could be due to an image field which is not quite flat (but may be reduced by stopping down) or just poor performance or both. Alternatively, if adjustments are possible, the enlarger may simply be out of alignment. *Distortion* can be checked by placing a straight edge along the image of a line in a print made from a focusing test negative.

Negative carrier

The negative carrier holds and locates the negative in the light path of the enlarger. There are various designs (fig 3.13), all with their own advantages. But the primary consideration is whether or not they hold the negative perfectly flat and per-

pendicular to the optical axis of the enlarger.

A *universal carrier* is completely removable and often has shaped receptacles to hold rolls of uncut film and so prevent them from obstructing the light path. The carrier takes interchangeable plates which have studs or slots to act as film guides, hopefully without scratching the film surface, and a small aperture may project the frame number. The negative aperture is usually smaller than the nominal film format to allow for small variations in the film gate size and, consequently, the image area, produced by different camera models. This is an annoyance if the whole negative area is to be printed, especially where part of the rebate is to be printed to make a narrow black border around the image. An aperture size of 25 x 37mm is provided for Leitz enlargers specifically for this purpose.

A very desirable feature is built-in *adjustable masking* using movable 'blades' to mask off any unwanted negative area during enlarging and so reduce the risk of flare or loss of contrast in the print. Four blades with independent movements are best. Often the blades are not very close to the film surface and may be out of focus so cannot be used to give sharp borders to a print in the

absence of a masking frame.

The negative is usually held flat by some form of sandwich arrangement of two plates. The main decision when buying new equipment is whether to use a glassless or glazed carrier. As noted previously, glassless types are suitable for small negatives, especially on 35mm film where the wide rebates can be firmly gripped to hold the film flat. With this, the dust and cleanliness problem of four additional glass surfaces is eliminated – you have only dust on the negative itself to contend with. For larger negatives such as those on 120 roll film, the small rebates and a larger area liable to 'popping' (buckling with heat from the lamp) mean that glass carriers are more practical. An *antistatic solution*, or compressed air used as directed, helps to keep the glass surfaces free from dust.

Unfortunately, glass surfaces can cause another problem – *Newton's Rings*. These are due to the close, but not perfect contact of glass with the rear surface of the film, trapping a thin film of air between. Faint, irregular ring markings, ie *interference patterns*, can show up in prints. To overcome the problem, the top glass of a carrier may have its lower surface slightly etched to provide a roughened area and avoid interference. These marks do not arise from contact between glass and the emulsion side of the film.

A compromise arrangement is for the etched lower flat surface of a plano-convex condenser to press the negative flat in a glassless carrier.

The carrier usually has a pressure release arrangement to allow the aperture plates or glasses to part slightly and let a roll of negatives be pulled through to the frame required with reduced risk of scratching.

The enlargement of small negatives, such as those on the disc film format may need a special adapter for the carrier.

Negative carriers constructed largely of plastic do seem to attract dust more easily than do metal types.

13 With glass film carriers you may sometimes be unfortunate enough to produce an interference pattern which appears on the print as 'rings' – this is due to a slight gap between the glass and the negative. These 'Newton's rings' are avoided by using a glassless film carrier or by fitting specially etched glass. Sometimes repositioning the negative, or cleaning can solve the problem.

3.11 Negative carrier. Various masks and carriers are available to accommodate different negative formats and mounted slides.

3.12 Masking frames and easels. 1 Conventional two blade design, 2 Versatile four blade design, 3 Fixed format design, 4 Test strip printer, 5 Multi-format design, 6 Contact sheet printer.

Masking frame

In essence, the masking frame is a mechanical device to hold flat the sheet of paper being exposed and to define the area and proportions of the print image.

The enlarger projects an image on to the baseboard and the masking frame sits on this. The frame should not easily be disturbed from its position, so a heavy type or one fitted with rubber feet or non-slip backing is desirable, otherwise due to accidental movement a composition will be spoilt and a run of supposedly identical prints not match up.

There are various designs of masking frame (fig 3.14). The simplest type consists of a sheet metal base with a hinged frame on top designed to lie on top of at least two edges of the paper sheet, shielding them from exposure and giving a white border. Two movable black blades then define the area to be exposed and also cover the edges of the paper to produce the other borders. Blades

which have runners at both ends and locking clamps are preferable to those which attach at one end only. A useful practical idea is to mark pencil lines on the base to show the actual picture areas most often used. This makes it quicker to set or re-set the blades as you do not then have to refer each time to the scales on the borders of the base. These scales give the picture size in millimetres and inches.

For speedy printing of standard sizes and with fixed borders, masking frames are available which have a fixed aperture only.

A useful refinement is the ability to vary the width of borders, say in 5mm steps, up to about 50mm wide. Simple variable paper-edge locators are positioned under the sides of the hinged frame. Remember that the variable blade settings must be adjusted accordingly.

With negative-positive printing, borders will be white. But for positive-to-positive printing they will be black unless a suitable black card mask is made to cover the image area entirely; then the frame and blades are lifted and a fogging exposure is given to the unexposed regions to record them as white on processing.

Few people bother with this, preferring to trim off black borders. A very versatile masking frame is one which has four adjustable blades so that for instance a 60 x 90mm image could be positioned anywhere on a 20.3 x 25.4cm (8 x 10in) sheet of paper with white borders.

There is always a demand for *borderless prints*, which are deemed to look more 'professional'. Of course, the print borders can be trimmed off, but this reduces the overall print size and trimming errors are not unknown. A borderless masking frame holds the sheet of paper flat by four specially contoured L-shaped grips, one for each corner. The grips are held in place magnetically.

Fortunately, modern polythene-coated (RC) paper base naturally lies very flat to assist this. Indeed, for black-and-white prints it can be just laid on the baseboard and positioned within the projected image under the light of a swing-in safety filter. A masking frame can become superfluous if accurate negative masking carriers are used.

Another type of masking frame is the *multi-format type*, such as the Durst COMASK where one 20.3 x 25.4cm (8 x 10in), two 12.7 x 17.8cm (5 x 7in) or four 10.2 x 12.7cm (4 x 5in) exposures can be made on one sheet of 20.3 x 25.4cm (8 x 10in) paper. While useful for making small prints on big paper for ease of machine processing, or repetitive printing, another purpose is for sequential exposure tests of the same image area. Exposure can be made by lifting up a numbered, hinged flap or by sliding pieces of plastic round the print area to form apertures. Such masking frames offer great convenience and economy for colour printing. One word of caution, they are not light-tight to white room light, but only to enlarger light. While paper is in the frame lay a simple cover or black drape over it if it becomes necessary to put on the room light.

There are other forms of specialist masking frame. One type is the *vacuum easel* which uses suction through multiple holes to hold paper firmly to the base. This is for precision work or to hold paper flat for projection printing on to a vertical easel.

Other expensive types incorporate auto-exposure devices for setting print exposure (see Chapter 4).

For professional purposes, a *roll paper easel* allows the use of rolls of paper for long runs of prints with automatic wind-on after each exposure. Various print sizes are possible on a given width of paper and enlarger exposure control is usually provided.

For complex print-image distortion or *rectification* of negative distortions (where parallel or vertical lines in the negative converge) the masking frame may be mounted on a special ball and socket head, like those made for tripods, and

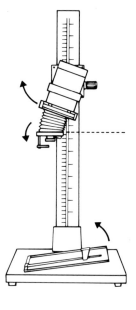

3.13 Distortion control. To obtain distortion control and retain edge-to-edge sharpness, the enlarger head and negative carrier should be rotatable, the lens panel should also be tilted and the masking frame raised as shown.

tilted as required (fig 3.15).

Masking frames usually have a white base on which to focus although a yellow type is also available. Many people prefer to focus on the back of a piece of paper of the type to be used. When exposing, a thin sheet of black paper positioned under the printing paper removes reflections from the white base which might otherwise cause a reduction in print contrast.

The edges of the hinged frame should be chamfered and not vertical, and also blackened in order not to reflect non-image forming light on to the exposed area of the print.

In choosing a masking frame, make it one size larger than you need for your usual paper size, ie an A4 or a 12 x 10in size for 20.3 x 25.4cm or 8 x 10in paper. Decide on the border type you need, check that the base does not slip on a smooth plastic surface and also that the movable blades are truly perpendicular.

Filters

An enlarger may be equipped with, or require a variety of filters for different purposes.

The simple black-and-white enlarger is usually equipped with a red swing-in filter above or below the lens to allow inspection of the projected image on the actual sheet of light-sensitive bromide paper to be exposed without fogging (fig 3.16). This is useful for checking composition or registration for multiple printing. It is also a reminder of the days when light sources such as mercury vapour discharge tubes were used. These could not be switched off and on at will, but were left on permanently and exposure made by removal of the swing-in filter. Such filters are unsuitable for use with colour paper, of course.

As well as light, considerable quantities of heat may be beamed through a negative and, if in a glassless carrier, heating effects may cause the negative to buckle or pop up or down in the centre, causing a focus shift. A *heat absorbing filter*, which is made of a special clear glass but not of optical quality and placed between lamp and negative, reduces or eliminates such problems.

Such a filter needs to be loosely mounted as it heats up and expands in operation. A gentle rattling of glass from the head as it is moved should not be a cause of instant alarm as it may be this heat filter.

The need for filters to remove infra-red (IR) and ultra-violet (UV) radiation from colour heads has been mentioned. Various glass and dichroic

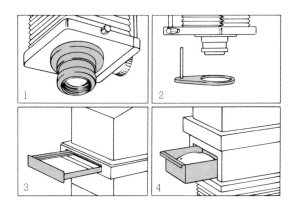

3.14 Features of an enlarger. 1 Interchangeable lens in mount, 2 Swing-aside red filter below lens, 3 filter drawer above condensers, 4 Interchangeable condensers.

arrangements are used for infra-red but simple perspex sheet suffices for ultra-violet.

For colour printing, or for variable contrast papers such as Multigrade, colour filters are generally required. Simpler enlargers use a *filter drawer* to take stacks of individual filters to form a *filter pack*. These filters need not be of high optical quality and can be dyed sheets of acetate, butyrate or polyester. If the filters are to be used below the lens they must be of optical quality and the minimum number employed to avoid loss of optical performance. Multigrade filters too, may be used below the lens. Accessory devices such as *filter turrets* allow red, green and blue filters to be positioned, in turn, below the lens for triple-exposure printing techniques.

The colour filters are in various strengths of yellow, magenta, cyan and red (being a combination of yellow and magenta). A typical filter coding is CP – 20M denoting a colour printing grade filter of optical density 0.20 to green light, the complementary to its magenta colour.

An ultra-violet absorbing filter is always needed with such sheet plastic filters.

A filter pack is cumbersome in use and the advantages of 'dial-in' filters are great in that continuous variation of filter value from zero to an arbitrary maximum value such as 80 or 150 or more, is possible. Note that these filter numbers do not correspond directly to Kodak CP filter values, nor do the various enlarger manufacturers use identical scales. So filter numbers are arbitrary reference numbers and not absolute or calibrated values.

Early colour enlargers of Agfa and Chromega

design with dial-in filters used filters of dyed gelatin on glass or fans of acetate filters but suffered from fading problems, giving a density 'pothole' in the linear relationship of the filter values.

Such fading problems, with only partially effective filtration were overcome by the use of *dichroic filters*. These are multi-layer thin coatings on a glass or quartz plate, using up to 25 coatings in a 'stack'. The optical interference effects, (from which the alternative name of *interference filters* comes) give very sharply controlled spectral absorption, unlike the 'broad band' absorption of previous filters (fig 3.17). The main problem with the previous type of filter was that alteration of one filter colour density affected other colour image densities as well as the complementary one.

The term 'dichroic' simply comes from the visual appearance of the filter. For example it may be yellow by transmitted light but blue by reflected light, hence 'two-colour'. Such filters do not fade even in the intense light close to an enlarger lamp.

Manufacturing techniques allow only small square or circular dichroic filters to be made at reasonable cost, so enlarger illumination systems had to be redesigned for these, resulting in compact heads.

Moreover, the filters must be used in parallel light, otherwise their properties alter. So a 'cold mirror' proximity reflector is required for the tungsten-halogen lamp to provide such a beam. The cold mirror is, in effect, a filter in that it reflects light but transmits infra-red radiation.

Focusing and focusing aids

The operation of focusing is to adjust the lens-to-negative distance to give the sharpest image with best resolution on the plane of the paper in the masking frame. The image appears more or less sharp as the lens is adjusted until, by progressively reducing the movement back and forth through focus, the best setting is found. Visually, it is very similar to focusing on the screen of an SLR camera.

The projected image may be dim, so using the lens at full aperture and switching off any safelight will help viewing.

The focusing mechanism may be a single or double *rack and pinion* arrangement with the lens panel on a short bellows. Greater precision but less extension is possible with a telescoping metal *helical focusing mount*. For big enlargements the

lens is likely to be quite close to the negative. A short focus lens may need a sunken panel in order to rack back far enough and this may set the limit to the degree of enlargement that can be achieved.

For small scale enlargements the lens must be racked out away from the negative. Not all enlargers allow sufficient lens extension to give X1 (same size) enlargements – a minimum of X2 or X3 is usual. For reductions, say from 60 x 70mm on to 24 x 36mm, special long *extension bellows* are needed and focusing is difficult.

Hand controls at bench level or extension rods on focus controls are a help for focusing. The criterion for sharp focus for black-and-white negatives is that the grain pattern be sharply rendered right across the field.

Some enlargers have the feature of staying in focus automatically when the degree of enlargement is changed. This is termed *autofocus* but is really a focus maintenance arrangement. It is very helpful for speedy work when a large number of prints of differing sizes is needed.

The usual autofocus arrangement is mechanical. Once the initial focus has been set manually using a focusing mount on the lens, movement of the head up and down the column then causes the lens panel also to move, guided by a shaped cam, and so adjust the lens-to-negative distance appropriately.

Such enlargers should be checked at intervals to see that focus actually is maintained. The autofocus range of magnification may be limited to, say, between X2 and X10 with manual focusing used in other cases. Precise focusing is made easier by turning off the safelights and projecting the image on to a sheet of paper, and then closing down the lens by two or three stops after focusing.

Be sure to check for possible focus shift due to the negative 'popping' in the heat from the illumination system during the exposure time. If this occurs, buy a heat filter or use a glass negative carrier.

It is also useful to check focus across the print area as slight misalignment of a negative carrier, especially one provided with tilt, can give a change of focus from one side of the picture to the other.

A great help for focusing and focus checks is a *focusing test negative*. This may be purchased in various designs and sizes. A regular pattern of dark lines and clear spaces provides a high contrast image for the eye to evaluate as sharp or

unsharp. For big enlargements or dense negatives the focusing negative may be used in place of the negative just to set focus.

In an emergency, make some scratches on a worthless negative to serve as focusing targets.

It is usually difficult to focus colour negatives, especially if a soft focus attachment has been used on the camera, as no distinct grain pattern is visible. To help matters, some colour enlargers have a 'white light' setting control which moves any colour filtration out of the light path to give a brighter image. Do not forget to reset this control after focus check or the result will be a dense, incorrectly coloured print! Otherwise, to focus set the filtration to zero.

A number of optical focusing aids are available. *Rangefinder devices* incorporated in the negative carrier give a split image when projected which merges into one when in focus.

Other types are free-standing optical magnifiers which you place on the masking frame. They select a portion of the projected image only and possess a screen which is in an *equivalent focal plane* to the paper. The projected image is seen highly magnified on this screen. The screen itself may be of ground glass or clear in order to provide an aerial image by which to judge focus (fig 3.18). Some *focus finder devices* are quite tall to allow the head and arms to be easily positioned for focusing big enlargements.

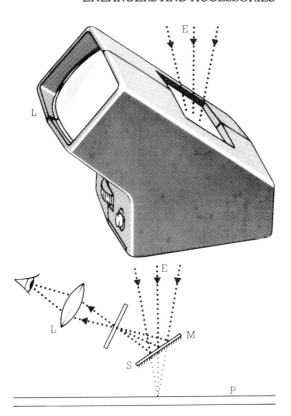

3.15 Focusing aid. Light from the enlarger E to be focused at the paper plane P is intercepted by mirror M to be redirected to a screen at an equivalent distance. The image is then inspected for sharp focus with the aid of magnfying lens L.

Timers

The necessary exposure time for the printing paper is determined primarily by the degree of enlargement, paper speed, lens aperture, light output and negative density. Exposure time is the prime means of control with an overall exposure level and then localised variations in exposure time.

Accurate timing is essential for good quality, not so much perhaps for exact duration but for repeatability so that results from an exposure test strip can be relied upon.

Traditionally, prints have been developed by inspection and *some* compensation made for slight over- or underexposure in the enlarger by reducing or increasing development time, respectively. But this practice is not feasible with colour prints where development time is critical and fixed, nor with machine processed black-and-white prints.

Various methods are used for timing print exposures and there are numerous designs of timer available.

The simplest method is to use a separate clock, preferably with a large luminous sweep second-hand, and switch the enlarger on and off manually. But for repetition printing, due to exposure errors, prints may not match. Short durations are difficult to time manually and for print shading or burning-in it is not easy to watch both the clock face and the projected image. A more modern equivalent is a simple digital clock or timer, again with a seconds display. Some models incorporate 'bleepers', audible signals that may be pre-set as required.

Other separate timing devices include a *metronome* or an electronic device which clicks or flashes at 1 sec intervals so that it is possible to count mentally while watching the image.

A timer connected to the electrical power supply of the enlarger is an improvement. They are of various types – clockwork, electro-mechan-

ical or electronic – with *analogue* displays or settings (using a moving hand) or *digital* (showing numerals).

An important safety warning is that the manufacturers' connecting instructions must be followed carefully, to avoid the possibility of electric shocks. If in doubt, get an electrician to make the connections for you. Some timers have additional features such as operation by *foot switch* to keep the hands free, or, as noted earlier, may be also connected to the safelight to switch it off when the enlarger is switched on, thereby to aid focusing and reduce the risk of fogging.

All such timers have a separate switch to bypass the timing device and switch the enlarger on continuously for focusing. A separate switch then actuates the timing action.

Simple clockwork timers have to be wound up by setting some given time before determining the exposure time needed. At the end a simple switch is opened to cut off the current. Electromechanical timers may use clockwork timing with a solenoid or other form of switch.

Both varieties are useful because the run-down time of the exposure is shown by the moving hands and shading or burning-in is then easily done for the required portion of total time.

The *electronic timer* uses either the charging time of a capacitor or a counter circuit linked to a quartz crystal oscillator. An LED display may be used to show time set or time remaining but usually no indication is given. A popular design is the three decade control type which uses three click-stop rotary switches with 10 positions for each. One switch gives 0 to 0.9 sec in 0.1 sec increments, the other 0 to 9 sec, the third 0 to 90 sec. So to set 13.5 sec, the 'tens' dial is set to 1, the 'units' to 3 and the 'tenths' to 5.

The electronic timer may be linked to an exposure metering system or colour negative analyser arrangement for automatic control of exposure time.

One special timer, the Nocon, allows local corrective action which may be set in fractions of stops. These are proportioned to actual exposure time and alter accordingly if the basic exposure is altered, eg. when changing magnification.

Sometimes, for very short exposures, the exact time is a matter of conjecture for the light output can be seen to rise slowly on switching on and fade similarly on switching off. This is due to use of constant voltage transformers, low voltage lamps and the operating properties of tungsten halogen lamps.

Enlarger systems and accessories

It is now rare to find a piece of apparatus dedicated solely to one purpose. Rather, it may be the central component of a 'system' and additional interchangeable parts and accessories extend versatility or allow other tasks to be performed. Enlargers are no exception.

The instance of interchangeable heads or lamp housings has been mentioned to allow use of black-and-white materials, colour paper, variable contrast paper or even specialist enlarging of microfilm.

A few enlargers allow conversion into a camera, complete with focusing screen, which can be tripod-mounted and used primarily for studio still-life work. The negative carrier is replaced by a special holder for a sheet of film, for Polaroid film or a cassette of roll film.

Most enlargers can be converted into a *vertical copy camera*. This is more elaborate than conversion into a copy stand (ie when the head is replaced on the column by a copy arm, fig 3.19). An accessory copy lamp array is available and a special grid may be projected by the enlarger on to the work to be copied. The negative carrier is replaced by a cassette to hold roll or sheet film. Alternatively, a focusing screen is placed in the negative carrier and inspected via a mirror arrangement. Special materials such as lith film may be used.

A colour head may be removed completely, inverted and placed on the baseboard to serve as a controlled, variable colour light source for duplication of colour slides with the aid of a copy arm. This arrangement is especially helpful with special slow, low contrast duplicating films.

A minor, but useful accessory is a clamping bracket to fix the top of the column rigidly to a wall.

Test strip holders and contact printing frames are handy for the initial evaluation of prints.

14 A standard negative (from a standard subject) is needed to set up an enlarger analyser. The standard subject should average out in tone to a mid-grey (18 per cent reflectance) and subjects such as the one shown are suitable – these should have a range of tones which are evenly spread between black and white. Predominantly light (high key) or dark (low key) scenes are most unsuitable.

15 Some subjects may be suitable as a standard for both integrated and spot readings for analysers. This example averages to an 18 per cent grey and also has large areas for spot readings. The best for spot measurement are the black sweater (minimum negative density) and the shoulder of the white cardigan (maximum negative density).

obtain your ideal or perfect colour print. There is no way of avoiding this procedure. The more effort spent to produce a good standard print, the more effective the subsequent negative analysis will be.

The printing information – magnification, lens aperture, exposure time, filter pack, colour paper batch and processing – is then used to 'program' an analyser.

Irrespective of the system or equipment used, this manual printing stage is absolutely vital before you can use the analysis technique. The more care and critical judgement you employ at this stage the higher the percentage of good prints you will obtain at a first attempt. It is best to become familiar with colour printing routines first

rather than start working with an analyser as a complete novice.

The analyser in its basic form consists of a photocell that can take spot or integrated readings of the image (fig 4.4).

The *filter turret* lays red, green and blue filters in succession over the photocell to record the relative intensities of the primary red, green and blue components, as well as a 'white light' setting to read the total intensity. The values are recorded as changes in (potentiometer) settings used to 'null' a meter needle or to light up a LED activated by the amplified output from the photocell at each filter setting.

To *program* the analyser, you carry this routine out with the standard negative in position, filter

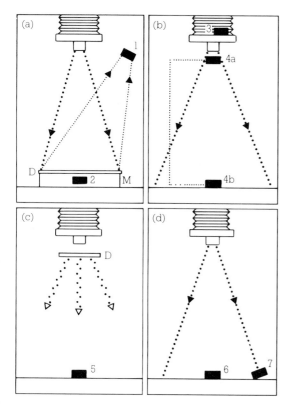

4.2 Position of probe or photocell. **A** Black-and-white printing – exposure monitoring, 1 Above masking frame M, 2 Beneath diffuser D in a special masking frame. **B** 3 Closed loop enlarger analyser system, 4a Beneath lens, 4b To determine exposure. **C** 5 Integrated reading, **D** 6 Spot or small area reading, 7 Tilted (cosine) corrections.

4.3 Colour negative analyser. 1 Condenser lens over measurement aperture, 2 Probe containing photocell and filter turret, 3 Flying lead, 4 Centre zero meter, 5 Nulling controls, 6 Exposure setting control, 7 Filter selection buttons, 8 On-off switch.

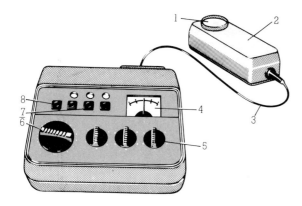

Other instruments

A variety of commercial instruments are produced which generally use a small photocell on a flying lead attached to a meter with convenient illuminated scales or indicator LEDs. The instrument may incorporate the enlarger timer.

At least one special masking frame has a translucent base containing a photocell so that the light transmitted by the paper *during exposure* determines exposure duration by control of the enlarger lamp.

An enlarger may have a similar arrangement actually built into the baseboard for full exposure automation. Naturally, with such integrated readings, subject factors may have to be applied.

Principle of the colour negative analyser

The argument for some form of instrumentation and automation applies even more to colour printing than to black-and-white because here costs are higher and time wasted can be greater.

The requirement is for an instrument that is simple to use, without calculations and of modest cost, that can give a first print from a reasonable negative that is 'acceptable'.

An *acceptable print* means one with the exposure level correct and colour balance either correct or nearly so, and requiring no more than a 5 or 10 filter value change for perfection.

The principles of such an instrument, a *colour negative analyser* (fig 4.3), are very similar to those of the enlarging exposure meter except that in addition to the *quantity*, the *colour* of the exposing light must be measured and evaluated.

The reproduction of colour by a three-colour subtractive synthesis system is based upon correct amounts of yellow, magenta and cyan image dyes being developed in the layers of the integral tripack print material following exposure to suitable amounts of blue, green and red light respectively. This may be done by three individual primary light exposures (*triple exposure* or *additive printing*) or by a single *white light exposure* of the correct composition (Chapter 9).

Print density, or exposure level, is determined by the *sum* of the individual red, green and blue exposures, while print colour balance is determined by the *ratio* of red to green to blue exposures.

Initially, you have to select a *standard colour negative* that represents the subject matter, type of film, lighting and processing that is typical for you. Then, by trial and error you print this until you

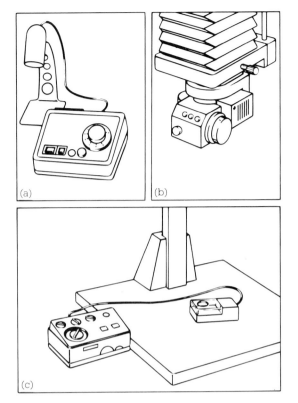

4.1 Enlarging exposure meters and colour analysers. A An automatic meter and timer using reflected light, B Self-contained colour analyser attached to an enlarger lens, C Meter/analyser using a probe for on-easel spot measurements.

difference between these can then be related to the paper grade required, eg a soft paper grade for a higher than 'standard' difference, a hard grade for a smaller difference. Specific instructions for use are given with individual instruments.

Exposure meter attachments

Most exposure meters of the 'system' type offer an enlarging exposure attachment. This allows a local, small area or spot reading to be made of the projected image, while the meter lies flat on the baseboard to permit the scales to be read.

The attachment usually consists of a small diffuser and *light pipe* arrangement to conduct the light to the photocell. An accessory calculator dial may simplify calculations and settings. The meter should have a high sensitivity to light as the projected image may be of low intensity with dense negatives or big enlargements.

Integrated or spot readings

It is often difficult to choose the optimum region on which to base exposure assessment readings, So, instead of such spot or small area readings as described above, a *large area* or *integrated reading* may be used (fig 4.2).

One method is to put a diffusing device over the enlarger lens to produce a uniform patch of light on the baseboard, allowing a meter reading in any location. But this diffuser also absorbs light, and so requires a sensitive meter. An alternative is to mount the photocell or meter close to the enlarger lens 'looking at' the image on the masking frame. Once again, the readings for a standard negative are related to those for other negatives or conditions.

An occasional problem with integrated readings occurs with atypical subjects – those where the tone distribution is significantly different from that of an average scene. The meter is calibrated on the basis of an average scene and may give over- or underexposure with negatives of low, or high contrast respectively, (ie from subjects of narrow or wide tone range).

A *subject multiplying factor* can be applied to the indicated exposure in that a high contrast scene may require a factor of X2.

Generally, the former method is used and a photocell measuring a small area is placed in a tone of the projected image from the standard negative set to give a standard print. This is usually a mid-grey tone.

The photocell output moves a needle over a scale and calculator dials are set to the lens aperture and exposure time. By this means a *paper speed factor* can be given for the box of paper, type and make, in use.

A change of say, magnification, would then indicate the new exposure time needed. Or the lens aperture could be adjusted until the same needle reading is given as before, and the standard exposure time may then be repeated.

Changing to another, unprinted negative, after setting print size and composition, the photocell is placed under an identical tone (as used in the standard negative) and the new exposure time or lens aperture needed can be read off (assuming that the same paper is in use).

A further application, especially useful if you are inexperienced in judging your negatives to determine a suitable contrast grade of paper, is to measure negative contrast by taking two readings, one each from a shadow and a highlight. The

4 ENLARGING EXPOSURE METERS AND COLOUR NEGATIVE ANALYSERS

The exposure conditions necessary to give a correct print are determined in much the same way as for the exposure of film in a camera. An image is projected by the enlarger lens on to the paper. The paper has a certain sensitivity to light, or 'speed', which is more or less constant given standardised processing conditions. The illumination level of the image is determined by the magnification, density of the negative, the light source used and the f-number or aperture of the enlarging lens. The main exposure control is the exposure duration, or time, given as an overall exposure or altered locally on the image for the purposes of 'burning-in' or 'shading' (Chapter 7).

The relationship between the principal quantities may be expressed as an equation:

$$\text{Print exposure time} = \frac{\text{Image illumination x Paper speed}}{\text{Lens aperture}}$$

In general, exposure is made at a constant aperture with the lens closed down about two stops from maximum, to obtain the best optical performance from the lens and to give exposure times of sufficient length to allow convenient local manipulation of the exposure with shading and printing-in. Alternatively, a fixed exposure time of, say 10 sec is used and the lens aperture varied to suit this duration. But in printing any roll of negatives, variations in camera exposure from frame to frame give differing image densities and also the need to change the degree of enlargement for selective image cropping means that exposure conditions may be different for each frame printed. A bigger enlargement requires more exposure time. A heavily overexposed negative also needs more exposure time while a small print or one from a very 'thin' negative requires a short exposure time, assuming a fixed aperture.

An approximate formula for making a *change* in magnification, given a known exposure time initially, is

$$\text{New exposure time} = \text{Previous exposure time} \times \frac{(1 + P)^2}{(1 + Q)^2}$$

where P is the new magnification and Q is the previous magnification, so that a 10 sec exposure for a X2 enlargement becomes $10 \times \frac{25}{9}$, or 28 sec for a X4 enlargement.

But the traditional method of determining exposure conditions is by the technique of the *print test strip*, as detailed in Chapters 7 and 9. While this is accurate and proof positive, it is also time-consuming and wasteful of materials to do this for each negative, especially for a roll exposed on the same subject where the only variation may be a slight change in magnification to give the best composition.

Enlarging exposure metering

To speed up exposure assessment, various forms of instrumentation may be used. These are generally grouped together as *enlarging exposure meters*.

Such a device may consist of anything from a simple attachment for a conventional exposure meter to a fully automatic device which sets the exposure (fig 4.1). But all require some care in setting up and calibration, plus some judgement as to how best to use the measurement system.

The essential first step is to make or select a *standard negative*, which has been correctly exposed and has received your normal processing so as to be representative of your usual negatives. The subject should be in focus, well lit and contain a good range of tones. This *average scene* negative should be capable of producing a high quality print with a full tonal range of greys between maximum black and white, when using a normal (grade 2) paper.

Such an *ideal print* has to be made by trial and error routines, giving normal print processing throughout. Ideally, no shading or burning-in should be necessary.

This negative/print combination then gives specific information as to conditions – degree of enlargement, lens aperture/exposure time, paper grade and processing. The enlarging exposure meter then uses this data together with a light measurement of the projected image itself (or, *image photometry*) to reproduce similar conditions for the printing of other negatives.

Principles

An enlarging exposure meter is a *light meter* or *photometer*, which measures either *image illuminance*, the amount of light incident on the easel plane, or *image luminance*, the brightness of the image seen by light reflected from the easel.

(a)

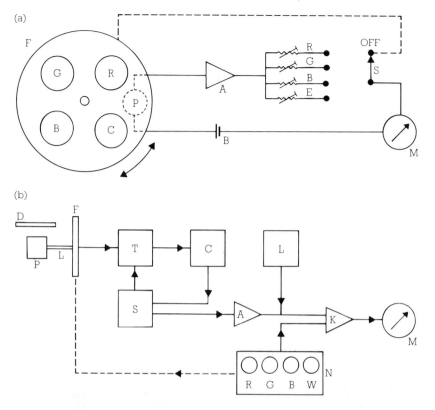

(b)

4.4 Colour negative analyser. **A** Simple circuitry of a battery-operated model. Filter disc F has a clear aperture C and Filters R red, G green and B blue. Photocell P, Battery B, Amplifier A, Rotary switch S and Attenuators R,G,B and E for exposure. Meter M is for nulling operation. **B** Schematic of a mains operated model. D Diffuser, P Probe, L Light pipe, T Photomultiplier, S High voltage supply, C Voltage controller, A amplifier, L Linearising circuits, K Differential amplifier, M Meter, N Nulling circuits

pack set and lens aperture adjusted to give a standard print at the desired magnification, as already determined.

On some instruments this program may be recorded on calibrated controls. On others, it is set and cannot easily be changed for another without going through the calibration procedure again.

The second stage is *analysis*. Here, you evaluate an unknown negative for printing, bearing in mind that a different magnification may be used, as well as small variations in the lighting, exposure and processing of this negative compared to the standard colour negative.

Set the colour analyser to read the projected image as before and use the filter turret to obtain the red, green and blue light intensities. If these differ from those of the standard negative, as shown by a deviation from the null settings, re-balance the instrument by a change in the filter pack values, followed by a white light reading for exposure determination.

Provided that the correct amount and ratios of primary light colours reach the colour paper and the chosen *reference area* appears correctly

exposed and with good colour reproduction then the other colours should also reproduce satisfactorily. Thus, the new filter pack settings are obtained directly.

Advantages of this technique are that it is done on-easel, that is, on the projected image. So 'drifts' in the performance of the equipment such as by the aging of lamps, loss of light transmission by lenses and condensers, spectral overlap or fading of filters are all acounted for, as well as magnification. No calculations are needed, assessment can be done very quickly and the exposure given directly.

Other methods based upon a diffused exposure to filter mosaics or arrays of tricolour filters are much less satisfactory. However, they are much cheaper because they do not involve photocells and electronics.

A colour analyser is less useful for making positive prints from slides as the original colour transparency itself acts as a reference for the colour print made from it and so visual assessment is swift and accurate. But it is still useful in the exposure mode to obtain correct exposure when making filter or magnification changes.

16 The integrated method is unsuitable for non-average subjects, such as this predominantly dark and light scene. The negative of this scene is, however, suitable for spot measurement because of the large areas of minimum density (printed as black) and maximum density (reproduced as white).

Reference areas

The colour negative analyser is most accurate when used in its *spot reading mode* and with a particular *reference area*. This could be a skin tone – a diffuse highlight on the forehead or cheek would be preferable. Obviously, skin tone and colour can vary between ethnic groups or with the use of make-up or by tanning etc. It is,

nevertheless, still useful.

Another favourite is the kind of neutral grey card sold for camera exposure estimation. You may include this in a corner of the subject and remove it when cropping the print. It must, however, receive the same lighting as the main subject – obviously, back lighting is of no use! Alternatively, expose one frame on each roll of film, or at

17 This type of subject with its large areas of white and maximum black is ideal for a spot analyser. The child's hat can be used as a maximum negative density and the right shoulder or the black above the hat can serve for a minimum density reading. The subject is rather dark overall and is not suitable for integrated readings.

18 An enlarging meter can only give a guide to printing exposure and does not take account of personal taste. In this example, the meter gave a lighter print than the one shown – it was decided to print it darker overall to emphasise the highlights on the foreground chair. In addition, the top left corner was 'burnt in' to prevent undue attention being drawn to this area.

the start of a sequence, to this reference card and use the data obtained for the remainder of the roll or sequence.

Other possibilities for reference purposes are a blue sky or green grass or the rebate area between negatives.

Versatile analysers may have *memory banks* to store programs for several reference areas, for different batches of paper or types of film as well as for spot or integrated readings.

Integrated readings

The possibilities of spot or large-area (integrated) readings for black-and-white printing have been described. Similar considerations apply to colour. Accurate analysis over a small, critical zone of the image requires a reference area. In the absence of this, for example with a landscape picture or a back-lit scene, or even when you are printing someone's negatives, the integrated reading must be used.

Once again, a diffuser may be placed over the enlarger lens and the photocell probe (in spot reading mode) calibrated using the coloured patch of light projected on the baseboard from the standard negative. This can be an additional

19 Black-and-white infra-red (IR) film was used to record this field – note the dramatic cloud reproduction and the tracks on the field itself. An enlarging exposure meter can be used with IR film just as well as for conventional black-and-white films.

program to store. Analysis is done in the same way with the diffuser in place.

A preferred method, which offers the advantage of greater light intensity, is to place the photocell immediately *beneath* the enlarger lens to receive the out-of-focus image, or even inside the enlarger focusing mount or bellows to read the *scattered light* from the colour negative.

The integrated method works well for, perhaps, 70 per cent of negatives. But spot readings are needed for the other 30 per cent of untypical subjects – that is, subjects with unusual tone and colour distribution. The assumption built into the integrated reading system is that the average scene will integrate to give a neutral grey reflecting some 18 per cent of the light falling on it.

So, not only is the contrast of the scene a factor, as for black-and-white printing, but also the predominance of any one colour. The classic

example is that of a white cat on a green rug. The dominant green is still assessed by the analyser as integrating to grey and the result is overcorrection for this colour, giving a print with a strong magenta cast. This produces a purplish cat on a degraded green rug. Once realised and recognised, such negatives can be assessed and a manual correction applied – in this case an increase would be given to the indicated magenta filtration for the cat negative.

Such instances are often called *subject failures* – misleadingly, for the subject has failed at nothing, it is rather that the instrument has shortcomings!

Photo-electric instruments

The majority of colour analysers are photo-electric instruments. The low light levels to be measured, especially through a tricolour blue filter, demand a level of sensitivity that an exposure meter cannot match. Many instruments use a *photo multiplier* and associated high voltage control circuitry, but the very small *silicon photodiode* (SPD) requiring only a low voltage battery is now popular. Often three such SPDs are used in a 'triad', with red, green and blue filters for a single *simultaneous reading* instead of the *sequential readings* from a single photocell and filter turret.

The photocell may be in a box-shaped *probe* on a flying lead to the main controls. Or, a prism and fibre optic light guide may conduct light to the photocell in the main body of the instrument. (Exposure to room lighting may damage the photocell.)

Since by the natural laws of illumination, the intensity of illumination of a projected image falls off increasingly towards the edge of an area relative to that at its centre, some instruments incorporate a tilting probe to maximise the illumination available for off-axis readings.

This is termed *Cosine Correction* as it is related to an illumination law called Lambert's Cosine Law.

Various arrangements are used to denote a *balance point* or *null point* when storing a program or analysing a negative. Moving needle instruments with a centre zero indication or LEDs seem to be favourites. Modern solid state circuitry allows a complete analyser for integrated readings to be built into a small attachment for use beneath an enlarger lens or, if separate, to be a little larger than a hand-held meter with battery operation.

Instruction leaflets for various instruments explain how they operate individually within the principles just described.

Big enlargements, dense negatives or heavy filter packs may not allow a bright enough image for assessment of the negative. In such cases, filter assessment may be done at small magnifications and with the lens at full aperture while the actual exposure can be worked out at the chosen final magnification. A change in size does not affect colour balance.

Usually, with the light set to the 'white' or 'exposure' channel, the lens aperture is altered to null the instrument and the exposure time is then given as for the standard print. But if the aperture range is exceeded without a balance point having been achieved then the standard time will have to be multiplied by a suitable factor, which can usually be read off the scales on the instrument.

5 PRINT PROCESSING ACCESSORIES

Processing serves to amplify or *develop* the microscopic specks of silver that form in the light sensitive emulsion of photographic printing paper after exposure under the enlarger. Processing produces a visible image composed of silver grains or clouds of coloured dyes. In subsequent stages of processing, *fixing* removes unexposed emulsion and unwanted silver images and *washing* removes chemical residues and by-products. Finally, the print must be dried. Some processing involves treatment to ensure archival permanence of finished prints where needed and this usually takes place between the fixing and final washing stages.

Processing routines

Every print material has a specified processing routine consisting of various chemical treatments in a given order, at specific temperatures and times and using certain agitation methods, to yield an optimum result. The details of such routines vary widely, from the very tight tolerances of colour paper processing to the more generalised handling acceptable to black-and-white-paper. Optimum results, however, can only be expected from following the routines specified by the manufacturer of the paper in use. With experience, it may be possible to deviate a little from a specified temperature, or to employ agitation better suited to the equipment in use or to try a substitute solution on the grounds of economy.

To assist with processing, a wide variety of equipment is available, ranging from the few essential items to expensive, automated machinery. Modest expenditure enables you to set up for black-and-white paper processing. Any further expenditure depends on which other processes are to be used, the amount of printing done and the need for large numbers of prints.

Developing dishes

For black-and-white printing, most paper processing is done by inspection in safelight conditions using *developing dishes* (fig 5.1) – shallow trays holding a volume of solution sufficient to cover the sheet of paper. They are agitated by alternately lifting by two adjacent sides to allow the liquid to swirl about. This ensures a supply of fresh solution to the developing emulsion and removal of exhausted developer and by-products.

A number of practical points are worth bearing in mind. Dishes may be made of ceramic, plastic, enamelled metal or stainless steel. Ceramic types are heavy, fragile and obsolete but do retain solutions at constant temperatures longer. Plastic dishes may be of PVC, polyethylene, polypropylene or fibre glass. They are light, reasonably tough, modestly priced and chemical-resistant. A useful feature is that they are available in various colours, such as white, grey, red, yellow and silver so that they can be assigned to specific chemical baths and identified by tone under a

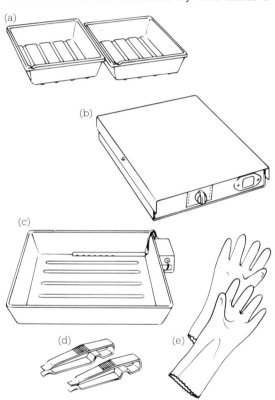

5.1 Accessories for dish processing. **A** Conventional dishes, **B** Dish warmer, **C** Dish with incorporated heater, **D** Print tongs, **E** Darkroom gloves.

20 This print has a full range of tones ranging from highlights (shirt), through ligher greys (path), mid tones (face), darker tones (trousers), to full blacks (parts of the bicycle). To obtain such a tonal range, the photographer must control all the exposing and processing steps for both film and paper.

darkroom safelight. Usually white is best reserved for the developer. Occasionally, transparent perspex dishes are encountered. These are intended for use with lith film as development is carried out over a red safelight for critical timing and judgement of image quality.

Sheet steel dishes with enamel coatings are heavy and prone to chipping so must be discarded when the metal beneath shows through. Stainless steel dishes of high grade material are very expensive but durable and easy to maintain at temperature. Substitute trays of metals such as copper or aluminium, or those with soldered seams, must be avoided as they cause chemical fogging of the photographic materials.

Dishes are normally rectangular and in the usual nominal dimensions of paper sizes. A dish one size larger than that of the paper is recommended, so that for instance 12.7 x 17.8cm (5 x 7in) prints are developed in a 20.4 x 25.4cm (8 x 10in) dish. This allows for efficient agitation. A luxury is two sets of dishes, a small size for general work and a much larger size for exhibition prints.

The dish should have sloping sides, not vertical, with one corner formed into a pouring spout. Corrugations in the sides give strength and rigidity. The base of the dish should be flat, to allow good thermal contact with a dishwarmer and give stability, but also have a few longitudinal raised ridges to keep the paper from the base of the dish for better chemical circulation. A slot or groove for a thermometer is a useful refinement.

Large prints may be processed in long, narrow deep dishes rather like troughs by a process of rolling and unrolling to ensure proper chemical contact.

The usual solution level needed in a dish is some 20mm deep and a new dish can be calibrated using water to this level, the volume measured and a convenient dilution calculated for the solution to be used. For instance, 800ml of developer used at 1 + 3 dilution requires 200ml of stock solution, while for fixer used at a dilution of 1 + 7, only 100ml of the concentrate is needed.

To develop a number of sheets of paper at a time by an interleaving technique, greater depth of solution is needed, say 40mm for 10 sheets of paper in the dish together.

Depending on the process, only two dishes may be needed, one for developer and one for fixer or as many as six or seven, in sequence – developer, stop bath, first fixer, second fixer, rinse, first wash and subsequent wash.

Temperature control

The temperature of a processing solution may be critical for correct or optimum results, especially where the developer is concerned.

Development at 20°C (68°F) is usually specified for black-and-white prints. At reduced temperatures, the developer becomes less active and needs longer processing times while higher temperatures give risks of uneven development, staining and chemical fog. Development at 38°C (100°F) precisely is required for most colour paper materials.

Not only is it important to have solution at the right temperature, but also to maintain it for test prints to have some value and for results to be repeatable.

Developing dishes with their large, shallow areas of solution are very prone to temperature changes, usually towards the ambient temperature. They are also altered by the presence of a warm human hand immersed in the solution.

A *dish warmer* is essential, at least in a country like the UK where a darkroom temperature of 20°C is uncommon. A warmer large enough for the developing dish only is adequate; with other solutions it is less critical. The basic design is a flat hob of enamelled metal containing an electrical heating element and thermostat. The exact setting required is arrived at by trial and error, allowing a dish of solution to warm up for an hour or so and come to a steady state before measuring the temperature.

This arrangement is unsuitable for colour paper processing because of the temperatures and the unacceptably high rate at which the developer

5.2 Darkroom timers. **A** Clockwork timer with stop and restart functions, **B** Programmable clockwork timer, **C** Programmable electronic process timer.

deteriorates by aerial oxidation, ie it has a very short dish life.

It is possible to buy heating pads which are inserted into the solution and lie flat on the base of the dish. Another luxury is a dish with a heater built into the base.

Other ways to provide a stable solution temperature are with water baths in which the dishes stand (metal dishes are the best heat conductors) or an enclosure of warm air in contact with the base of the dish.

Processing machines, as described elsewhere, generally incorporate some form of electrical heating element or heat exchanger arrangement with a thermostat.

Thermometers

An accurate thermometer is a vital accessory for photographic processing and a number of types and designs are on sale.

The temperature range to be covered is not great, say from 10°C (50°F) to 49°C (120°F), so an expanded scale for easy reading and accuracy is an advantage.

The traditional glass thermometer is perfectly

adequate for most purposes but the long, thin shape is prone to accidental breakage. If possible, purchase a *stirring thermometer* where the glass has been thickened and toughened for such rigours. Note that partial immersion to a mark, or total immersion, are required to indicate correct values.

For preference and safety, choose an alcohol column thermometer. The liquid is dyed blue and is easily read even under safelighting. Accidental breakage releases only harmless liquid rather than the mercury contained in other types of thermometer.

Another form of thermometer is the bimetallic type. This uses the differential thermal expansion of two dissimilar metals in contact when subjected to temperature change. This effect is used to move a pointer over a calibrated dial. Such *dish thermometers* have the dial at the end of a metal

21 Cleanliness in both processing (film and paper) and printing is essential if you are to obtain prints free from irritating marks, which would be most noticeable on the even grey background of this portrait. To avoid long hours of retouching, keep your negatives and enlarger free of dust.

rod which is placed in the solution. It is sensible to check the accuracy of any thermostatically controlled device against a certified thermometer.

A deluxe type of thermometer is the *digital* variety. An interchangeable *probe* is placed in the solution and a thermo-electric effect gives an amplified output to an LED or LCD display. This battery-operated thermometer is useful for monitoring temperature as the display is connected to the probe by electrical leads.

Cleanliness and safety

Constant care is needed to maintain cleanliness in the darkroom, not just from airborne dust but also from the chemicals themselves. A common source is *contamination* by splashing or drips from a wet print being carried over a dish. Your fingers too, can be a source of contamination just from perspiration and grease inhibiting processing sufficiently to give distinctive fingerprint marks on the print. So handle prints by the edges only.

More serious contamination comes from bare hands, used to manipulate prints in the solutions followed either by a cursory rinse and dry, or drying on a contaminated towel or cloth. Residual fixer on the fingers can easily cause finger marks.

For this reason and for sensible safety precautions in minimising skin contact with processing solutions, two alternatives are suggested.

Direct contact can cause skin irritation and is best avoided. You can wear protective thin plastic or rubber gloves on the hands when immersing them in solutions. But these can be a nuisance and still cause finger marks. An alternative is to use plastic *print tongs* for inserting, agitating and removing paper from solutions. The tongs may be colour coded for various solutions.

A *print paddle*, looking rather like a large perforated frying spatula, serves to keep prints immersed and moving in a fixer bath or in a dish of washing water.

Another useful accessory is a *processing apron*, made of plastic or rubberised cloth which protects clothing from accidental splashes or chemical spillage. A dark colour is preferable as this prevents any troublesome reflections from light coloured clothing reaching the paper surface when printing. Even a carpenter's working apron can be useful to protect clothing.

Any spillage of chemicals or water should be mopped up and the area rinsed with water. If allowed to dry out naturally such spillages may leave a deposit of chemical crystals which later become airborne.

The obvious dangers of electrical appliances and liquids in close proximity have already been mentioned.

Cleaning apparatus

When you have finished printing or processing, clean all the equipment before storing it away.

Processing dishes may simply be rinsed out with water and left to drain and dry, stored vertically in a suitable rack. If left flat for some time, a dust film may accumulate and you must brush this off before putting any solution in the dish.

Dishes used for stop-bath, fixer or wash seldom become stained or marked. But a developer dish soon acquires unsightly brown stains and a roughness from chemical deposits. You can remove these with a rinse in dilute acetic acid (about 3 per cent strength, such as that used for a stop bath). For persistent stains a proprietary dish cleaner is suitable, including those domestic varieties with bleach and abrasive content.

In the case of deep tanks, processing drums and machines, the specific instructions given by the manufacturer should be followed.

Deep tanks are only cleaned out thoroughly when a complete change of chemicals is necessary, but all the outside surfaces, lids and paper carriers should be kept scrupulously clean. With a generous number of carriers or racks, thorough washing and drying to prevent contamination is possible while other prints are being processed.

Print processing drums, with their intricate and labyrinthine light traps and funnels, are particularly difficult to clean and dry thoroughly after use. Once again, two or more drums are useful.

Processing machines with trays or tanks of solutions and roller transport for the paper need careful cleaning to prevent a build-up of dirt and chemical deposits on the rollers. On start-up, it may be necessary to process a piece of material without an image just to remove any accretions from the rollers and solutions. These are termed *'clean-up'* sheets.

Developing tanks – deep type

Developing dishes are very suitable for black-and-white print processing but not for colour, owing to difficulties of temperature control, aerial oxidation effects and the costs of chemicals which must be thrown away after use.

A traditional alternative is the *deep developing*

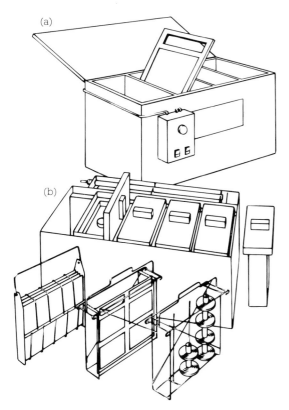

(a)

(b)

5.3 Print processing in a deep tank line. **A** Simple self-contained tank line with a light-tight lid. Sheets of paper are held in special holders. **B** A more elaborate tank line with additional wash facilities. Several sheets of paper are held in a basket. Other materials may be processed by changing the tanks.

insertable immersion heater and thermometer plus vigorous stirring, will retain its temperature long enough for a process, due to the mass of the solution and the small heat losses that are possible.

The paper to be processed is held individually in *clip hangers* which grip each corner, or in a channel type *holder* into which the paper edges locate in grooves. Modern resin-coated papers have insignificant dimensional change when wetted. Such arrangements are satisfactory for up to six sheets of paper, but for more than this some form of *processing basket* which fits into and fills the tank is necessary. Sheets of paper are loaded back to back in narrow vertical compartments constructed of mesh. Cleaning after use must be very thorough!

For processing, you transfer the paper holders or baskets by hand from tank to tank to complete a processing cycle. For this you need the help of a *process timer* which requires a visible seconds indicator so that a suitable *draining time* can be given, typically 15 sec at the end of each cycle. You have to work in the dark, of course, until a stage is reached when the room light may be turned on.

While deep tanks and their accessories are more costly than dishes and require larger volumes of chemicals to begin with, they do have definite practical and economic advantages.

It is possible to process larger numbers of prints in one run, each with identical processing – important if a number of matching prints are to be made. Processing units are available which contain all the necessary tanks, water jacket, heater and thermostatic control in one compact package which can stand on a bench or sink needing only one electrical connection and a water supply. They can be left on permanently for instant use or have a warm-up time of 15 min or so, so the tedium of measuring chemicals and temperature adjustment is avoided. A considerable throughput of prints per hour is possible.

The whole economy of processing is based on chemical cost saving which can soon pay for the initial capital outlay for such a processing unit. Initially the tanks are made up with from 2 to 15 litres (3.5 pt to 3 gall) of solution as appropriate to fill them. These solutions are then *replenished* with slightly modified versions of the colour developer, bleach, bleach-fix or whatever is used. Only a small volume, typically 10 to 50ml of replenisher solution, is added to each tank per

tank (fig 5.3). The 15-litre (3-gallon) size hard rubber or plastic tank has been the mainstay of professional processing routines for film and paper on a medium scale. Suitable paper holders or racks allow up to 24 sheets of 20.4 x 25.4cm (8 x 10in) material to be processed together.

A tank is needed for each step of the process plus another for washing. The dimensions of the tank are such as to accommodate the paper size suspended vertically in the solution and to have minimum surface area of solution open to the atmosphere. Put floating lids on the solution surface when not in use to reduce further the risk of contamination by splashing or effects such as evaporation and oxidation. A tight fitting tank lid gives added protection.

Temperature is controlled by an integral heater with thermostat or from an external jacket of heated air or water. But even a simple tank of solution, if brought up to temperature with an

print processed, to make good the chemical exhaustion and changes caused by processing. Thus, once chemical equilibrium has been reached the solutions can be used for many weeks or months. Some further addition may be needed to make up for any drop in solution level due to evaporation or carry-over by the print holder to the next bath, as well as for the through-put of paper.

Developing tanks – drum type

Another form of processing tank is the light-tight cylinder or drum which holds the paper against the inner surface, emulsion side out (fig 5.4).

This idea is a modification of the film developing tank. You load the paper into the drum in the dark (with the guides and clips provided) replace the light-tight end lid and then go ahead with the processing in normal room lighting.

You mix the correct volumes of chemicals and bring them up to temperature by using a water bath. Temperature controlled water, and washing water at suitable temperatures, are also required.

The measured amount of solution, which is quite small, typically 50 to 100ml, is poured into the drum via a light-trapped funnel. The drum is revolved on a horizontal axis to cover the entire paper surface with a film of chemical by way of agitation. Agitation may be rotation followed by counter-rotation plus intermittent tilting action.

The drum can simply be rolled by hand backwards and forwards on a suitable flat bench top, with consequent irregularities in agitation and temperature drift (however, this method is suitable for low temperature processes such as Cibachrome). But preferably it should be semi-immersed in a tank of water at the correct temperature and rotated by means of a hand crank or a (battery or mains driven) motor.

At the end of each step, the drum is up-ended and the residual chemicals drained out to be thrown away. They are used once only, rather than replenished as with a deep tank. While this does ensure fresh chemicals for each print, it can be more expensive than deep tanks, depending on the number and size of prints processed. Chemicals which are unused and have reached the end of their storage life will have to be thrown away, so make up only sufficient chemicals for your fairly immediate (say, 2 weeks') needs.

The drum and its components must be thoroughly cleaned and dried between each use to avoid chemical contamination which results in

5.4 Drum type print processors. **A** Simple type rotated by hand in a water bath, **B** Motorised base – battery operated, **C** Motorised rotation with a programmable process control unit.

prints of altered colour and density the next time the equipment is used.

Two or more drums are best for speedy working, so that while one is drying, the other is in use.

Such drums are not very suitable if moderate numbers of prints are to be made, especially if they must match. But only small amounts of chemicals are needed even for large print sizes. Probably for prints larger than 20.4 x 25.4cm (8 x 10in), especially only on occasion, the drum is preferable to any other system, particularly on economy grounds.

Automatic processors

Processing with dishes, tanks and drums is always done by hand and, consequently, there is always some risk of inconsistency.

An automatic processor is a machine which accepts the exposed sheet of paper, subjects it to a standardised sequence of processing cycles

22 For most printing purposes, resin-coated (RC) papers have all the advantages. Their processing cycle is much shorter than fibre-based papers require and they produce prints of excellent tonal quality and clarity. RC prints, such as the one reproduced here from glossy paper, are easy to dry and are very suitable for reproduction in magazines and books.

and finally delivers a processed print.

A number of such machines are available for amateur or semi-professional use, and, while costly (at least several hundred pounds to purchase) may nevertheless justify the capital outlay if enough prints are required. They also release the user to continue printing while the processing is under way.

Being enclosed in a light-tight casing, the processor may be used in room light. It requires only that the paper be loaded in the dark. A very modest amount of bench space is required, even for a machine capable of processing paper up to 66cm (26in) wide, plus a 13 amp power supply and cold water connection. A drain connection may also be needed.

A typical processor uses a sequence of tanks of solution or washes. The paper is conducted through the solution by drive rollers in contact and shaped plastic guides (fig 5.5). Alternatively, a close-packed set of synchronously driven rollers guides the paper down into one tank, up again and transfers it via guides to the next tank of solution. The dimensions of the tank and the speed of the rollers determine the time in each tank. Where necessary, the solution is heated by a thermostatically controlled immersion heater.

The cheaper machines have no replenishment system and may handle only narrower widths of paper, usually up to 200mm (8in) wide. Volumes of solution are made up, put in the appropriate tanks and then thrown away when a given

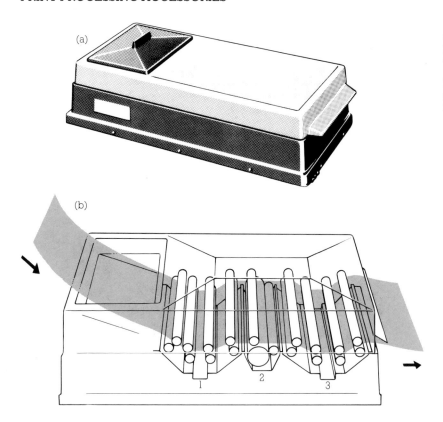

(a)

(b)

5.5 Roller transport print processor. **A** External view of a typical machine – the Durst RCP20 processor. **B** Path of paper through three solution tanks in the machine.

number of prints has been processed. Usually the quality of the prints emerging will indicate when the solution life is near its end.

More sophisticated machines operate some form of automatic replenishment system, usually by the injection of a given amount of replenisher per unit length of paper processed. This may be controlled by a microswitch activated by the passage of paper through the machine.

Strict cleaning routines are necessary for automatic processors.

Features such as variable temperature control or timing may be possible so that a machine can be used to process black-and-white paper, conventional negative-positive, and reversal colour paper as well as Cibachrome.

For reasons of cost, with many machines the processed sheet of paper emerges wet to receive its final wash in a dish, followed by drying. An integral, or add-on drying unit adds considerably to the cost and needs adequate room ventilation, but dry-to-dry processing in some 12 min can be achieved.

With such machines the possibility of unforeseen repair costs or occasional maintenance charges must also be borne in mind.

Special machines

From time to time, unique machines are marketed for the production of colour prints using special materials. A typical such example is that for the Kodak Ektaflex process. The properties and uses of this material have been described in detail in a companion volume in this series *Colour Printing in Practice*. Briefly, a diffusion transfer reversal (DTR) system is used where the dye formation is initiated by an activator solution squeezed between the exposed sheet of Ektaflex material and a transfer sheet on which the final print is formed.

An Ektaflex processor contains the activator fluid and enables the correct sequence of coating and lamination to be carried out. This machine needs no electrical connection, temperature control or replenishment arrangements but a motorised professional version is available for larger print sizes.

Print washers

The object of washing prints is to remove residual

chemicals from the emulsion and washing procedures can be varied to give a particular degree of archival permanence, as determined by tests.

The thoroughness of washing required has a bearing on the choice of print washing equipment. There are various possibilities, all with practical advantages and limitations (fig 5.6). Fibre-based black-and-white papers, especially with a double weight base, are the most difficult to wash to archival permanence.

Conventional processing dishes may be used for washing. This wash can be a rinse bath, a holding bath prior to washing proper, a bath containing a *washing aid* or a two-dish washing procedure. The practical problems are to ensure a sufficient number of changes of water, not too many prints per dish and efficient agitation. Wash water temperature should not exceed 27°C (80°F) with a lower limit of 18°C (64°F).

A design improvement is a *cascade washer*, using three vertically staggered dishes or tanks which overflow top to bottom. Prints are progressively moved from the lowest to top dish.

A simple dish may be fitted with a *dish syphon*. This regularly empties the dish into which water is flowing.

Improved arrangements employ *wash water sprays*, where a water pipe injects jets of water into a dish or tank to ensure circulation and agitates the prints. The force of water ensures that if the sides are corrugated, prints do not stick to them. Such water injection tanks can stand in a sink and are quite effective.

An improved form of washer, especially for producing prints of archival permanence, is a deep tank, usually constructed of acrylic plastic, containing a basket of prints held separately and in a vertical position by dividers. Water enters by a spray inlet at the base to overflow and/or be syphoned down at intervals.

Water filters

The need to provide a supply of *clean water* for washing prints is often overlooked. Water issuing from a tap may contain matter from the water source pipes and storage tanks and might, perhaps, even contain excessive chlorine. These can cause spotting and discoloration of prints. Small particles of iron rust, in particular, can damage colour prints.

The simple answer is to use an in-line water filter device, preferably attached to the source immediately in use, such as the cold water tap in

5.6 Print washers. **A** An archival type of washing apparatus for fibre based paper. The rack of prints fits inside the tank.

B Plain dish and washing trough with a spray device to keep prints in motion. The water supply is fitted with a water filter.

the darkroom sink.

Such water filters have an inlet and outlet for water, clearly marked, and a cylindrical body containing the actual filter element. This element may have little effect on reducing the water flow, but this depends on its construction and pore size. Effective filtration of particles from 3 to 10 microns in size is common.

An activated carbon filter removes excess gases as well as rust, chalk or sand sediments. The cartridge is discarded when exhausted.

Conventional filter elements are made from perforated nylon and when clogged up, can be reversed in the unit and flushed out, to be used again.

A sample of your mains or tank water may be filtered through some cotton wool in a filter funnel to see whether there is any residue, and if there is a need for continuous filtration.

Print driers

After washing, prints have to be dried. Once again, there is a choice of ways, depending on the size of print, the finish required and the type of base (fig 5.7).

Simplest of all is a set of *clips* to hang the prints vertically by one corner from a washing line. This is best located over a bath or sink to catch drips. This method is excellent for resin-coated (RC) paper (page 72) prints which dry rapidly and lie flat. But fibre based prints dry unevenly and give a cockled result which needs careful flattening before mounting or display.

An alternative is to use large sheets of acid-free

5.7 Drying prints. **A** A combined rotary drier/glazer for fibre based prints, **B** Drying cupboard for RC base prints, **C** Hot air drier for RC base prints using wire mesh trays.

photographic blotting paper to interleave with a pile of wet prints. Once again, some prints just refuse to dry flat. A related method is to use layers of plastic screen or mesh to allow air circulation, but drying is slow.

Once quite common, if rather expensive, are the *flat-bed* and *rotary driers* and *glazers* for fibre based prints. In the former type, the prints are held in contact with a heated curved platen by means of a tautly stretched canvas 'blanket' until dry. For surface-textured or unglazed prints the emulsion side is in contact with the blanket. The blanket must be washed carefully and frequently to prevent staining. For hot glazing a chromed glazing sheet is used over the platen with the prints placed emulsion down on the surface.

The latter type of dryer uses a rotating, heated chrome-plated cylinder with a canvas blanket in contact over most of its area. Washed prints are fed in on the moving blanket to be dried or glazed, depending which side is in contact with

the drum. Glazing requires greater blanket tension.

Resin-coated paper base does not absorb water and cannot be dried in this manner. Both front and back must be accessible to air as water vapour from drying cannot penetrate the base to evaporate. Drying is very rapid, even in normal room conditions and a *drying rack* may be used to hold prints vertically and separated after squeegeeing or wiping to remove excess moisture.

An *RC paper print drier* of moderate cost usually takes the form of an enclosure with removable mesh shelves on which the prints lie horizontally. A stream of warmed, filtered air is blown over the shelves to promote drying.

For anything approaching mass production of prints, a more sophisticated and expensive RC print drier is needed. This incorporates squeegee rollers followed by an *air knife* stream of heated air directed on to both the front and rear of the print. The print is dried in a matter of seconds.

Miscellaneous items

One or two accessory items not mentioned so far are of vital importance (fig 5.8).

Graduated chemical measures allow chemical stock solutions to be diluted with water to working strength and correctly made up to final volume.

Glass measures are costly and fragile and so not recommended for home darkrooms. Plastic measures are preferable and sufficiently cheap for several of different capacities to be purchased – a useful set of sizes would be 50ml (1¾ fl oz), 100ml (3½ fl oz), 500ml (17½ fl oz) and 2 litres (3½pt). Several small ones may be used to provide the measured quantities of chemicals for a processing run.

Chemical *storage bottles* are needed to hold stock solutions. Glass is excellent for this, preferably dark brown to exclude light. But *never* use old beer bottles or lemonade bottles in case the contents are mistakenly taken for the real thing. All bottles should in any case be clearly labelled with the contents and the date when the solution was made up.

Plastic bottles are preferable to glass even if they are less airtight. Special dark brown plastic 'concertina' bottles allow excess air to be

5.8 Darkroom accessories. **A** Chemical storage containers, **B** Measuring jugs for mixing solutions, **C** Stirrer, **D** Funnels, **E** Digital thermometer with probe.

removed by compression before sealing up the contents.

A large, and a small *pouring funnel*, help with transferring liquids from measuring cylinders to bottles.

A *print viewing light* above the fixer dish, fitted with a pull-cord switch to operate, enables you to make a swift visual assessment of exposure and contrast without carrying the print to view by room light.

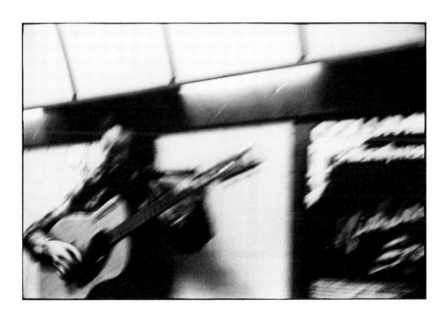

23 When archival storage may be envisaged, a fibre-based paper should be used. The print shown here was made on double weight paper and processed according to the archival procedure described in Chapter 8. Finally, the print should be presented in a mount made from acid-free board – see Chapter 12.

6 MATERIALS AND PROCESSES

The photographic materials used for enlarging are generally referred to as *print materials* and this term is usually taken to mean paper base materials in the standard sizes.

Many are also available in the form of long rolls of various width ranging from 35mm to 1 metre or greater.

Print materials differ significantly from camera materials in that, apart from their physical composition, they have a very much lower *speed* or sensitivity to light. Also, their *spectral sensitivity* to coloured light may be much more restricted, or not panchromatic, and their *contrast* is normally very high. It is upon print materials that the final image is formed for mounting and appraisal by others. These materials must also accept retouching and afterwork. The desirable, but largely indefinable print *quality* that so strongly influences the judgements made of photographic images is given by appropriate choice of print material and care in its processing and treatment.

There are various printing routes to take, and these depend on the final print required and the type of original to be printed (figs 6.1 and 6.2).

Negative working materials

Many print materials are *negative working* in that they give a reversal of tones in the same way as a negative film used in a camera – ie areas of high intensity or low density in a negative are rendered as dark or dense regions in the print. As the camera negative is the intermediate stage in a two-stage process, the final image produced from this is *positive* and so has correct tonal rendering with respect to the original subject (fig 6.3).

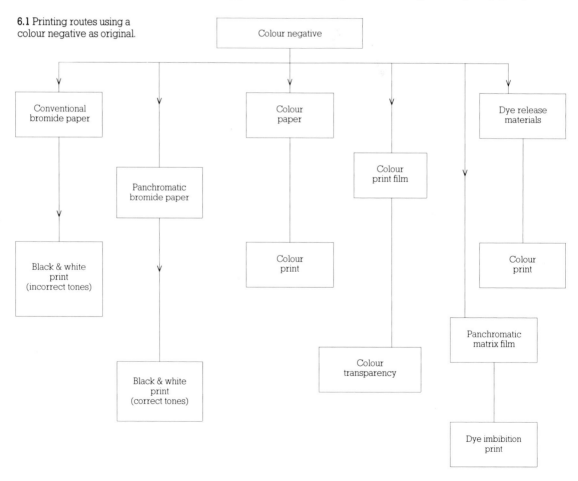

6.1 Printing routes using a colour negative as original.

6.2 Printing routes using a colour transparency as original.

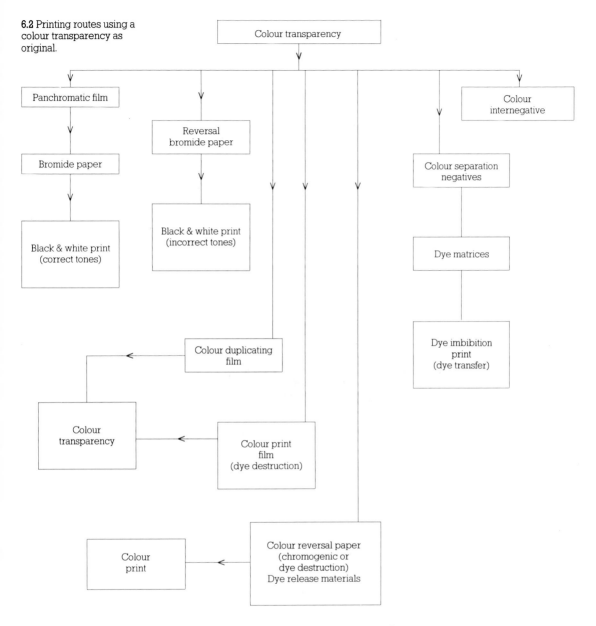

Positive working materials

Alternatively, a wide range of print materials are *positive working* in that exposure and processing produces tones in the same relationships as the original scene or transparency, dark tones being rendered dark in the print. With these, a one-stage reproduction from a positive such as a colour transparency is possible. Indeed, with some positive materials the actual scene may be recorded by them directly, in a camera, much as with *self-developing materials* such as Polaroid or Instant Print.

The meaning of contrast

The term 'contrast' is used loosely in photography and applied to original scenes as well as negatives and prints. In each case, the implied meaning is different, but each is important in the reproduction process from subject to finished enlargement.

Scene or *subject contrast* is the *luminance range* of the subject as determined by its inherent darkest and lightest areas and the *lighting ratio* of the illuminants used. Scenes may have, typically, a ratio of light intensities (of light to dark regions)

6.3 Reproduction of a scene in colour by positive and negative working materials.

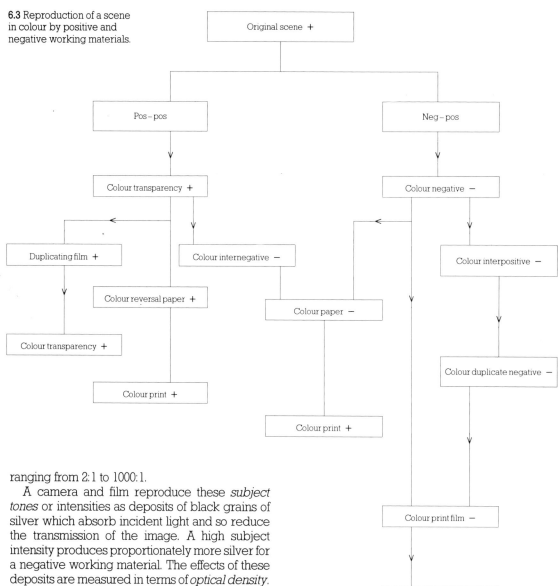

ranging from 2:1 to 1000:1.

A camera and film reproduce these *subject tones* or intensities as deposits of black grains of silver which absorb incident light and so reduce the transmission of the image. A high subject intensity produces proportionately more silver for a negative working material. The effects of these deposits are measured in terms of *optical density*. In mathematical terms the optical density is the logarithm of opacity which is defined as the ratio of incident to transmitted light. So a wide range of scene luminance values is compressed into a short scale and an optical density increment of 0.3 indicates a *halving* of light transmission. The relationship between *camera exposure*, expressed also in logarithmic units, and optical density as a result of this exposure gives a graph known as the *characteristic curve* of the material. The feature of such a curve is its *slope*, a measure of the *density range* between two exposure levels representing the subject luminance range or contrast.

Normally, this *negative contrast* represented by density range is much less than the subject contrast. But this former is strongly influenced by the type of film material and by development conditions. In particular, additional development increases negative density range or contrast.

Negative contrast control (relative to the subject contrast) by exposure for particular tones and appropriate development forms the basis of the *Zone System* of camera exposure. For optimum

6.4 Negative-positive printing.

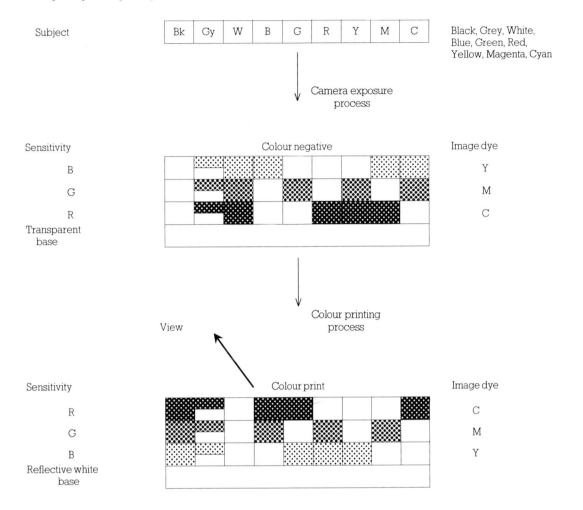

print quality, negative contrast must be matched to printing requirements.

Print materials have an inherently high contrast relative to negatives so that their combined result in a print gives a tonal scale rendering similar to that of the original scene.

Here, there are two confusing uses of terminology. *Print contrast* is usually taken to mean the absence, presence or abundance of grey tones that appear between black and white if the print is described as of 'high', 'normal' or 'low' contrast respectively. But a print material, given its standard processing, has a fixed *reflection density range* from white base to *maximum black*, as given by insufficient exposure and minimum adequate exposure respectively.

This ratio of exposure levels to give white and

black plus all the intermediate grey tones, is provided by exposure through the negative. The ratio of exposure levels necessary, as given by the negative densities over a useful density range (contrast), characterises the contrast of the paper material, usually referred to as a *grade*. But note that *hard*, *normal* and *soft* grades of paper are all capable of the full range of densities which the paper can give (fig 6.4). Typical examples of the logarithmic values of exposure range a paper grade can accommodate are given in fig 6.5. Conventionally, papers are graded from 0 (extra soft) to 5 (extra hard) as the log exposure range (or usable density range of the negative) decreases.

Manufacturers supply processing data for negatives such that *normal development* gives

(a)

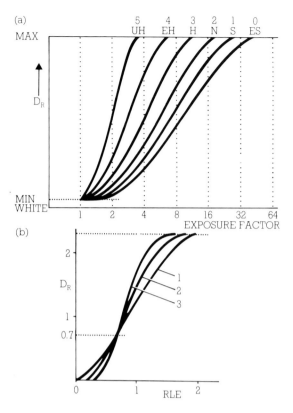

MAX

D_R

MIN
WHITE

5	4	3	2	1	0
UH	EH	H	N	S	ES

1 2 4 8 16 32 64
EXPOSURE FACTOR

(b)

2

D_R

1

0.7

0 1 RLE 2

1
2
3

6.6 The effect of paper grade on print contrast. The same negative printed on six grades of paper from 0 to 5.

0

3

6.5 Printing paper grades. **A** Comparison of characteristic curves of reflection density D_R against exposure factor giving ultra hard UH grade 5 to extra soft ES grade O. **B** Typical characteristic curves of three grades of bromide paper having the same paper speed for a reflection density of 0.7. The exposure scale is in relative log exposure (RLE).

a negative of density range suited to the log exposure range of grade 2 (normal) paper. A negative with a longer or a shorter density range due to combinations of subject and development conditions must be printed on paper of a longer (soft grade) or a shorter (hard grade) exposure range respectively (fig 6.6). Hence, there is a range of paper grades to suit negatives of ranging contrast. Remember also that, due to the scattering effects of the silver image of a negative, the type of illumination used in an enlarger may cause a change in optical contrast as recorded by the paper. For example, a diffuser-equipped enlarger *reduces* negative contrast compared with a more specular form of enlarger illumination system using condenser lenses. The availability of different grades of paper allows correct prints to be made irrespective of the make of the enlarger. Colour printing, which uses non-light-scattering

1

2

4

5

dye images does not present a problem of contrast variation between enlargers.

Tone reproduction

The manner in which a scene containing areas of differing intensity is reproduced as a print is referred to as *tone reproduction*.

Depending on negative processing and other factors, the subject tones (in terms of luminosity or *visual brightness*) are reproduced as shades of grey between white and the maximum black of which the print material is capable.

There are limits to the range that can be recorded. Also, the negative density gradation for the shadows and highlights may be non-linear and differ from that for the mid-tones. So tone reproduction is altered in these regions and may even be non-existent.

The print material, assuming a maximum reflection density of 2.0 or a reflection of one-hundredth of the incident light, can only give, at most, a tone range of 100:1, and usually much less so, again, tones are either compressed or lost altogether. Moreover, subject tones are also, in general, coloured and the luminosity of the colours plus the spectral sensitivity of the film (and any use of camera filters) will influence the final density of these tones in the print. So colour filters too, may influence print contrast.

Black-and-white print materials: composition

The general *composition* of such materials is as shown in fig 6.6. The photographic *emulsion*, consisting of a suspension of light-sensitive *silver halide crystals* in gelatin, is coated on a white reflective surface on a *paper fibre base* which serves to reflect light for viewing the final print. The reflective materials are pigments such as baryta and titanium dioxide. Various other layers

are present to reduce the effects of abrasion, avoid static electricity and encapsulate the paper base.

The emulsion swells when wetted to allow chemical development to proceed and it shrinks again when dried.

The emulsion surface of print materials is hypersensitive to touch, whether from fingers or rough handling and should be treated with great care. The emulsion side should be identified carefully as textured surfaces may be mistaken for the reverse side and the paper inadvertently exposed through the base. Sometimes there are manufacturers' names printed on the reverse side to help avoid confusion.

Packaging

Print materials have a standardised form of packaging. The sheets are stacked without interleaving material in a light-proof bag of black polyethylene, contained in an outer box of acid-free cardboard. For convenience, many users transfer the unexposed paper to a *paper safe* with a locking cover as a means for dispensing the sheets individually.

The quantity of paper per package depends very much on the marketing ideas of the manufacturer, as well as the size, surface and type of paper. In general, smaller sizes such as 12.7 x 17.8cm and 20.3 x 25.4cm (5 x 7in and 8 x 10in) can be purchased in packs of 10, 25 or 100 sheets, and perhaps even as many as 500 sheets. Larger sizes may be in packs of 10 or 25 sheets.

A wide range of sheet sizes are sold, but 12.7 x 17.8cm, 20.3 x 25.4cm, 30.5 x 40.6cm and 40.6 x 50.8cm (5 x 7in, 8 x 10in, 12 x 16in and 16 x 20in) predominate. Other metric and Imperial sizes are available too. Another economical form of purchase is to buy long rolls of paper, available in various widths. Some labour is necessary to cut these rolls up as required and fibre based materials do retain some curl if purchased in this way.

Storage

Recommended paper storage conditions are

6.7 The structure of black-and-white printing materials. **A** Fibre base: 1 Gelatin supercoat, 2 Silver halide emulsion layer, 3 Reflective layer of baryta and pigments, 4 Paper base, **B** Resin-coated base; 1 Gelatin supercoat, 2 silver halide emulsion layer, 3 polyethelene layer containing reflective pigments and fluorescing dyes 4 Paper base, 5 Polyethylene layer, 6 Anti-static layer.

detailed by each manufacturer in the instruction leaflet accompanying each package. In general, paper should be securely wrapped to be light tight, preferably in the original packaging. Avoid excess heat or humidity and gaseous fumes which could cause chemical fogging. Do not carry out sepia toning, which can produce noxious fumes of hydrogen sulphide gas, near your stock of paper. Most forms of radiation are best avoided and cool conditions are best. The shelf life of paper is quite reasonable, possibly two years or so, with only slight deterioration as shown by an increase in *fog level* or a decrease in contrast grade.

Grades

Paper grades have been explained above. The usual full range is six grades, running from 0 to 5. Manufacturers make some effort to ensure that grades 0 to 4 have similar paper speeds to reduce complications of a change of exposure when altering the chosen grade on the basis of a test print. The hardest grade, grade 5, is usually slower than the others by a factor of two or so. Grades and grade spacings vary slightly between different manufacturers' products. Not all paper surfaces and sizes are available with a full range of grades, and in some cases grades 1, 2 and 3 only may be available.

Variable contrast paper

The use of graded paper always gives rise to stock problems, because it is difficult to know how much paper of each grade you should purchase. It is irritating and expensive to have to buy 25 sheets of grade 5 paper when only the occasional negative needs such a hard grade.

The use of *variable contrast paper* greatly simplifies stocking problems as you need only buy one type of paper. The grade is then selected by the use of suitable colour filters in the enlarger or by dial-in colour filtration (fig 6.9). Such paper, for example Ilford Multigrade II, makes use of two types of emulsion coating with hard and soft inherent contrast and differing spectral sensitivities.

By altering the colour of the exposing light with suitable filtration you expose more, or less, of one emulsion than the other and so change the resulting combined gradation. Intermediate grade values are possible, as are local changes in grade to suit parts of a negative that are otherwise difficult to print. Special enlarger heads are available using controlled mixtures of coloured light to

6.8 Paper grade characteristics

Kodak	AGFA	Grade number	Density range of negative	Log exposure range of subject
Extra soft	—	0	More than 1.4	1.4 – 1.7
Soft	Soft	1	1.16 – 1.4	1.15 – 1.4
Normal	Special	2	0.91 – 1.15	0.95 – 1.15
Hard	Normal	3	0.66 – 0.90	0.80 – 0.95
Extra hard	Hard	4	0.51 – 0.65	0.65 – 0.80
Very hard	Extra hard	5	0.36 – 0.50	0.5 – 0.65

6.9 Printing Ilford Multigrade II variable contrast paper

Grade required	Filtration needed Y	M
0	92	16
0.5	74	22
1	56	28
1.5	46	37
2	36	46
2.5	28	53
3	20	60
3.5	12	75
4	04	90
4.5	00	130
5	N.A.	N.A.

The data indicates the filtration required for the effect of different paper grades using a Durst colour enlarger with dial-in filtration.

give the required grades at full and intermediate steps, with the same paper speed for each, which is a great working convenience.

At present the range of sizes and paper surfaces available is somewhat limited. The material is only available in resin-coated (RC) form.

Surfaces

By suitable callendering or texturing treatment during manufacture, printing papers may have a range of surface textures other than the common 'glossy'. Named textures include 'pearl', 'matt', 'semi-matt', 'silk' and 'art'. The choice today is limited compared with earlier days and not all surfaces are available in all sizes and grades.

As well as convention, there is a creative element in the matching of a surface to the subject matter of the picture. For instance, technical illustrations or press prints are always required on glossy finished surfaces.

Many people prefer a textured surface, perhaps because these are much less susceptible to finger print marks or because they do not give glaring reflections when put on display.

Surfaces other than glossy give pronounced scattering of the viewing light and consequently reduce print contrast. The maximum black is, as a consequence, reduced in density. Such prints never seem to have the same visual contrast as do the glossy type, which, if they are fibre based and glazed in addition, can give very deep blacks.

Base properties

High quality paper is used to provide the flexible, stable base for print materials unless these are of the 'film-base' type when the usual tri-acetate and polyester plastics are used. Other special materials, including thin sheets of metal, are used on occasion.

The white paper base usually has a front surface coating of baryta or titanium dioxide particles to give a highly reflective white. Texturing of this layer beneath the thin emulsion gives various finishes.

Some special papers are available with coloured, metallic finishes or fluorescent colour bases to allow for black-on-colour graphic effects or merely to enhance a subject. The base may be treated with fluorescing agents also. Base thickness may vary from an 'airmail' thin type to 'double-weight', which is akin to cardboard. Larger paper sizes may only be available in double weight.

Fibre or resin-coated base?

The traditional fibre based paper has some undesirable properties. It will seldom lie flat before or after processing, it exhibits dimensional changes after processing and it retains chemicals which may reduce archival permanence.

As an alternative, the base may be sealed in manufacture with a thin coating of 'resin', such as the transparent polymer plastic polyethylene, hence the description *resin-coated* (RC), or PE for materials of continental origin. This coating prevents ingress of chemicals or water except at the edges and so greatly reduces the processing times required. Drying too, is rapid because of the very low water retention. Glazing is not needed as the plastic surface provides a natural finish and the print lies flat even with changes of humidity.

There are also slight drawbacks. RC paper is only available in a medium weight base. An antistatic backing layer is needed. Back-stamping or writing on the print requires certain spirit-based inks. Other markings will come off, or worse,

transfer to the next print in a stack. The low melting point of polyethylene, about 105°C, means that *dry mounting* needs mounting tissue with a low melting point and a mounting press temperature not exceeding 90°C.

The emulsion layer can readily be stripped from the base but this property is made use of in the 'canvas mounted' prints that are currently popular. There are unconfirmed worries about the archival properties of RC papers and certainly there is a 'crazing' pattern which may appear after many cycles of temperature change, but the situation is still unclear.

For the amateur with primitive home processing facilities, RC paper with its ease of handling, is greatly superior to fibre based materials.

Image tone

The granular silver image of a black-and-white print is nominally a neutral black in colour, but this *image tone* may be varied considerably by suitable treatment apart from the traditional chemical toning processes.

The colour can range from blue-black to an almost sepia brown-black purely by the choice of developer and paper, particularly depending on the presence or absence of chemical *toning agents* in the emulsion. The 'warm' image tones are given with slow-working developers that have high concentrations of *restrainers*. These give an image of very finely divided silver particles which scatter light and appear brown.

Toning may be carried out as an after-process but RC papers respond less well than do those with a fibre base.

Image tone may vary from neutral to warm black during the course of a printing session as the developer in use beomes progressively exhausted and loaded with restrainer.

Choice of materials

With the wide range of materials available, the beginner may be bewildered by the choice for his first attempts. Initially, it is best to purchase only reputable named materials rather than anonymous 'government surplus' stock. Buy a quantity of grades 1, 2 and 3 in a small size such as 12.7 x 17.8cm (5 x 7in) reserving choice of one grade in a larger, expensive size until the printing characteristics of your enlarger and negatives have been established. A glossy surfaced RC paper would be suitable.

Alternatively, a variable contrast paper is a

24 This photograph was made from a negative of higher than normal contrast and was therefore printed on grade 1 paper. In addition, a glossy surfaced paper was chosen to obtain the widest possible tonal range and produce very deep blacks.

25 A subject which has a full tonal range and both subtle shadow and highlight detail must be carefully processed and printed to obtain accurate reproduction. Choice of materials also affects the final result.

good choice but the necessary filters and filter holder are an additional expense.

Manufacturers' codes

Each major manufacturer has an alphanumeric coding system for his products. The various letters and numbers in groups denote paper surface, thickness, grade and type in general.

Be sure to check these prominent codings carefully when purchasing to ensure that you have bought the correct material. It is usually very difficult to exchange sensitised materials bought in error.

Special materials

Apart from the conventional materials described above, a variety of *special purpose* or unusual print materials is available. These include panchromatic sensitised bromide paper for making monochrome prints from colour negatives with correct tonal rendering, *reversal paper* for proof prints from colour transparencies, ultra-high con-

trast materials of lith and line types, sensitised linen based and opal film based materials.

Black-and-white print processing: basic processing chemistry

Detailed consideration of the chemical principles and procedures are beyond the scope of this book. An outline only may be given as follows.

During print exposure, the light-struck silver halide crystals produce a *latent image* related to exposure levels (undetectable by any physical means including electron microscopy). Development of an image in metallic silver is the only sure proof of adequate exposure or indeed exposure in general. Chemical development is an *amplification* process with a gain of hundreds of millions, converting crystals with suitable latent images into grains of metallic silver to provide a graduated image.

There are four stages involved in the production of a stable silver image for viewing.

First comes *chemical development*. Here, an alkaline solution of reducing agents converts the insoluble silver halide into silver where ever a developable latent image is present. Crystals without a latent image should not initiate development, but develop anyway, and contribute a near-uniform background level of image silver termed *chemical fog*. Next a *stop bath* in the form of a simple acid solution arrests development at a suitable stage. Most print materials develop to *finality* which is a minimum time beyond which no further image is produced, only more chemical fog. The third stage is *fixation* where the still light-sensitive residual silver halide crystals are converted to water-soluble compounds that are insensitive to light. Finally, a washing stage uses water to flush out the gelatin layer, removing all the residual chemicals and by-products to impart degrees of archival permanence to the residual silver image.

There are a number of practical points of interest in each of these stages of print processing.

Print developer

A print developer is an alkaline, aqueous solution containing two *developing agents* which act as the chemical reducing agents. There are two choices, a combination of metol and hydroquinone (MQ) or of Phenidone and hydroquinone (PQ). The latter PQ type is the better choice since it is less likely to cause skin irritation by contact, it has a better *dish life* as a working strength solution

26 Variable contrast paper is useful when local control of contrast is needed. The overall contrast of this image was considered correct when a No. 3 Multigrade filter was used. But the window reflections were too light and lacked contrast, so extra exposure through a No. 5 filter was therefore given to them.

27 Black-and-white papers produce images which vary in 'colour' from cold blue-blacks to warm brown-blacks; the final colour depending on the chosen paper and developer. Gentler subjects, such as that shown here, are often better printed on warm papers – it is not possible here to indicate the warmth of the original print.

28 For maximum control of tonal range, this print was made using fibre-based paper and a 'slow' print developer. It was possible to develop the print until the desired quality was achieved in the facial tones.

and it has greater print processing capacity. Other ingredients include an *alkali*, an *antifoggant* to suppress chemical fog during prolonged development and a *preservative* to neutralise by-products that could stain the developed print, (fig 6.9). In use, the diluted developer may become cloudy due to precipitation of calcium from water hardness and gelatin sources and also become discoloured. Neither affects the efficiency of the developer.

Print developers are sold in the form of powders and concentrated liquids. Powders are more economical for quantities, liquids are more convenient. The powders are in twin-sealed packets, usually labelled A and B. The A powder is the one containing the developing agents and is dissolved first in a specified volume of warm water. When this is dissolved the larger B powder is added.

The solution is made up with water to its final volume to form a *stock solution* which is further diluted for use – typically, one part of stock plus three parts of water. The *shelf life* of the stock solution is usually at least six months. Concentrated solutions, as bought, are used in a higher dilution, normally one volume of solution plus nine of water. On no account should a negative film developer such as D-76 or Microphen be used for print development – only a weak image will appear even after many minutes of development!

There are special formulations for RC papers which give a fully developed image in some 60 sec compared with the 1½ to 2½ min for conventional print development. Standard development conditions are at 20°C (68°F) and with continuous agitation.

As a guide to capacity, approximately 45 sheets of 20.3 x 25.4cm (8 x 10in) paper may be processed in one litre of PQ developer, diluted to working strength.

Stop bath

This weakly acid solution is used to arrest development and is conventionally made from acetic acid or from sodium metabisulphite powder.

It is a very cheap solution and should be made up freshly for each printing session or, with prolonged use, replaced regularly.

Proprietary brands of stop bath are sold which require diluting with water in the proportions 1:30 to provide a working-strength solution of about three per cent acetic acid. Very conveniently,

6.10 Print developer formulation

Chemical component	Function	Quantity
Metol	Developing agent	3g
Anhydrous sodium sulphite	Preservative	50g
Hydroquinone	Developing agent	12g
Anhydrous sodium carbonate	Alkali	60g
Potassium bromide	Restrainer	4g
Water to make	Solvent	1000ml

The example given is Ilford ID-20 developer, making a stock solution to be diluted 1 + 3 with water for use.

most also incorporate an *indicator dye* which turns from yellow to purple when exhaustion is reached. In a yellow safelight the stop bath therefore turns from a clear to a dark solution.

The stop bath can also act as a *holding bath* between developer and fixer when processing a number of prints together. Prints should be immersed in the stop bath for at least 30 sec but no longer than a couple of minutes. Temperature is not critical.

Streams of bubbles may be seen issuing from the print in the stop bath as harmless carbon dioxide gas is released by the chemical action of neutralising residual developer.

The stop bath also prolongs the life of the fixer which follows, as the fixer need not then also act as a stop bath, an action that can interfere with fixation.

Fixer

The active component of this solution is a chemical species termed a *thiosulphate ion* which reacts with silver halide to form complex compounds called *argento-thiosulphates*. These are water soluble, unlike the silver halide alone. The prime ingredient is the traditional sodium thiosulphate or *hyposulphite of soda*, hence the generic name of 'hypo' for the fixing solution.

Another compound, *ammonium thiosulphate*, allows a higher concentration of the active ion and is more suitable for *concentrated fixers*. These are diluted with water in the ratio 1:7 for use as print fixers, which are more dilute than film fixers. They serve as *rapid fixers*, requiring a fixing time of only some 2 min compared with the minimum 5 to 10 min in a fresh hypo solution (fig 6.10). Naturally there is a price premium to pay for this convenience.

Fixers may be purchased as powdered chemicals to be made up into a stock solution, or as a proprietary stock solution of the traditional, or

6.11 Properties of fixers for use with black-and-white printing papers

Description	Shelf life (years)	Dish life (weeks)	Hardener	Fixing time (minutes)	Fixing capacity (8 x 10in Prints per litre) Fibre based	Resin coated	Dilution
Powder fixer	1	1–2	NR	5–10	40	80	1+2
Powder fixer with hardener	1	1	Incorporated	5	40	80	1+2
Liquid fixer	1	1	NR	5	40	80	1+5
Rapid liquid fixer	1	1	NR	1	40	80	1+9

rapid fixer variety. The properties of various fixers are shown in the accompanying table.

In order to function correctly, a fixer must be an acidic solution. This means that it can also act as a stop bath but any *carry-over* of developer into it soon neutralises this acidity. With this comes the risk of losing the fixing effect and staining prints.

Some fixers are sold with a *hardener* incorporated, or as a two-solution pack, with the second solution as a liquid hardener to be added as needed. However, hardener is required only to make up a fixing bath for films. On no account use it for a print fixer as this will interfere with fixation, cause glazing problems and reduce the efficiency of washing.

The *fixation capacity* of a print fixer is proportionally less than for a film fixer, usually about 40 20.3 x 25.4cm (8 x 10in) fibre based, or 80 similar RC base prints per litre of fixer. While fixation will continue beyond this point, the progressive build-up of silver complexes in the solution will cause washing difficulties later on and may make it difficult to produce *archivally permanent* prints. The silver content of a fixer may be determined by the use of *silver estimating papers* which exhibit a colour change graded by a reference scale.

Fibre based papers can tolerate a concentration of up to 2g of silver per litre of fixer while RC base papers tolerate 4 to 6g.

In commercial use, fixers may be regenerated for a longer life by electrolytic precipitation of dissolved silver. For amateur purposes, fixers may be replenished adding fresh fixer and removing an equivalent volume of used fixer. Typically, 125ml is added for every 10 sheets of 20.3 x 25.4cm (8 x 10in) RC base prints fixed, and 250ml for fibre based paper.

Another alternative is *two bath fixation*. For this you make up two separate baths of fixer of equal volume. You fix a print in Bath 1 for half the recommended time and transfer it to Bath 2 for the remainder of the time. Continue this until Bath 1 is exhausted, when it can be discarded and replaced by Bath 2. You then prepare a fresh Bath 2. This method assures efficient fixing.

Fixing time may be exceeded without causing undue harm, but prolonged immersion can bleach the image. The temperature of the fixer should be within 5°C of the developer temperature. Prints in the fixer must be agitated thoroughly.

Under normal conditions, the shelf life of a fixer in a sealed bottle is greater than a year, but rapid fixers may go cloudy yellow due to the precipitation of sulphur and should not then be used.

The contamination of developer by a fixing solution has disastrous effects and must always be avoided.

Washing aid

Normally, after fixing, a print is washed in running water. By use of a *washing aid* this wash time can be drastically reduced for fibre based papers and so enhance their keeping properties. This additional solution, usually sodium sulphite, helps remove the silver complexes from the paper base. It is not needed for RC base papers. After fixing, the paper is rinsed in water, immersed in the washing aid for 5 min and rinsed again. It is then washed for some 10 min more instead of the hour that is usually necessary. The savings of time and water are considerable.

Washing the print

The washing water removes the fixed-out silver halides in the form of water soluble complex compounds. This process can be aided by various print washing devices already described. Washing efficiency is determined by the number of complete changes of water the print receives as the complexes diffuse out of the paper.

Typical wash times for single-weight and double-weight papers are 30 and 60 min respectively, while RC papers need only some 5 min. The water temperature affects the washing rate. Although less effective at low temperatures, anywhere above 24°C should be avoided.

For aftertreatments such as *toning*, washing must be particularly thorough to prevent uneven tones.

Washing is more efficient in 'hard' water than in 'soft' water and, indeed, sea water is even better.

Where running water is not immediately available, prints may be soaked for 5 min at a time in several complete changes of water to give the usual total washing time required.

Archival needs

Normal washing procedures give a print that is stable for many years in average conditions. However, the traces of residual silver complexes and hypo in the base may break down by chemical action such as that of sulphurous gases in the air to give brownish stains of silver sulphide. This is a random form of sepia toning!

Archival permanence (Chapter 8) beyond this level requires additional chemical treatment of the print during washing. One method is to apply Kodak Hypo Clearing Agent and then check the print for residual hypo with a suitable test solution. Additionally, the silver image may be converted to a more permanent image by the process of sepia, selenium or gold toning.

Toning

Toning is a form of *aftertreatment* which converts the black metallic silver image into another, of a different colour. There are two distinct methods of toning, termed respectively *metallic toning* (ie, chemical toning) and *dye toning*. Both require that the silver image first be bleached by immersion in a ferricyanide solution to convert the silver back into creamy-coloured silver bromide. Such a solution is called a *rehalogenising bleach*.

The silver bromide image may then be re-developed in various ways. If a *darkener solution* of sodium sulphide is used, a brown silver sulphide image develops. This traditional *sepia toning* process emits evil-smelling hydrogen sulphide gas which is hazardous both to life and to photographic materials. Toning by this method should be carried out in a well-ventilated place. Alternatively, odourless commercial toners may be used. Other forms of metallic toning use solutions of selenium or gold compounds to give purplish or bluish images respectively. But do note that selenium compounds are very poisonous and gold compounds are very expensive.

If, however, the permanence of metallic toning is not required and a wider range of colours is necessary, then dye toning procedures are preferable. This time, the toning solution is a conventional colour print developer to which a cocktail of *colour couplers* or *colour formers* has been added. A silver image is reformed on development but accompanied by a transparent dye image whose colour is determined by the mixture of couplers used.

These dye images are not particularly permanent nor are the colours produced very saturated. A bright red, for instance, is not possible. For some effects, the silver image can again be removed to leave only the dye image.

The chemistry of these processes is similar to that of *colour development* for colour paper, discussed later on. Practical aspects of toning are examined in Chaper 12.

Chemical mixing instructions

Chemicals will only function properly and give trouble-free use if the solution has been correctly prepared, assuming that the manufacturer has included the right ingredients, the shelf life has not been exceeded and the storage conditions were suitable.

It is vital that mixing instructions should be read and properly understood. These are normally found in a leaflet inside the package or on a label or outer carton. Where possible, the chemical is supplied as a single solution for dilution with water, using a simple ratio such as 1:2, 1:5, or 1:9 of concentrate to water. Do ensure that you use the correct dilution as various dilutions may be quoted for different purposes, such as replenishment. The water should be filtered in order to be free of particles and be at the specified temperature. If the instructions state that the container of concentrate must be rinsed out and the rinses added to the solution, do not forget to do so.

You can make considerable economies in chemical costs by purchasing a large sized kit or large volume of concentrate and diluting only as much as you need for a printing session. The partially filled container of concentrate may then have a reduced shelf life. If no data is given, the necessary dilution rate may be determined by measuring the total volume of concentrate and comparing it with the amount of working-strength solution it will give. For example, if a 25-litre kit has a concentrate volume of 2.5 litres, then the dilution rate is 1 + 9, so a 1 litre working strength solution requires 100ml of concentrate added to 900ml of water.

Chemicals supplied in powder form should *not* be divided up on a similar basis of total weight to total volume, but made up in one batch. There is no guarantee that the various ingredients have been mixed homogeneously, and a vital small concentration of one component could be missed entirely if only part of the volume is made up. In addition, the opened packs of chemicals may deteriorate rapidly if not adequately resealed.

A powder form kit may consist of a single mixed powder or have two or three powders or a bottle of concentrate as well. These must be added to water in the correct order and they will be labelled A, B, C or 1, 2, 3 etc for this purpose. It is essential to start with the correct initial volume of water at the recommended temperature to help the chemicals to dissolve, to stir each component until dissolved completely and then make up to the final volume with cold water. Allow the final solution to cool before use. Use suitable mixing vessels with accurate volume gradations and rinse them out thoroughly after use and before making up the next solution, to avoid contamination. The same caution should be applied to stirring rods and thermometers. Each container of solution should be clearly labelled with its contents, the date made up, a *use-by' date* if applicable and the *throughput* of materials if it is a reusable solution and not a *one-shot* chemical (ie. a chemical which is discarded after a single use).

If necessary, for personal safety or to avoid skin inflammation by contact, gloves and apron may be worn, also protective goggles or a face-mask as considered appropriate.

The instruction leaflet should be preserved in a folder of processing data. It is useful to check these occasionally against a new kit of chemicals as mixing instructions or processing data details do change from time to time, not necessarily with much prior warning. The safe storage of chemicals has already been discussed.

Finally, the disposal of used chemicals must be considered. Usually, these go into the domestic drain and finally into public sewers. Normally, flushing each chemical away individually with large quantities of water is adequate. Do not mix solutions of different types and then dispose of them. It may be necessary to neutralise some solutions before disposal, but specific instructions for this will be given.

In some districts, the disposal of processing wastes may be subject to local and environmental restrictions.

Colour print materials: composition

The structural make-up or composition of colour print materials is much more complex than that of black-and-white and there are also distinct variations.

A conventional negative-working colour printing paper reproduces colours by *subtractive synthesis*. That is, the incident white light is reflected from the paper base and differing amounts of the three primary colours, blue, green and red, present in the 'white' light, are absorbed by their complementary transparent coloured image dyes, namely yellow, magenta and cyan respectively. So blue light is absorbed by a yellow dye layer in proportion to the quantity of dye present in the layer to give tonal gradation.

The yellow dye is produced in the layer in proportion to the exposure received. No exposure produces no dye, a heavy exposure level a lot of dye. To ensure that this dye deposit is a record only of the blue information in the colour negative, which is also recorded as a yellow dye layer, this emulsion layer in the paper is sensitive only to blue light.

In a similar manner, a green sensitive emulsion produces a magenta dye to modulate incident green light and a red sensitive layer gives a cyan dye to modulate incident red light.

The schematic representation of colour reproduction by a negative-positive process such as this is shown in fig 6.11.

So, essentially the print material consists of three emulsion layers coated on top of each other on a white paper base. This is termed an *integral tripack* material (fig 6.12).

The layers are individually sensitive to blue, green and red light, commonly in that order, from the paper base to the top of the stack. Other layer orders may be used in other types of material.

It is worth noting that each emulsion is also very sensitive to ultra-violet radiation and the red sensitive layer responds to infra-red radiation as well (fig 6.13). The light from the enlarger is suitably filtered by ultra-violet and infra-red absorbing filters before reaching the paper, to avoid anomalous colour reproduction from such origins.

Colour print paper is therefore fully panchromatic and very sensitive to light. The various comments about handling it in safelight conditions mentioned earlier in this book should be consulted.

The emulsion layers consist of conventional suspensions or 'emulsions' of light sensitive silver

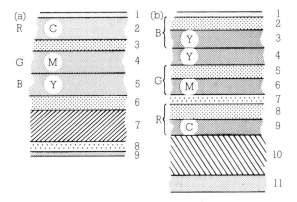

6.12 Structures of colour paper (neg-pos) and (pos-pos). **A** Neg-pos: to give good image dye stability. 1 Gelatin supercoat, 2 Red sensitive layer, 3 UV absorbing layer, 4 Green sensitive layer (includes a dye stabilizer), 5 Blue sensitive layer, 6 Polyethylene layer with white pigments and UV absorbers, 7 Paper base, 8 Polyethylene layer, 9 Anti-static layer, C Cyan dye image, M Magenta dye image, Y Yellow dye image. **B** Pos-pos: to include a masking layer (Cibachrome). 1 Gelatin supercoat, 2 Blue sensitive layer, 3 Blue sensitive with yellow dye, 4 Yellow filter and masking layer, 5 Green sensitive, 6 Green sensitive with magenta dye, 7 Interlayer, 8 Red sensitive, 9 Red sensitive with cyan dye, 10 Opaque white plastic support, 11 Matt anti-curl backing layer.

halide crystals and no image forming dyes are present. But as a precursor to these, chemical compounds termed *colour couplers* are also dispersed in the emulsion layers to react with development products and form the appropriate image dyes. The blue sensitive layer therefore contains colour couplers which on reaction will form a yellow dye. The unused couplers are removed in subsequent processing steps. Producing image dyes in such a way is called *chromogenic development*.

This arrangement of an integral tripack, with incorporated couplers, is also used for some types of positive working materials designed for making prints from colour transparencies (fig 6.14). There are some notable exceptions however, which use entirely different chemical principles.

First there are the *silver dye bleach* (SDB) materials such as the various Cibachrome materials on a film or paper base. Again, these use the integral tripack construction, this time with the layer order: blue-, green- and red-sensitive (from the top downwards). But the various layers also contain their appropriate image forming dyes as dye layers (fig 6.15). So the blue sensitive layer also contains a uniform yellow dye deposit.

The particular dyes used are known as *azo dyes*, which are very stable to light and so give excellent image permanence. Their presence also reduces *light scatter* within the emulsion during exposure and thereby improves the sharpness of the image.

The important property of these azo dyes is that they can be bleached to a colourless form with any silver present acting as a catalyst. So this can be triggered by the silver image formed in the exposed material by a conventional black-and-white developer. This bleaching effect is greatest where the image is most dense, so there is a reversal of colour tones compared with those present in the original image. Thus, a positive image is obtained in one step from a colour transparency.

In essence, compared with chromogenic development, the SDB materials begin with a uniform dye image and lose dye to produce tones, whereas chromogenic materials form deposits of dye as tones in a clear transparent layer.

Another method of image formation uses a *dye release system*. Once again, the image forming

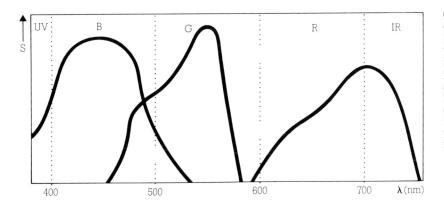

6.13 Special sensitivity of colour paper. Representative curves for the tripack of conventional negative working colour paper. The relative sensitivity S is shown for the visible spectrum and adjacent regions. Note the high sensitivity to both ultra-violet and infra-red radiation.

6.14 Schematic representation of positive-positive colour printing (chromogenic).

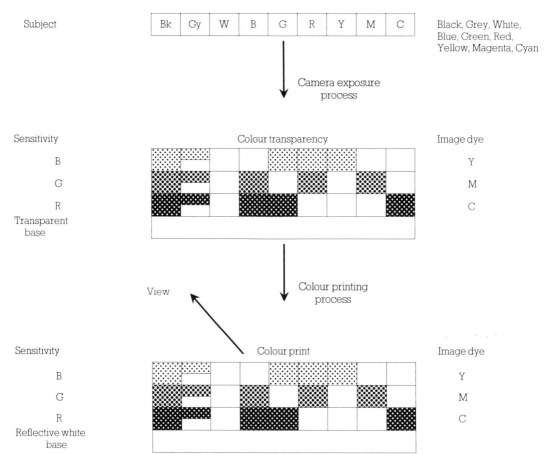

Subject

| Bk | Gy | W | B | G | R | Y | M | C |

Black, Grey, White, Blue, Green, Red, Yellow, Magenta, Cyan

Camera exposure process

Sensitivity Colour transparency Image dye

B Y

G M

R C

Transparent base

View

Colour printing process

Sensitivity Colour print Image dye

B Y

G M

R C

Reflective white base

dyes are already present but are chemically anchored to, or associated with, a developing agent also present in the tripack emulsion layers. So the traditional integral tripack arrangement this time has a blue-sensitive layer with incorporated developing agent and a yellow image forming dye.

Following exposure to light, development is initiated by a simple alkaline solution and any exposed silver halide is developed in a very short time by the closely adjacent *dye-developer* systems. The action of development either releases the associated dyes or anchors them in place depending on whether a negative or a positive working system is required.

The dyes released from development or as non-anchored types then diffuse swiftly through the tripack to a *receiving layer* where they are promptly anchored by chemical means to form the final dye image for viewing (figs 6.16 and 6.17). Materials for this *diffusion transfer reversal* (DTR) type include Kodak Ektaflex PCT, Agfachrome Speed, Polaroid and Instant Print materials. All of these can be used to produce colour prints from colour slides, albeit by different forms of exposing and processing hardware.

Base properties

No colour papers are available on a fibre base. To enable the materials to be speedily processed without the residual chemicals that could cause dye instability or staining problems RC base is now universally adopted. Additionally, drying and handling problems are almost non-existent.

Once the initial separation has been started, the processed emulsion layers can easily be stripped

6.15 Schematic representation of positive-positive colour printing (Cibachrome silver dye bleach).

Subject

Black, Grey, White, Blue, Green, Red, Yellow, Magenta, Cyan

Camera exposure process

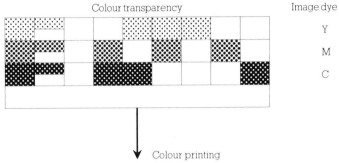

Sensitivity

B

G

R

Transparent base

Colour transparency

Image dye

Y

M

C

Colour printing expose

Latent image

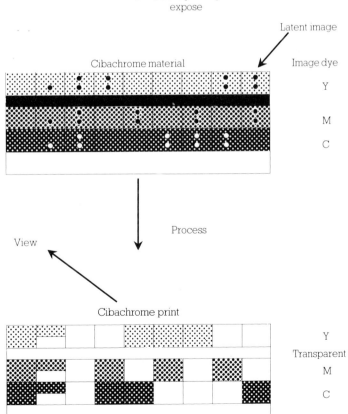

Sensitivity

B
Yellow filter

G

R
Opaque white base

Cibachrome material

Image dye

Y

M

C

Process

View

Cibachrome print

Y
Transparent
M

C

6.16 Schematic representation of image formation using Ektaflex PCT materials (neg-pos).

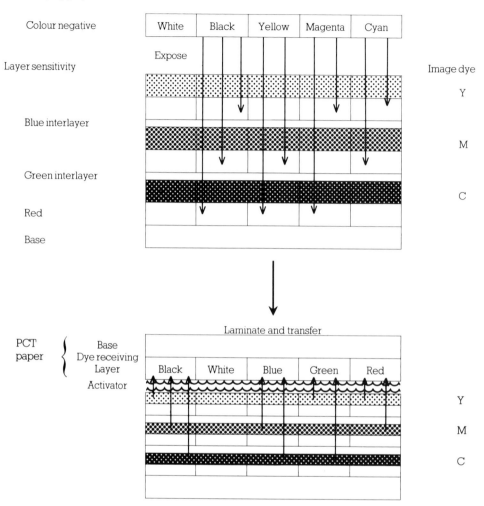

from the base by peeling off. This property is provided in at least one *stripping material* so that the colour image can be transferred to another surface or support.

Most print materials can be laminated to a heat-sealable transparent film and this sandwich is stripped from the paper base and then mounted on to a canvas base. The emulsion takes on the new surface texture and *canvas mounted* colour prints enjoy popularity as pseudo-paintings.

Some other print materials use sheets of plastic for their base material, such as tri-acetate or polyester film. These confer greater rigidity, resistance to attack by processing chemicals and improved dimensional stability than do RC paper materials. Naturally, such plastic bases are considerably more expensive but are used in some positive working materials such as Cibachrome and Agfachrome Speed.

Grades

Unlike black-and-white papers, colour print materials are available only in one grade, corresponding to normal grade 2. The theoretical reasons for this puzzling situation are that colour negative materials are, or at any rate should be, processed in a standard manner to a known density range, and also the type of enlarger used is immaterial since image forming dyes are non-scattering.

6.17 Layer order and image formation in Agfachrome Speed material.

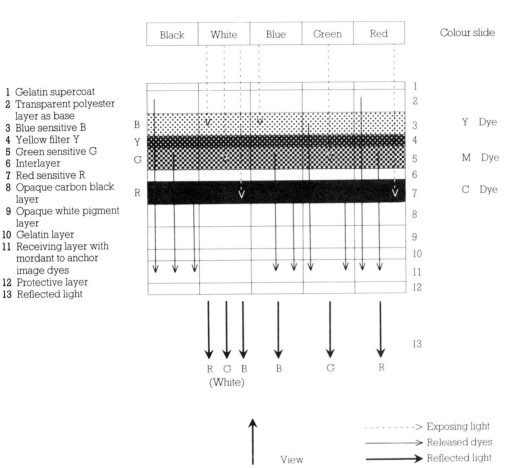

1 Gelatin supercoat
2 Transparent polyester layer as base
3 Blue sensitive B
4 Yellow filter Y
5 Green sensitive G
6 Interlayer
7 Red sensitive R
8 Opaque carbon black layer
9 Opaque white pigment layer
10 Gelatin layer
11 Receiving layer with mordant to anchor image dyes
12 Protective layer
13 Reflected light

In practice, it would be useful to have a range of say, three grades and, in fact, both Kodak and Agfa offer two paper contrasts which differ by about half a grade from normal to soft. Some variation may be possible by altering the processing chemicals.

In the case of Agfachrome Speed, contrast may be reduced or increased as required by the addition of potassium bromide solution, or of plain water, respectively to the activator solution.

Batch properties

Colour paper manufacturers strive to produce a good quality product with constant properties. But the complexities of structure and the number of variables of colour emulsion coating do mean that there are slight, but significant, variations in properties from batch to batch of the same material.

Every packet or box of material bears a batch number together with some information about the printing characteristics and effective paper speed of the batch. Normally, different sizes or surfaces of the same type of paper are of different batches and hence have different characteristics.

This feature is a nuisance if you decide that a subject you have printed initially to a small size deserves a larger print. Another test print will have to be made to determine the new filtration and so match the colour balance of small and

large prints. One way round this is to purchase paper only in large sizes and cut it down to the smaller dimensions as required. But very few people bother to do this.

It is also sensible to decide upon a paper type, size and surface, and to buy as large a quantity as the purse will stand, all of the same batch. Purchasing a 100-sheet box, while initially costly, is actually cheaper per sheet than an equivalent amount in smaller packs of different batches and saves test print wastage.

The paper batch information can be used to obtain a close match between batches, by subtracting the difference in filter data from the filter pack previously used and by correcting exposure time using the ratio of paper speeds or *exposure factors* of batches.

For example, for white light printing, the relationships:

New filter pack =
$$\left(\begin{array}{c} \text{Old filter} \\ \text{pack} \end{array} - \begin{array}{c} \text{Old filter} \\ \text{pack adjustment} \end{array} \right) + \left(\begin{array}{c} \text{New filter} \\ \text{pack adjustment} \end{array} \right)$$

and

New exposure time =
$$\text{Old exposure time} \times \frac{\text{Exposure factor of new batch}}{\text{Exposure factor of old batch}}$$

So, if an exposure of 20s at $f/11$ using a filter pack of 80Y + 40M with a paper of batch characteristics −05Y + 10M and exposure factor 80, is to be converted for use with a new paper batch of characteristics 10Y − 15M and exposure factor 90, we have

New filter pack =
[80Y + 40M − (−05Y + 10M)] + (10Y − 15M) =
95Y + 15M

and

New exposure time = $20 \times \dfrac{90}{80} = 22.5s$

In the case of positive working materials for making prints from slides, a *starting filter pack* may be given for a range of transparency materials. This data is usually printed on the outside of the packet or box and is only intended as a guide.

Paper storage

Like all colour materials, colour printing papers benefit from storage in cool or cold conditions. Each manufacturer makes specific recommendations but a typical set of requirements states that storage at 13°C or below is essential for the unopened package.

An important point, however, is *warm-up time* before use or exposure. For example, a 100-sheet box stored at −18°C, 2°C and 13°C requires 4, 3 and 2 hours respectively to reach a 21°C ambient temperature. To avoid condensation forming on the material, the pack should only be opened when fully warmed up.

After use, the remaining material should be stored in its original packing with excess air excluded. A domestic refrigerator is adequate for short-term storage and manageable warm-up times, but a deep freeze unit is best for long-term storage. Another characteristic of colour paper is that the *latent image* in the emulsion after exposure may undergo changes if there is a time delay before processing. These changes cause colour shifts in the image and their magnitude is greater immediately after exposure and progressively reduces as the time interval increases. So try to keep the time interval between exposure and processing as near constant as possible. Sometimes it may be necessary to keep exposed paper overnight or even longer until there is an opportunity to process it, for example, by accidentally spilling or contaminating your whole stock of colour developer just as you are about to process some prints, late on a Saturday night. If a delay until, say, Monday evening is unavoidable, the paper should be deep frozen at −18°C or less, but for not more than 72 hours.

In use, if possible avoid handling colour paper in conditions of high ambient temperature and humidity as these can cause shifts in colour balance.

Archival keeping properties

The stability and light-fastness of chromogenically produced dye images have been greatly improved in recent years. But such colour prints cannot be regarded as fully stable and their life before detectable fading is related to their chemical processing, storage and history of exposure to light. Few specific facts are available.

On the other hand, SDB and DTR colour materials use much more stable dyestuffs and have superior long-term keeping qualities.

7 BASIC PRINTING CONTROLS

Printing, the final stage in the process of making a photograph, is the culmination of all your effort. Skill and patience here are crucial, if you are to produce a final print which accurately captures the image that first attracted you, and reflects your interpretation of it.

It is a great mistake to simply print as many negatives as possible in one session. Never sacrifice quality for quantity; it is much more satisfying to use your time in the darkroom to produce fewer prints, each of which is as near to your ideal as possible. Be discriminating and take your time.

This chapter will deal with production of 'straight' prints to a professional level of quality.

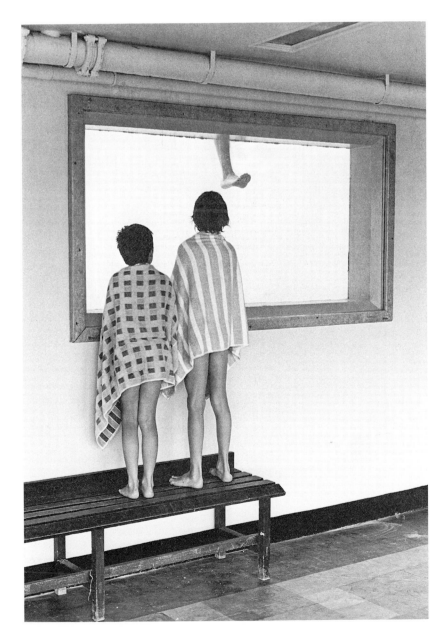

29 Where the subject content is so powerful, as in this humorous incident at a holiday camp swimming pool, it is often only necessary to make a 'straight' print. There is no need in this case to alter the image presented to the camera, but only to allow it to speak for itself.

In Chapter 11 we discuss methods of manipulating the image in the darkroom.

Before starting, check that all your equipment is correctly wired and is safe. Adjust the enlarger for even illumination (page 26) and make sure you have the correct lens and condensers in the enlarger.

Although *colour enlargers* can be used successfully for black-and-white printing, remember that they have a diffuse illumination system (page 26) which is designed to produce excellent results with the dye images of colour films. The majority of colour papers are intended to be used with low-contrast enlarger light sources. So, if you intend to use a colour enlarger for black-and-white printing, you should try to develop your negatives to a fairly high contrast (CI = 0.56, gamma = 0.70) in order to compensate for the diffuse light source.

If you process standard chromogenic black-and-white films, such as Ilford XPI and Agfa Vario-XL, in a standard commercial C-41 solution, you will get standard non-variable contrast, ideal for printing most subjects on grade 2 paper. However, very low contrast subjects may not produce satisfactory results, even on grade 5, and the answer here is either to ask the laboratory if they will push-process the film, or to process and control the negative contrast yourself. The methods available for this purpose are discussed in another volume in this series, *Photographic Developing in Practice*.

Many colour enlarger heads are detachable, so for black-and-white work you may be able to replace the one on your enlarger with a condenser type; this is particularly suitable for 35mm and 120 work. Colour heads can be used with variable contrast papers, such as Multigrade, Polycontrast, etc (see page 71).

Remember, a top quality enlarging lens is really essential if you are to produce good work, and the accessories discussed in Chapter 3, such as an enlarger timer (bleeper) and focusing aid are very worthwhile.

Black-and-white printing in outline

The materials and processes for black-and-white printing have already been discussed in detail. As a reminder, here is a brief summary of the complete process:

The negative is projected by the enlarger on to the black-and-white photographic paper and exposed for a measured time. The image becomes visible after processing (ie, developer, stop bath, fixer). The photograph is then examined, and another print(s) made if further improvements to the image can be made. The print is finally washed and dried, ready for presentation, mounting, etc (Chapter 12).

Your first print – step-by-step

To make a monochrome print on, say, 12.7 x 17.8cm (5 x 7in) paper from a black-and-white negative, follow this procedure:

1 With the room lights on (ie, 'white light') make up the three processing solutions (developer, stop bath, fixer) as recommended by the manufacturer (Chapter 6). Use hot and cold water to ensure that the developer is at about 20°C (68°F); a cold developer takes a long time to produce a full image and over-warm developer works too rapidly, and is liable to deteriorate (oxidise) fairly rapidly.

The usual procedure is to work from left to right, so arrange your dishes accordingly on your wet bench.

2 Place the negative in the enlarger's film carrier with the emulsion (dull) side facing down towards the paper easel – the numbers along the film edge should read correctly. Place the negative upside down as well (ie, 180° from correct viewing) so that the projected image appears correctly orientated.

3 Switch off the white light and turn on the safelight(s) – see page 18 for the correct colour and intensity of safelight. Set the enlarger lens at full aperture (for maximum brightness and most accurate focusing) and adjust the height of the enlarger to give the desired image composition and magnification. Focus the image carefully, preferably with the help of a focusing aid (page 38), and stop the lens down to *f*/16.

4 Turn off the enlarger light, and place a sheet of grade 2 paper in the easel; the paper emulsion, which should face up towards the lens, is recognisable by its slight shine or textured appearance, and a tendency to curl slightly towards the emulsion side.

5 Follow fig 7.1, and make a *test strip* comprising exposures of 5, 10, 20 and 40 sec.

6 Place the exposed paper, emulsion side down (see note below concerning dermatitis) and rock the dish slowly back and forth to ensure adequate coverage of the paper and sufficient solution agitation. After about 20 sec, turn the paper over and

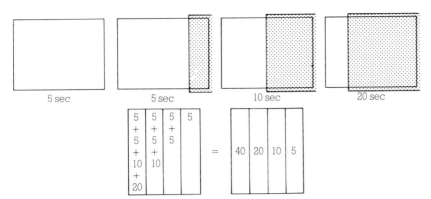

| 5 sec | 5 sec | 10 sec | 20 sec |

5 + 5 + 10 + 20	5 + 5 + 10	5 + 5	5		40	20	10	5

7.1 The upper line shows the four exposures given to a test strip, (left to right): 5 sec to entire paper; one quarter covered with card (shaded area) held just above the paper but not touching it; half of paper covered; three quarters of the paper covered. The lower figure shows the resulting test strip having exposures of 5, 10, 20 and 40 sec.

30-31 Test strip and the final print – see text.

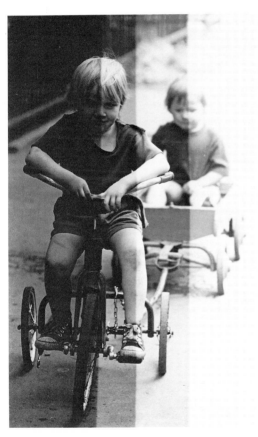

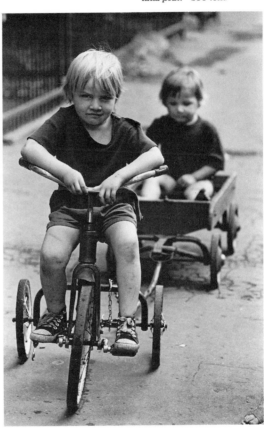

continue to rock it gently. The image should start to appear about 30 sec after the paper has been placed in the developer, depending on the paper type and developer used. Continue agitation until the full recommended development time is reached; for RC papers this is usually 1-1½ min, and for fibre-based paper 1½-2½ min.

7 Lift the print out of the developer and drain it for 5 sec, place it in the stop bath for 20 sec and agitate. Lift and drain the print, and place it in the fixer; agitate for 30 sec. Rinse and dry your hands.

8 Check that your photographic paper is safely boxed or securely in the dark drawer. After the print has been in the fixer for about 1 min (for RC paper and rapid fixers) or 2 min (for fibre-based paper and conventional fixers), switch on the white light and examine the test strip. If you are at all susceptible to skin irritations such as dermatitis, use processing paddles or tongs and a PQ type developer (page 74). Rinsing your hands in

clean water and drying them properly will help to avoid skin irritations.

Examining the test strip

Your ability to judge a test strip accurately will improve with experience. However, the following guidelines will help you in your first efforts:

1 From the four bands of exposure, select the one which is most pleasing in terms of overall density. Remember, the darkest band has been caused by the greatest exposure (40 sec). You may decide that an intermediate exposure time (say 15 sec) would produce the best overall density.

2 To avoid very short or very long exposure times (15 sec is about ideal for most purposes) you may have to adjust the lens aperture. For example, if the 40-sec exposure is about correct, then open up the lens by one stop to *f*/11 and use half the time, ie 20 sec. A 5-sec exposure at *f*/16 becomes 10 sec at *f*22, or 20 sec at *f*/32. If your lens does not have a setting below *f*/16, you must ensure that the short exposure time is accurately controlled, preferably by using an enlarger timer or bleeper.

3 If your test strip is too light overall (probably because your negative is very dense), repeat the test strip, using *f*/5.6. For very dark test strips, use the smallest marked aperture on the lens (on no account stop the lens down past this last *f*/stop, because the resulting image quality will be very poor due to light diffraction) and precise exposure times of 2, 4, 8, 16 sec.

4 Make a full print (in safelight conditions) using the selected time and lens aperture.

5 Examine the full print in white light.

Adjusting print contrast

A good quality black-and-white print should contain a white which is as clear as the borders of the print, and a black which is the maximum obtainable with the paper and surface used (see page 71). Check the black against the black of the overexposed part of the test strip; if the print does not have these clean whites and maximum blacks, repeat the test strip, this time using grade 4 paper (see page 71).

If the print has too high contrast and lacks subtle mid-greys, use grade 1 paper.

It is a common mistake for beginners to make 'flat' prints which lack sparkle, and for this reason it is better to start with prints which are too high in contrast, and then to come down by a paper grade or two until correct tonal qualities are reached. The most frequently used method – making flat prints and slowly increasing paper grades – often results in a print which never quite reaches a high enough contrast.

The best method of establishing your own criteria for what a good quality print looks like, is to visit as many exhibitions a possible, and judge other people's work for yourself.

Printing with variable contrast papers

Papers such as Ilford Multigrade and Kodak Polycontrast have been discussed on page 71. It is important to remember that the filters for one product should not be used with another. The essential step-by-step procedure for Multigrade papers is:

1 Put the negative in the enlarger as usual and estimate the filter required. The image can be focused without the filter in place; this can then be inserted into the filter drawer or below the lens without harming the image sharpness; this is because of the high optical standard of the filter, and is a particularly convenient feature when you are using the denser filters (4-5).

2 Make a test strip as previously described, and then produce a full-sized print.

3 Examine the print; if you find it slightly too high in contrast, change the filter to the next one or two down. If the print seems too soft, use a filter number one or two higher. Remember, you will need to double the exposure time when changing from filters 0-3½ to 4-5, and halve it when going in the reverse direction.

If your enlarger has a dial-in colour-head, use its magenta and yellow filters to produce the various contrast grades. You will need to experiment before you produce the most satisfactory settings, but fig 7.2 gives a guide to start you off.

If you are using a colour head, you might find the higher contrasts difficult to achieve. This is because Multigrade filters are more strongly coloured (narrower cutting in their absorption) than filters designed for colour printing.

Ilford produces a Multigrade enlarger head with a special control unit to give automatically timed exposures when using a variety of filter numbers. However, this product is very expensive, although you could justify buying it if you are intending to produce a large number of prints.

If you use Polycontrast papers, follow the

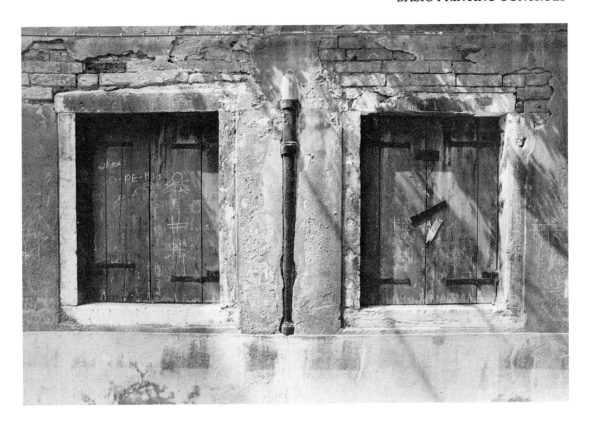

method described above for Multigrade. The only difference is that the Kodak product uses a calculator to determine the exposure time required for each filter (the paper speed must first be set on the dial).

If you are using a colour head, Kodak recommend as approximate equivalents to PC (Polycontrast) filters the following filtrations: 30Y (PC1), 20M (PC2), 100M (PC3), maximum M (PC3½). It is unlikely that your colour head will have sufficient magenta filtration to reach the equivalent of PC4. Use the Kodak guidelines to start your own tests.

Control of print development
Only by testing will you discover the exact effect of a developer on a particular paper. Note the following, which is applicable to each paper/developer combination:

1 The rate at which the image develops can vary, with some combinations giving full print quality in 60 sec or under, and others taking up to 2½ min.
2 The contrast of a paper may change slightly depending on the developer used.

32 A good quality print should have a clean white and a maximum black. However, the range of tones between these two extremes depends on the subject and personal taste. In this example, the paper grade was chosen to give sufficient contrast to accentuate the wall texture, especially close to the centre pipe, and to define the graffiti, but not so much contrast as to lose the softness of lighting. The right side of the print was 'burnt in' to avoid an inbalance of tones.

7.2 Suggested colour head settings when using Multigrade paper

	Durst colour heads		DeVere colour heads	
Paper grade	Filter	Exposure factor	Filter	Exposure factor
0	110Y	1.8	170Y	2.3
½	90Y	1.6	150Y	2.1
1	70Y	1.5	115Y	1.8
1½	30Y	1.3	85Y	1.5
2	0	1	0	1
2½	30M	1.3	20M	1.1
3	45M	1.4	70M	1.4
3½	55M	1.5	90M	1.7
4	95M	2.0	120M	2.0
4½	130M	2.3	200M	2.8

Grade 5 is unobtainable with most colour heads

3 The colour of the image may vary from warm brownish to cold bluish-black tones.

The paper has the greater influence over these variables.

Ideally, an image should reach full development within about 1½-2 min. A shorter time than this may not allow you sufficiently accurate control, and longer times can be impractical and inconvenient. Not all paper/developer combinations work at the same speed. Some develop the image very quickly and then make little subsequent change, while others develop the image more gradually and evenly. Whichever combination you choose is, of course, entirely up to you. But for most purposes, a combination that gives a fairly fast initial development followed by a certain amount of image change is generally the most suitable.

Different developers produce a slight variation of image contrast, but this is overriden by your own visual choice of the best grade of paper for each negative. Using different toners (page 158) with one paper may also produce a range of different tonal characteristics.

Decide on the relative warmth or coolness that you want for your final print, bearing in mind what is most suitable for your subject. For example, portraits often call for a warmer tonal range, particularly in the more formal studio portrait, and here the warmer tones of chlorobromide papers will give you what you want. On the other hand, colder papers will give the sitter a tense, dramatic look, which is best suited to documentary photojournalistic work.

Some hints on paper developers

While it is not really feasible to describe any one paper/developer combination as 'the best', because this must depend on personal taste and subject matter, it is possible to help you make the best choice in each case by observing the following:

1 Study the section of this book devoted to paper choice and read the manufacturers' data sheets. Then make a choice of two or three types of paper. You will find this easier if you stick to either RC papers (where you could choose, say, Ilfospeed, Kodabrome or Multigrade) or, if you prefer conventional fibre-based papers, you might choose Agfa Portriga-Rapid for warm tone, Agfa Brovira or Ilford Galerie neutral tone. You will

33 A straightforward print using variable contrast paper, which required the face to be lightened by dodging during the printing exposure.

need small quantities of grade 2 paper.

2 Now do the same with paper developers (fig 7.3), reading this book together with product data sheets. Make your choice of two or three products and purchase small quantities of each. One of the developers that you buy should ideally be recommended by the paper manufacturer.

3 Select a good quality negative, choosing one which will be suitable for grade 2 paper, and which will give you a good range of shadow detail, a sufficient range of mid-tones and subtle highlights. Try not to choose a subject which really needs to be printed on to a specific paper, for example, a warm-toned formal portrait. In fact, it may well be a good idea to specially photograph a suitable subject for these tests, as you can then be sure that the negative has all the criteria described above.

4 Make the best possible print from the negative

7.3

Paper Developer	*Properties	Liquid/powder
Agfa Neutol NE	Neutral black.	Liquid & powder
Neutol WA	Warm black.	Liquid & powder
Metinol	Neutral black. Gives slow image build-up.	Powder
Adaptol	Neutral black. Gives slow image build-up. Recommended as two-dish developer with Neutol WA.	Powder
Ilford Bromophen	Neutral black. Recommended for Ilfobrom paper.	Powder
Ilfospeed	Rapid developer recommended for Ilfospeed paper. Not suitable for Multigrade.	Liquid
Multigrade	Rapid developer for Multigrade paper.	Liquid
LS	Warm blacks.	Powder
PQ Universal	Very versatile GP developer.	Liquid
Johnsons Bromide	Neutral/warm tones.	Liquid
Contrast	Rapid acting.	Liquid
Kodak D-163	GP developer.	Liquid & powder
Dektol	Cold tones. Mainly US availability.	Powder
DPC	Multipurpose developer recommended for Kodabrome papers.	Liquid
Selectol	Warm tones. Mainly US availability.	Powder
Selectol-soft	Lower contrast version of Selectol.	Powder
May & Baker Suprol	GP developer.	Liquid
Paterson Acuprint	GP developer. Recommended for all papers including Multigrade.	Liquid
Tetenal Centrabrom	Lower contrast developer.	Liquid
Eukobrom	Recommended for RC papers including Multigrade.	Liquid & powder
Eukospeed	Rapid processing of RC papers.	Liquid
Neutral	Warm tones.	Liquid & powder

* Image tone is determined mainly by paper choice.

using each paper/developer combination; if you choose three papers and three developers, you will have nine prints. Make straight prints, without dodging or burning-in at this stage.

5 When the prints have dried (remember, many papers will show delicate highlight details only after they have 'dried in') look at them carefully under a bright directional light source. Be very critical, noting tonal gradation, particularly as it appears in shadows, highlights, image colour, whites (for clarity) and blacks (for density).

This type of test should narrow down your choice of paper/developer combination; you will probably select two or three combinations and use these according to the subject matter.

Post-developer steps

It is important to remember that if you use chemicals which are near to exhaustion for the post-development stages (ie, stop, fixer and wash), you run a serious risk of staining your print. These stages should be carried out to completion, but use reasonably fresh solutions each time.

As we have already seen, you can extend the life of the fixer by using an acid stop bath after the developer, as this neutralizes the alkalinity of the developer and thus maintains the acidity of the fixer. But if retaining greater control over development is more important to you than economy (see page 77), simply use water.

On the whole, it is more economical as well as more efficient to use two fixing baths. Make up the last fixer freshly before you start each session; and remember to make this the first fixer the next time you use it. You must follow exactly the paper manufacturer's recommendations for time, dilution and type of fixer.

About 5 min fixing time in both fixing baths is ample for fibre-based papers and sodium thiosulphate fixers, while about one minute is sufficient for the fast-working ammonium thiosulphate fixers. Make sure your prints receive adequate fixing time but do not leave them in the baths for much longer than the recommended time (the absolute limit is about four times the time specified). Beyond this, the fixer starts to dissolve silver from the print, and you will begin to lose subtle highlight detail. If, for any reason, you cannot be sure to keep to the shorter fixing times demanded by rapid fixers it is best to use the slower sodium thiosulphate type for paper processing, because you can then leave prints in the fixer until you are ready to remove them for washing.

Washing the prints after the fixer is ideally done with continuous supplies of running water, to ensure that the used water is immediately removed from the environment. If your facilities do not include access to continuous running water, try to ensure that the water in the wash tank

is changed as regularly as possible (about every 2 min for RC papers and every 5 min for fibre-based materials). As we have seen, the length of time you should take for washing the print depends on the temperature of the water, the type of paper and the efficiency of your washing facilities. However, it is usually recommended that you wash single weight and double weight conventional fibre-based papers for 30 min and 45 min, and that RC papers be washed for only 4 min, or even less. The times given for fibre-based papers may seem lengthy, but remember that you can shorten them by washing aids.

Do not over-wash RC papers as you will lose optical brightners from the paper, which will affect the brilliance of the whites. Over-washing can also make RC papers curl at the print corners.

Local density control

This technique is concerned with 'correcting' specific areas of the print which need attention to produce desired shadow or highlight details that might otherwise be missing.

Test the negative on several grades of paper to find which is best overall, or nearest your ideal. As before, start at the *top* end of the paper grade

34 For low-key subjects with a wide range of subtle shadow tones it is often beneficial to extend development to the maximum possible (say 3 min) and keep the printing exposure to a minimum. This technique works particularly well with fibre-based papers.

scale and produce initial prints which are too hard, and then move down the scale.

Holding back exposure to certain areas of the paper (known as 'dodging' or 'shading') and giving extra exposure ('burning-in') are, in effect, the same thing, as they both adjust exposure locally, counter to what is happening to the rest of the paper. You may prefer to burn-in small parts of some photographs in order to darken them, while in other cases you may choose to lighten areas by shading. Both burning-in and dodging may be necessary to correct more complicated scenes.

To get the best results from this technique, you need to assemble a fairly extensive range of hand-made printing tools, such as lengths of wire supporting lumps of modelling clay, pieces of cardboard with different-shaped holes cut out, a small penlight torch, and other aids. There are a few magicians who produce perfectly controlled printing exposures by contorting their hands in

the enlarger beam; not easy, but it is certainly fun to try.

Print tones compared with subject tones

You may want to compare the final print tones that you have achieved with those of the original subject; you will most certainly want to do this if you are considering using the Zone System (page 103). As the maximum brightness range from a glossy-surfaced print is about 128:1 (maximum density of 2.1) and the range of subject brightness may be much greater, it is important to retain some separation of tones in your photograph, distributed in a similar fashion to those in the original scene.

In theory, an original scene which has the brightness range 128:1 (ie, a seven-stop variation from shadows to highlights) could be exposed

and developed correctly to produce a negative when could then be 'perfectly' printed on to grade 2 paper, giving a glossy print in which 'no-detail' shadows appear at maximum density of 2.1 and no-detail highlights appear as print density of 0.0 (theoretical only). Thus, the original subject's brightness range (Log E of 2.1) is interpreted as a print luminance range of 128:1 (density range of 2.1).

This perfect transposition can happen only if there is a straight-line response between photographic films and papers. But, in fact, these materials all have S-shaped D/Log E curves. This means that the information on the subject's shadows is recorded in the toe region of the characteristic curve of the film and some compression of tonal range cannot be avoided. How-

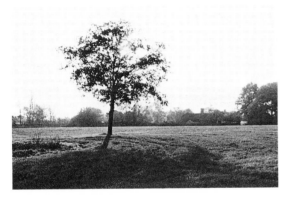

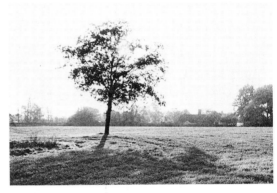

35-36 The print on the left is a straightforward exposure without any local density control – the print on the right has the same overall exposure but the foreground has been held back for half the total time.

It is a matter of personal taste which print is preferable. Notice how the dodged print directs the viewer's attention towards the foreground grass and away from the tree.

37-38 The print on the left has received a simple overall exposure whereas the right hand print has been given this straight exposure, plus an additional time to the foreground. The

darkening of the grass by 'burning in' removes the feeble appearance of this area in the left print and also helps to centre interest on the horse.

39 The tones of this print closely match those of the original scene and no attempt has been made to alter them by local density control during printing. It was decided to keep the front of the face in deep shadow and not to lighten it by dodging.

ever, the paper's S-shaped curve removes some of the compression of shadow detail, since the low contrast toe of the film is printed on to the high contrast upper part of the film's curve (fig 7.4).

If the brightness range of the subject is beyond 128:1 (Log E is greater than 2.1) the tones of the final print can only ever be proportional to the tones of the subject, and this is assuming that the wide brightness range has been produced on film through careful exposure and film development (fig 7.5).

If the subject has a low brightness range this will be 'stretched' if it is printed to produce dense blacks and clean whites. So, a subject photographed on a cloudy day with a brightness range of, say, 1:20 (Log E of 1:3) would, as a rule, be printed to give a full density range of 2.1 on glossy paper (fig 7.6). The difference between the tones in the final print would be greater than the tonal

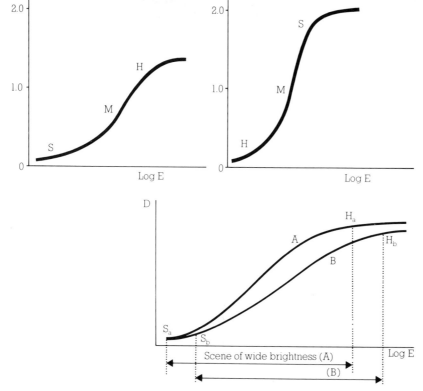

7.4 The characteristic curve of the film (left) shows how the subject's shadow S detail is recorded on the long sweeping toe while the mid-tones M are recorded on the straight portion of the curve and the highlights on the shoulder. When projected on to paper (right curve) the low densities of the negative expose the upper parts of the paper's curve to produce the dark shadow areas of the print.

7.5 A scene of wide brightness range when exposed on the film 'normally' and then developed for the standard time causes some loss of shadow (Sa) and highlight detail (Ha) because the film is unable to record such a large range of subject brightness. However, if the film is overexposed (underated ISO/ASA) and underdeveloped (curve B) no loss of shadow and highlight detail occurs.

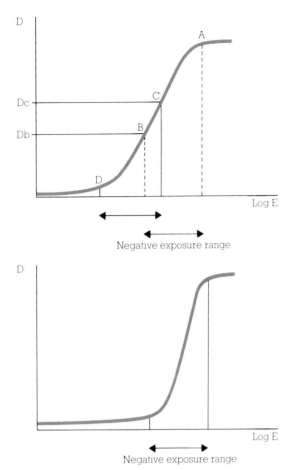

7.6 The top diagram shows the result of printing a negative of short density range on grade 2 paper. If the paper is exposed to give deep blacks (A) the highlights are muddy (B); reducing exposure retains clean highlights (D) but the shadows are not very dark (C). The same negative printed on a high contrast paper (bottom diagram) gives both clean highlights and deep blacks.

40 The first print from this negative was made using a simple overall exposure to give the desired tones to the foreground and the bridge. However, the sky appeared almost white and the sun was not visible. It was therefore necessary to burn in the sky area for 4X the initial time, giving progressively more exposure to the top part of the sky.

differences in the original subject. The examples given above are based on the maximum density of 2.1 for photographic paper, which is only achievable from glossy surfaces. The majority of prints made for exhibiting are printed on to surfaces such as pearl, which have a lower density range (about 1.8). Thus, most subjects (including those of average brightness) are compressed on to the limited luminance range of the paper. When matt papers are used, this compressive effect becomes even more apparent; the maximum density may be as low as 1.4.

However, it is important to remember that, when viewing a print, we are not concerned with the original subject, and only judge the quality of the image we are looking at. To accept and enjoy the photograph, it is only necessary to ensure that the picture contains a black which compares favourably with other printed blacks, either nearby or in the memory, and for the photograph's tonal distribution to accord with the subject.

For further information on the tonal reproduction of black-and-white prints, the reader should consult specialist books, such as *Black-and-White Photography in Practice*, a companion volume in this series.

8 FURTHER PRINTING CONTROLS

As well as the controls previously mentioned, one or two other techniques are well worth trying.

Changing the nature of image borders, or vignetting, is a very old technique but most effective. You hold a cut-out card between the enlarger lens and the paper (the most usual shape of the card is an oval cut-out) which you move very slightly during the exposure. This produces a portrait shape with borders that are softened, to what degree depends on how much the card was moved during the exposure. The card used can be any shape, and the print borders softened as much as you want.

The picture and its surrounds

Another attractive effect is to produce a fairly small print within a large sheet of photographic paper. Lay a cleanly cut-out printing mask in contact with the photographic paper during exposure. The card must be black to avoid scattering enlarger light and it may be kept in place by weights, or form part of a hinged printing frame (fig 8.1). Do not use glass, as it can cause optical distortion and would need to be kept impossibly clean.

'Containing' a subject such as a landscape, with its large areas of sky and sand, for example, can be done very effectively by surrounding the photograph with a thin black line. There are several ways of achieving this:

1 If your enlarger projects the whole negative image area and some of the clear surrounding area of the film, you can allow the clear area to expose the paper to give black. Enlarge the negative in the usual manner and adjust the sides of the

8.1 Simple printing mask. The base should be constructed of a fairly sturdy material such as wood or thick card, while the top is made of a thinner material (such as thin black card) so that it stays in contact with the paper emulsion. Use good quality linen tape for the hinges.

Print

8.2 Double mask printing frame which produces a black line around the print. The first exposure is of the image through the cut-out rectangle, and the second white light exposure is made when the line mask is in place. The line mask can either be attached to a *clean* acetate sheet, or the centre portion can be held separately during the non-image exposure.

White light exposure

Image exposure

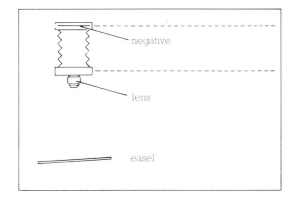

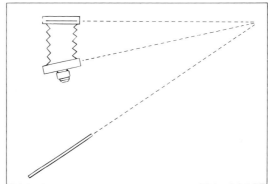

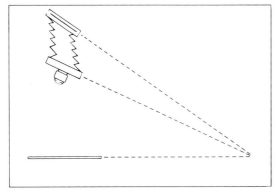

uncorrected corrected

8.3 Three methods of correcting image shape (eg. converging verticals) during enlarging. Top left: easel tilt for enlarger without movements; top right: easel and lens panel tilt; bottom left: lens panel and negative carrier tilt. The dotted lines indicate the ideal situation, in which all planes should meet at the same vanishing point (Scheimpflug rule). See text for full details.

paper easel to give a thin white strip around the projected image. You can control the width of the strip by adjusting the easel arms; some easels have a wide control of image border sizes and you can therefore produce a black-lined print surrounded by a great deal of white. This technique is most easily achieved when printing a 35mm negative in a 6 x 6cm film carrier, but you will probably need glass in the carrier to keep the film flat.

2 If you produce most of your pictures as a standard size and shape, make a two-part printing mask (fig 8.2), one part of which permits the image area only to be exposed. The other part should be a cut-out line in a separate piece of thin black card which, used with a white light exposure such as a torch, lamp or enlarger without negative, will give black. This method permits the black line to be positioned at any point beyond the image (for example, image edge / white / black line / white), but a new mask will be necessary for each different print size and picture proportion. Make sure that the edges of the mask are cut cleanly to produce sharp, even lines.

3 With some special photographic 'art' papers, such as Kentmere Art or a 'document' paper, you can draw a black line on to the final print, but you need a steady hand and a technical drawing pen, otherwise the results look amateurish.

4 Mount the print on black paper or thin card, and this, in turn, on to white card (Chapter 12).

Controlling the image shape

We described earlier how you can use an enlarger with a tilting lens panel and/or a tilting negative holder (usually part of a tilting head) to change the shape of a projected image. Most commonly, this technique (fig 8.3) is used to correct converging lines on the negative to appear parallel on the print; for example, the effect on the parallel sides of tall buildings when you point a small format camera upwards, such as a 35mm or 120, or any camera without movements or a shift lens. However, there is a limit to the correction to be achieved using this method.

41 In this example, a No. 3 Multigrade filter was used for the main overall exposure while the right side next to the path was held back during half of this exposure. An additional exposure, using a No. 5 filter, was then given to the previously dodged area, for extra shadow contrast.

42 Fine adjustments in development. This print was developed for about 45 sec and subsequently transferred to a water bath. Developer was then painted on to the highlight areas until they appeared almost correct. Finally, the print was re-immersed in the developer for 30 sec.

The most workable method of applying it is to keep the baseboard with the paper and easel in their normal horizontal position. The required amount of correction can then be reached by using both the lens and negative tilt.

Another method is to tilt the lens and paper easel to reach the same degree of image change. This is slightly more cumbersome than the method described above, but is useful if the enlarger has lens tilt adjustment only.

You can still control image shape to some degree if the enlarger has only head (negative) tilt; stop the enlarging lens down to a very small aperture so that the total print area is adequately sharp.

Varying contrast within the printed image

Use of variable contrast papers (Multigrade, Poly-contrast etc) will give you complete control of the image. Not only can you control the density of individual areas of the print through shading or burning-in, but you can also vary the contrast from one part of the image to another. You may not have considered using this extra control, but there are some negatives which can benefit from it.

The best procedure to adopt for local density and contrast control is given here:

1 Make tests to find the most suitable printing grade and exposure for the major part of the image, then make a full-size print.
2 Study the print; which area(s) need to be lighter/darker, and which areas need higher/lower contrast?
3 Make tests on these area(s) to determine the new exposure time (shading/burning-in only) and the new exposure time with new printing filter (contrast changes). Make notes if necessary.
4 Make a print using all extra exposures for local density and contrast control.
5 Refine exposures/contrast filters, as needed.

Fine control of print development

If all your printing exposures, including local density control, are exactly right, you should find that you can develop your paper in the normal manner and produce a perfect print. But everyone finds, at some time or other, that they have not exposed a sheet of paper quite correctly; perhaps one area is slightly too dark, or another slightly too light. In such cases a water bath instead of a stop bath after the developer can prove useful.

As the print develops, take note of any areas that are turning too dark, or not dark enough, for example with overexposed shadows where detail starts to disappear, and highlights which are not appearing quickly enough. Remember to agitate the print fairly vigorously during this first, reasonably short, development, to avoid uneven development. As soon as you notice any of the flaws mentioned above, place the print in the water bath and agitate it vigorously for about 20 sec.

The print will now develop very slowly, because of the small amount of developer contained within the emulsion, helped by any developer which may remain in the water from other prints.

If, in cases where the shadows are going too

43 Convention forces most prints into a rectangular shape with about 4:5 proportions. But there are sometimes good reasons to produce prints of different shapes. The circular format used here adds to the abstract nature of the tree bark.

44 Where there is no need to make the dominant compositional force follow either a horizontal or vertical axis then a square format might be the most appropriate. In this picture, the square shape allows the lines (car lights recorded with long camera exposure) to flow evenly out of the frame.

dark, you have decided to 'pull' the print (ie, take it out before the full development time has elapsed) then 'paint' the remainder of the print with developer, ensuring that none is allowed near the problem shadows. For this operation, use a paintbrush, or simply dip your finger into the developer, but if you decide on the latter course use a Phenidone type of formula rather than a metol-based developer, to lessen the risk of dermatitis – and, of course wash your hands very thoroughly after you have finished processing each print.

If you are prone to dermatitis, use print tongs or gloves and a brush to paint on the developer.

In the cases where the highlights do not appear quickly enough, 'paint' developer on to the highlights only, and then put the print back into the developer dish to ensure proper development.

This operation can only be used to make minor adjustments to print tones; it will not repair inaccurate printing exposures. The technique is best suited to slower-developing fibre-based papers, and less to fast-developing papers such as Kodabrome and Ilfospeed, as these are less easy to control in the developer.

However, in certain cases the technique can greatly improve the quality of a print and is well worth mastering.

Print shape

Although the traditional shape of a photograph is rectangular and follows the classic format of paintings, there is no reason why all your work must be presented in this way. Be flexible, experiment with more unorthodox presentations, and, above all, let the composition decide the format.

At the printing stage, you can change the image by cropping, unless you follow the purist belief that cropping has no place in printing, and should be part of the decision made at the moment the photograph is taken. However, for most people printing presents another opportunity to change the original image.

Size of print

Although there are no rules regarding the size of the print, this will be governed by a number of factors, the most important being the purpose for which the print is being made. If, for example, it is to appear in an exhibition, it will need to be fairly large (40 x 30cm or more) to allow the viewer to stand back and look at it properly. But a small print displayed within a group of 50 x 40cm prints will also attract attention if it is good enough to hold the viewer's interest once its novelty has worn off.

Do not enlarge a negative so much that the image quality begins to break up, as the viewer is

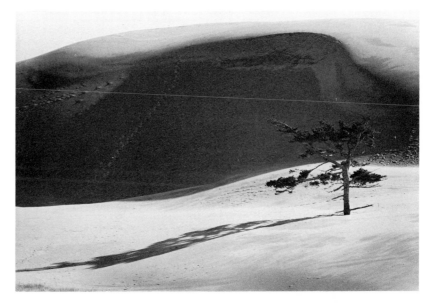

45 The Zone System is most easily applied to landscapes or any subject which remains relatively unchanged for a period of time. Spot meter readings were taken of the large shadow of the sand-dune and the lightest parts of the sand – they were placed as zones II and VIII respectively, in the print.

then preoccupied by the loss of definition and obvious graininess – such technical details will prevent him from 'seeing' the photograph itself. Keep the size of the print within the limits of the negative, and bear in mind the subject matter, camera format used, amount of cropping (if any) and lighting, both the subject lighting and that which is to illuminate the final print.

Small prints, particularly those surrounded by large areas of tone, can be memorable in the way of painted 'miniatures'. But the subject matter must be suitable and the treatment carried out to a high artistic standard; if not, the final effect will just be pretentious.

Zone System

To obtain very high quality black-and-white prints of predictable appearance (ie, where the photographer can predict the final print tones for each part of the scene), you can use the very exacting Zone System. This approach involves making precise light measurements of the scene, controlled film exposure and developmnt, and careful printing. It is best applied to large camera format (cut film) landscape work, but its principles can be adapted for all styles of photography. For more information on the system consult *Black-and-White Printing in Practice*.

Processing for archival preservation

The standard processing procedures and times given for photographic papers are, in the words of the manufacturers, sufficient to ensure 'satisfactory permanence for most purposes'. However, to

46 For reproduction in a magazine or book, a print should have a good range of tones, well defined highlights, and shadow detail which is well graded and not too close to maximum black.

8.4 Archival processing of Ilford Galerie paper

	Time (min.)	Comments
Developer	1–4	eg. Ilford PQ Universal or LS.
Stop bath	½	Can use water bath
Fixer	½	Rapid type without hardener. eg. Ilford Hypam 1 + 4.
Wash	5	Good supply of fresh, running water.
Washing aid	10	Intermittent agitation in Ilford Washaid (1 + 4).
Final wash	5	

8.5 Thiosulphate test solution

Water	750 ml
*Acetic acid (28 per cent)	125 ml
Silver nitrate	7.5 g
Water to make	1 litre

*Made by diluting 3 parts of glacial acetic acid with 8 parts of water.
Store test solution in a dark glass bottle; avoid contact with negatives, prints, hands and clothing, otherwise staining occurs.

achieve archival permanence you need to follow a rigid processing procedure such as that described for Ilford Galerie (fig 8.4). Use only fibre-based paper for work intended for archival purposes.

You can also achieve this type of permanence by using hypo clearing solution after a short wash; this improves the efficiency of washing by a factor of about eight. For example, 3 min in hypo clearing agent is equal to about a 24 min wash. This is followed by a bath of hypo eliminator solution which converts the remaining thiosulphate to the more soluble sulphate form, which is then washed out. The silver image must be free of all thiosulphate if it is not to fade.

The image is then further stabilized by use of a gold protective solution. The final step in the archival process is a wash, followed by drying in a dust-free atmosphere.

For maximum permanence, running into centuries, the print must be stored in conditions of low humidity and low temperature. For even greater stability, the silver image can be converted to silver sulphides and selenides to give a sepia-toned (brownish) print. These are commercially very popular and can be very appealing, but not all subject matter is suited to this treatment.

Test for residual thiosulphate

If the efficiency of your washing to remove thiosulphate is in any doubt, perform a residual thiosulphate test by taking a spare print out of the wash and removing most of the water from its emulsion surface. Put one drop of the test solution (fig 8.5) on to the white unexposed margin of the print, let it stand for 2 min and then rinse off the excess reagent. Compare the tint of the stain thus produced with the manufacturer's reference tints. If the residual hypo is too high, continue washing and do the test again after about 20 min.

Prints for reproduction

Some observations on producing black-and-white prints for reproduction in newspapers, books, magazines and other printed matter may be helpful at this point.

Look at the photographs reproduced in this book under a magnifying glass; you will notice that they consist of small black-and-white dots. This pattern is called *halftone* reproduction. The lightest parts of a photograph printed in this way consist of white paper with small regular dots of black ink. When viewed from a normal distance the small dots merge into the white to create a light tone. The middle tones of a photograph reproduce as dots, covering about half the paper area, and are called 50 per cent dots. The darkest parts print as black ink with small areas of white showing through. So, the tonal scale of the original photograph is reproduced as halftone dots, with the size varying according to the depth of tone.

The halftone screen used to make the printing plates determines the number of dots appearing within a given area. In high quality reproduction this screen is very fine (about 133 lines/inch or 50 lines/cm) while for less exacting work it is coarser (about 60 lines/inch or 20 lines/cm).

This coarser quality is characteristic of newspapers with their high printing speeds and low quality paper. These restrict the available tonal range to give only modest blacks and lose very fine image detail. Bearing in mind the compression of tonal information at the extreme ends of the tonal scale, for this purpose it is best to supply photographs with most of their information in the mid-tones and without too much fine detail. Always supply newspapers with prints made on glossy-surfaced paper.

In contrast, most magazines and books use high quality coated paper which can reproduce a fine halftone image. As the quality of reproduction is frequently extremely high, you should supply only top quality (exhibition standard) prints containing a wide range of tones and with shadow and highlight detail clearly separated. Again, print on to glossy paper to ensure the maximum tonal range.

9 COLOUR ENLARGING

It is useful to preface the practical aspects of colour enlarging with a brief outline of the principles of photographic colour reproduction. Due to the nature of our visual perception, many light sources appear to emit 'white light' when viewed in isolation. Such light may be analysed by techniques of refraction or diffraction and dispersed into a *visible spectrum* of colours. The rainbow is an example from nature. Several hundred colours may be distinguished by a detailed inspection but, in general, such a spectrum appears to consist of three broad bands of colour – red, green and blue, plus a narrow band of yellow.

Additive and subtractive colour mixing

The reverse of such *colour analysis* is *colour synthesis* or *colour reproduction*. It has been found that all the spectral colours can be repro-

duced or matched by a suitable mixture of light of only three spectral colours, either as narrow spectral lines or as broad bands. Arbitrarily, red, green and blue light are chosen for this tricolour additive process and are known as the *additive primaries*. The light mixture is additive colour synthesis. Note that this refers to the admixture of light and not dyes or pigments.

The first demonstration of an additive method of colour reproduction was given by Maxwell in 1863 (fig 9.1). The most common everyday example is seen on the screen of a television set where triads of phosphors glow blue, green or red to form colour images. Additive synthesis has been used for colour transparency materials by means of mosaics of tiny red, green and blue filters, recently revived in the Polachrome process of self-developing colour slide material. But such methods are unsuitable for colour printing materials, due to the light losses involved.

An alternative, more efficient method of colour synthesis is by *subtractive* methods. Here, we

9.1 Colour synthesis.
A Additive overlap of three coloured beams of light on a screen, **B** Overlap of three coloured filters on a light box.

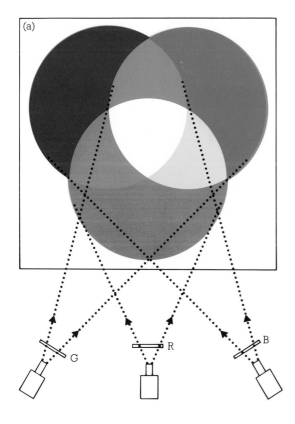

47 A typical test strip from a colour negative. The exposure times were 5, 10, 20, 40 sec – note that the area chosen included skin tones which are a critical feature for good colour balance. The print was judged to be too magenta/red, resulting in the addition of 05Y and 10M to the filter pack.

begin with white light and remove the unwanted spectral bands by means of suitable colour filters. For example, a yellow filter absorbs blue light but transmits red and green which, of course, form an additive mixture giving the filter its yellow appearance by transmitted light. Yellow is termed a *subtractive primary* colour or a *complementary* to the additive primary blue.

Likewise, magenta filters absorb green light and cyan filters absorb red light, so that the presence in suitable strengths of the three complementary filters (taking the form of transparent dyes in front of a white light source) can be used to match all spectral colours. In practice, it is not possible to get perfect absorption of these colours and this causes some deficiencies in colour reproduction. The colours formed by equivalent amounts of the three dyes are shown in figure 9.1.

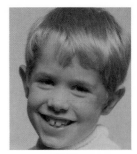

20 Blue

48-64 A ring-around set of colour prints.

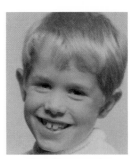

– 30% exposure

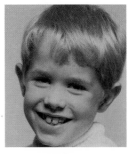

20 Cyan

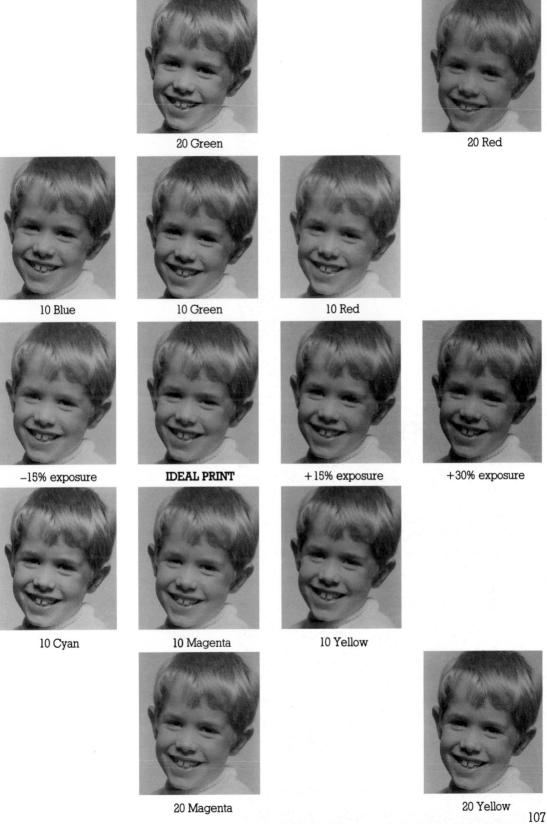

20 Green

20 Red

10 Blue

10 Green

10 Red

−15% exposure

IDEAL PRINT

+15% exposure

+30% exposure

10 Cyan

10 Magenta

10 Yellow

20 Magenta

20 Yellow

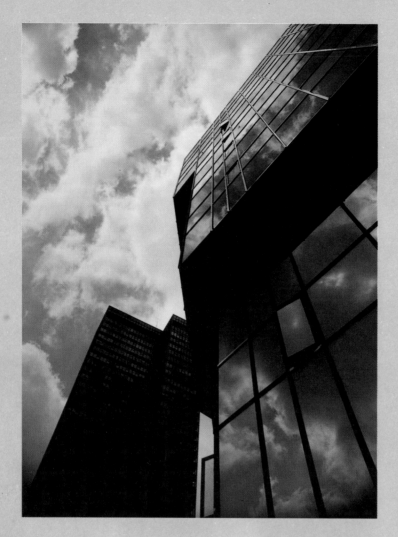

65 This reproduction was obtained from a Cibachrome print which was made slightly darker than the original slide in order to emphasise the clouds. A polarising screen and wide angle lens were used on a 35mm camera.

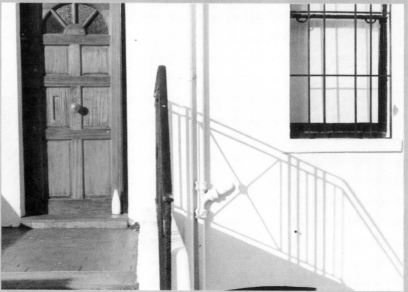

66 This print from a colour negative was deliberately produced slightly light and yellow to indicate the early morning sunlight. Note the slight coldness (bluishness) of the shadows caused by only blue skylight reaching these areas.

Note that pairs of the complementaries form the additive primaries and all three form a neutral grey.

Almost every colour process uses layers of yellow, magenta and cyan transparent dye to give a colour reproduction. Colour transparencies use transparent film base for viewing by transmitted light. Colour prints use a white paper base for viewing by reflected light – the colours are formed by the selective absorption of the white light on its double passage through the dye layers. So, a coloured subject or scene may be reproduced by first analysing all the colours present into their respective red, green and blue components and recording these in terms of their respective complementary colours as transparent dye layers.

This may be a two-stage process as, for instance, when using a colour negative material which acts only as an intermediate stage. The subject is analysed into its red, green and blue components by the *integral tripack* structure of the colour negative material. This is a basic three emulsion layer arrangement with sensitivities to blue, green and red light with the aid of a suitable yellow filter layer. This information on the relative amounts of blue, green and red light is recorded ultimately as yellow, magenta and cyan dyes respectively, their individual amounts being proportional to the exposure level received. A reversing of tones also occurs, as for all other negative working materials. The image, in complementary colours relative to the original scene, is obscured by the presence of additional dyes in the emulsion layers giving an overall orange appearance. Their function is corrective – to compensate for the deficiencies of the image dyes formed by chromogenic development.

Printing the colour negative on to another integral tripack material to form a print records the red, green and blue information once again as image dyes of cyan, magenta and yellow respectively, after processing. The tones are again reversed to form the final positive image and, as the coloured images in the colour negative are given as *their* complementaries, the image colours now correspond to those in the original scene.

Colour reversal materials also use the integral tripack construction, analysing the scene into blue, green and red components. But the reversal stage takes place during processing and these colours are recorded as complementary dye images whose densities are inversely propor-

tional to exposure and so give a positive colour record of the subject. Positive working colour print materials, too, reproduce colour using a tripack construction with complementary dye deposits inversely proportional to exposure level. (Full details have been given in Chapter 6.)

Triple exposure printing methods

Colour printing may be carried out by a triple exposure method, which is usually called *additive printing*.

When making a (positive) print from a colour negative the colour paper with its blue, green and red sensitive layers may first be exposed to the colour negative with a deep blue (tricolour blue) filter in the light path. This filter transmits only blue light and so selectively exposes the blue sensitive layer of the paper. But this blue light is locally modulated in intensity by the presence of the yellow dye image in the negative, as yellow dye absorbs blue light. The yellow dye image is itself a record of the blue light components of the colours of the scene. The exposed layer of the paper then produces another yellow dye image after processing, proportional to its exposure. In its turn, this yellow dye image modulates the white light used to view the print.

Likewise, the green and red sensitive layers are selectively exposed by green and red filtered light to produce the magenta and cyan dye layers respectively. So it can be seen that the accuracy of colour reproduction or *colour balance* of the print depends (amongst other things) on the *ratio* of the three individual filtered exposures. The *density* or *exposure level* of the print depends on the *sum* of the three exposures.

From the explanation above it can be reasoned that a print with an excessively yellow appearance may be corrected if the next print has a reduction in the blue filter exposure. Table 9.2 lists the main corrective actions.

In practical terms, the three filter exposures may be given individually, changing filters between exposures and being careful not to knock the enlarger and so throw the three images out of register. Alternatively, three light sources may be used in the enlarger; they are then individually filtered to give blue, green and red light. The intensities of each lamp are varied individually, as required, and the three are mixed in an *integrating chamber* (or mixing box) to give a coloured light which is used for a single exposure to the paper.

9.2 Corrective adjustments to exposures when colour printing by additive (triple-exposure) methods

Appearance of test print on visual assessment	Printing from colour negatives (negative-positive)		Printing from colour slides (positive-positive)	
	Remedy		Remedy	
	Either	Or	Either	Or
	Reduce exposure time through these filters	*Increase* exposure time through these filters	*Reduce* exposure time through these filters	*Increase* exposure time through these filters
Yellow	Blue *	Green + red	Green + red	Blue
Magenta	Green *	Blue + red	Blue + red	Green
Cyan	Red *	Blue + green	Blue + green	Red
Blue	Green + red	Blue *	Blue	Green + red
Green	Blue + red	Green *	Green	Blue + red
Red	Blue + green	Red	Red	Blue + green
Too dark	Reduce exposure in proportion through each filter		Increase exposure in proportion through each filter	
Too light	Increase exposure in proportion through each filter		Reduce exposure in proportion through each filter	

* Recommended procedure

These two methods may be controlled quite easily with a built-in colour negative analysis system which can insert each filter in turn for the necessary exposure time, or adjust the intensities of individual lamps.

Subtractive printing methods

A correctly exposed and balanced colour print is produced when the correct amounts of blue, green and red light expose their respective sensitised layers in the print material.

As an alternative to additive printing, it is equally possible to begin with 'white' light (as emitted by the enlarger lamp) and to *subtract* blue, green or red light from this by adding pale yellow, magenta or cyan filters to the light path (usually in the illumination system rather than below the lens). These colour printing (CP) filters are of low density because they do not need to absorb the whole of their complementary or primary colour, only the small excess of each as necessary. Thus, more light is available for the print exposure.

Another advantage is that these filters can be used in tandem to form a 'filter pack' with say, yellow and magenta filters used together. The yellow filter will absorb some blue light, transmit the remainder, leaving the green and red components virtually untouched. The magenta filter, in its turn, transmits the (adjusted) blue and red components virtually unaltered but absorbs some green light as necessary and transmits the remainder.

A single exposure can be given and the exposure level adjusted using the lens aperture/exposure time combination. The colour balance of the print is determined by the amount of corrective filtration used and thus may be achieved either by adding individual filters to the 'pack' or by gradually inserting a single filter into the light path (Chapter 3).

As an example, consider once again a yellowish test print resulting from excessive exposure to the blue sensitive layer. If a suitable yellow filter is added some or all of the excess blue light will be absorbed. Consequently, the exposure to the blue sensitive layer is reduced, less yellow dye is produced in the image. Conversely, excessive yellow filtration will produce a blue tinged image. A useful rule for corrective colour filtration is: *To reduce a colour cast on a test print, corrective filtration of the same colour should be added*

9.3 Corrective adjustments when colour printing by white light (subtractive) methods

Appearance of test print on visual assessment	Printing from colour negatives (negative-positive)		Printing from colour slides (positive-positive)	
	Remedy		Remedy	
	Either	Or	Either	Or
	Add filter(s) of this colour	Remove filter(s) of this colour	Add filter(s) of this colour	Remove filter(s) of this colour
Yellow	Yellow *	Magenta + cyan	Magenta + cyan	Yellow
Magenta	Magenta *	Yellow + cyan	Yellow + cyan	Magenta
Cyan	Cyan	Magenta + yellow *	Magenta + yellow	Cyan
Blue	Magenta + cyan	Yellow *	Yellow	Magenta + cyan
Green	Yellow + cyan	Magenta *	Magenta	Yellow + cyan
Red	Yellow + magenta	Cyan	Cyan	Yellow + magenta
Too dark	Reduce overall exposure		Increase overall exposure	
Too light	Increase overall exposure		Reduce overall exposure	

* Recommended procedure

to the light path.

In practice it is considered good technique to adjust the minimum number of filters to obtain a correction and not to have all three subtractive filters in the light path at the same time as this creates a *neutral density* of grey in addition to the corrective effects. For example, a test print with a filtration of 80Y + 40M may have given a green cast which is considered correctable by the addition of 20 Green. Green is added by a combination of yellow and cyan filters so 20Y + 20C is needed, resulting in a final filter pack of 100Y + 40M + 20C. But this includes a neutral density of 20Y + 20M + 20C. Subtracting this leaves a filter pack of 80Y + 20M only. In other words, some casts may be removed by taking filters of a complementary colour from the pack, if any are present.

These various practices are summarised in Table 9.3. The 'ring-around' set of colour prints described later, illustrates corrective filtration. Finally, for automated colour printing, truly subtractive filters, each of which absorbs the appropriate one-third of the spectrum, can be used with white light. An unfiltered exposure is given to start with, then each filter in turn is inserted into the light path, after an appropriate time interval, to remove its primary colour. This is, in effect, a form of simultaneous, triple-exposure printing with different exposure times.

Basic equipment needed

It is not necessary to possess every item of equipment described in this book in order to begin colour printing, only a few basic items are needed and others can be added later. Obviously a darkroom, improvised or permanent, is necessary, with a suitable enlarger fitted with a colour head (fig 9.4). This should have a tungsten light source, a reliable timer, constant voltage transformer and means of adding colour filtration. A colour corrected lens is essential, as is a simple masking frame.

A safelight is not essential nor is a focus finder nor a colour negative analyser.

Some means of processing the colour print is needed, such as a colour print drum with some chemical measures, storage bottles, thermometer and a simple timer. A notebook and pencil should be at hand always.

Such a beginner's kit may often be purchased as a package containing all that is needed to start colour printing.

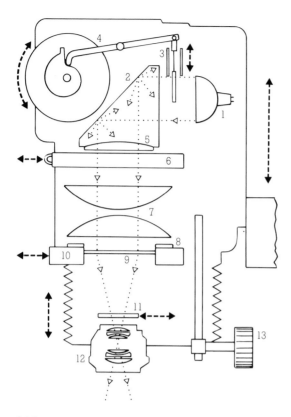

enlarger such as condensers, negative carrier and lens. Fit the correct lens and carrier as required for the negative format to be printed. Ensure that all the enlarger movements such as a rotating head or a tilting lens panel are at 'neutral', so that the negative carrier, lens panel and masking frame are all parallel with one another. Keep the printing notes or information to hand and other items such as the box of paper together with a spare one for the exposed paper – both in their allocated positions.

6 Make sure that the processing chemicals have been made up correctly, that they are in date and are suitable for the paper materials. Measure out the correct volumes of each solution in separate beakers, check temperatures and place in order of use. Be especially sure that the processing drum has been cleaned thoroughly, is dry and does not leak.

7 Have the processing instructions handy in case of problems. Inform someone of your whereabouts and intentions to be in the dark and left undisturbed.

8 Secure the darkroom door!

Exposing the first colour print

The following is a suggested routine for making your first colour print. It assumes that you are printing a colour negative and using a colour enlarger with dial-in filters.

1 Make sure you are familiar with all the controls of the enlarger, particularly the on and off switching arrangements. Follow the check list detailed above and arrange everything in order.

2 Select a colour negative, that has been correctly exposed and processed. One that has already been hand-printed commercially will do if the print gives a good example to work towards. Insert the negative in the enlarger carrier to give a projected image that is correctly orientated (fig 9.3). The negative should be emulsion side (ie, dull side) down in the carrier, that is, with the emulsion side towards the enlarger baseboard. With some negatives, it can be very difficult to decide which is the correct side. Edge numberings or markings on the film rebates, when reading correctly, mean that the emulsion is on the reverse side. Also, if the markings read correctly in the projected image before masking off, the negative is correctly positioned.

3 Centre the negative and mask off the frame edges or unwanted areas if the carrier has adjust-

9.4 A colour enlarger head. 1 Lamp, 2 Integrating box/reflector, 3 Colour filters, 4 Filter value setting control, 5 UV filter, 6 Drawer for additional filters, 7 Condensers, 8 Negative masks, 9 Negative, 10 Negative carrier, 11 Filter, 12 Enlarger lens, 13 Focusing control.

Preparing to print

Turning now to the practical matters of making a colour enlargement, here is a checklist of necessary preparations.

1 Ensure that the darkroom is truly light-tight and that if a safelight is to be used then it, too, is really safe for the print materials (page 18).

2 Check that the enlarger lamp is working and that the filters move in and out of the light path as required, especially if a *white-light setting* is provided.

3 Test the enlarger timer with a couple of timed operations.

4 Make sure that the colour paper has had adequate time to warm up if it has recently been removed from refrigerated storage. Check also that it is the type and batch number required for printing if two or three varieties are stocked.

5 If necessary, clean all the optical surfaces in the

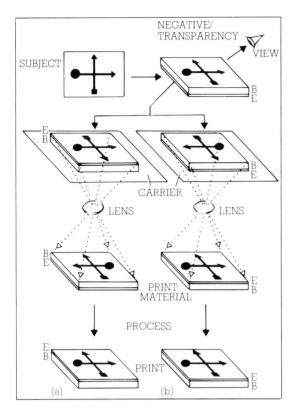

NEGATIVE/
TRANSPARENCY
VIEW
SUBJECT
B
E
E
B
B
E
CARRIER
LENS LENS
B
E
E
B
PRINT
MATERIAL
PROCESS
E
B
PRINT
E
B
(a) (b)

9.5 Correct orientation of negative or transparency in enlarger. **A** For Ektaflex PCT and Agfachrome

Speed materials. **B** Conventional for chromogenic and SDB materials.

able masks.

4 Open the lens to full aperture and set all colour filtration to zero. This gives a bright image for ease of focusing. Compose the image within the masking frame and set the focus. Remember that moving the enlarger head changes image size *and* focus together but the lens focus control alters only the image sharpness. Let us assume that you are making a 20.3 x 25.4cm (8 x 10in) print and that your masking frame permits you to expose four separate areas or 'quadrants' of 10.2 x 12.7cm (4 x 5in) for test purposes.

5 Set the enlarger lens to *f*/16 and keep the filter settings at zero. Remove a sheet of colour paper from its wrappings in total darkness. Check which side is the emulsion. This may be done by touching (remember however, the danger of finger marks) or by testing with the tongue in one corner – the emulsion side is stickier.

6 Put the paper in the masking frame with the emulsion side upwards and make sure that the paper is correctly aligned in the frame. Uncover

one 'quadrant' and expose for 3 sec. Cover it again, switch on the enlarger and move the second quadrant of paper behind the protective flaps of the masking frame to the same region as quadrant one. Reset the timer, uncover the quadrant and expose for 6 sec.

7 Repeat for quadrants three and four, giving exposures of 12 and 24 sec respectively. Remove the sheet of exposed paper and put it in a light-tight storage box or directly into a processing drum if this is to be used. The four exposure times of 3, 6, 12 and 24 sec can be given by covering up the static masking frame in stages with a piece of black card. After a 3 sec exposure to the whole area, give a further 3 then 6 then 12 sec to each smaller area exposed.

8 Repeat the procedure above with a second sheet of colour paper, but this time dial in a respresentative filter pack of say 80 yellow plus 40 magenta (80Y + 40M).

9 Note carefully all the negative and exposure details using a suitable colour printing data sheet.

10 Process the exposed sheets of paper, as detailed in Chapter 10, and examine the results carefully – this reveals much information.

Assessing the first results

The two prints made as described will, in general, appear very different. The first, *exposed without colour filters*, should have a strong orange colour bias, and the four images should give progressively darker pictures with increased exposure. Hopefully, one picture, even if orange, will look of the correct density. Let us assume that the exposure for this particular print was 12 sec. This gives an idea of the exposure level needed for this particular combination of enlarger, lens aperture, negative density, magnification and paper batch characteristics. The orange colour balance is due to an imbalance of exposure levels to the different layers in the paper. The blue sensitive layer is relatively overexposed, giving excessive yellow image dye. So, too, is the green sensitive layer, giving an excess of magenta dye. The combined effects of these results is an orange cast overall. This is shown schematically in fig 9.6.

The second colour print should have a much improved colour balance. Indeed, it could be near 'correct', depending on circumstances. The action of the 80Y filter value is to reduce exposure to the blue sensitive layer, so reducing the yellow dye deposit. Likewise, 40M reduces magenta density in the print. So the orange colour is

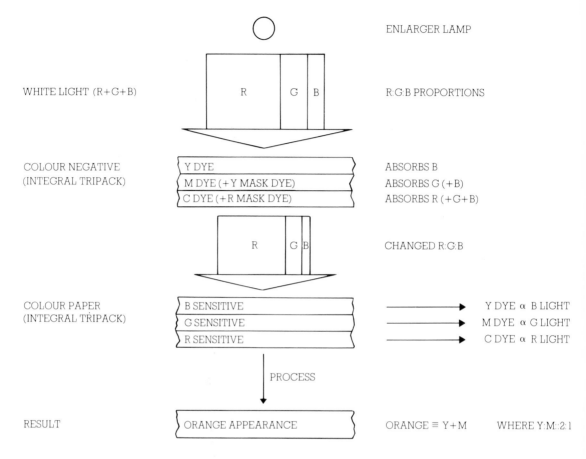

WHITE LIGHT COLOUR PRINTING *WITHOUT* FILTERS

9.6 White light colour printing *without* filters.

lessened or even corrected (fig 9.7). Note also that the four quadrants still show progressive increases in density with exposure time, but as the filters added remove light by virtue of their *filter factor*, the 12 sec exposure is not now correct, but too short. The 24 sec exposure may be more appropriate.

An exposure correction is usually necessary when filter value settings are altered to improve or change colour balance. Details of typical filter factors are given in Table 9.8.

If not quite correct, the second colour test print may be further assessed and adjustments made to the filter pack until a final ideal print is achieved by trial and error.

Colour print evaluation routines

There is no precise method of achieving a good colour print automatically but a few guidelines

may be helpful.

First of all, do not evaluate for colour balance on a test print that is too dark or too light. Adjust the exposure level until density appears satisfactory, even if the colour balance is not, and then make judgements. A print that is too dark is improved by reducing the exposure time given, and vice versa. In fact, there is only about a plus or minus 15 per cent latitude in exposure time from the optimum value.

Colour balance may be judged in three principal ways: by *guesswork* plus experience and a knowledge of colours, by using *print viewing filters* or by reference to a *ring-around* set of specimen colour prints.

The first method improves with experience and constant practice – the strength of a colour cast may be correctly assessed and the appropriate filter correction applied. It may be helpful

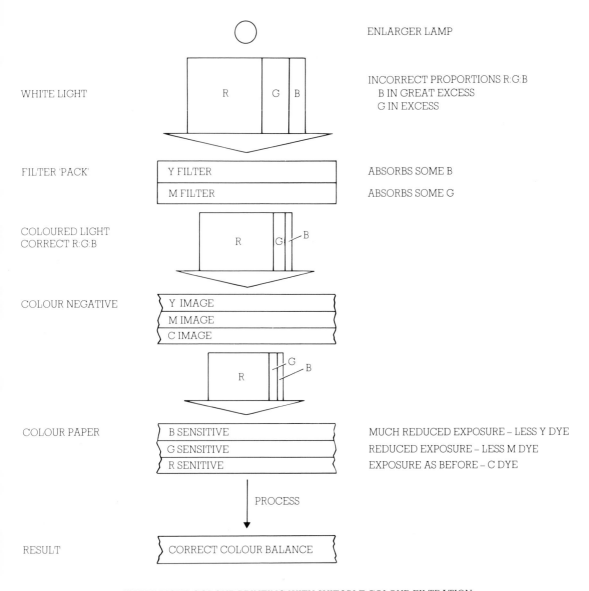

WHITE LIGHT COLOUR PRINTING WITH SUITABLE COLOUR FILTRATION

9.7 White light colour printing with suitable colour filtration.

for the beginner to try a few such guesses at first and then see the results. But a more systematic approach saves time, temper and paper.

Viewing filters are sets of pale filters, usually yellow, magenta and cyan. The technique with these is to make up a filter pack to hold close to the eye when viewing the test print, so that it then appears improved or even correct in colour balance (fig 9.9). To avoid the natural adaptation effect of the eye, the filter pack should only be used for a few seconds at a time. The suggested

correction is then one-half of the filter pack density, and complementary in colour, added to the filter pack in the enlarger used for the test print. For example, if the print appears magenta and this is confirmed by viewing filters of 40Y + 40C (which equals 40 Green) then the filtration in the enlarger is altered by adding 20 magenta to the values used. Some people find that viewing filters are useful just for evaluating residual colour casts, requiring corrections of 5 or less.

The third method works by direct comparison

9.8 Exposure corrections for filter changes

Filter value change	Yellow	Magenta	Cyan
00	1.00	1.00	1.00
05	1.01	1.05	1.03
10	1.02	1.10	1.06
15	1.03	1.15	1.09
20	1.04	1.20	1.12
25	1.05	1.25	1.15
30	1.06	1.30	1.18
35	1.07	1.35	1.21
40	1.08	1.40	1.24
45	1.09	1.45	1.27
50	1.10	1.50	1.30

When using a dichroic filter colour head, the necessary corrections to exposure time due to filter changes for improved or altered colour balance may be estimated from the table below. The method is to multiply the original exposure time by the factor(s) for the filter change(s) added to the original filter pack and divided by the factor(s) for any subtraction(s) to give the new or corrected exposure time.

$$\frac{\text{New}}{\text{exposure}} = \frac{\text{Old}}{\text{exposure}} \times \frac{\text{Factor for filter value added}}{\text{Factor for filter value subtracted}}$$
$$\text{time} \qquad \text{time}$$

For example: 10 sec with 80Y + 40M

Filters changed to 100Y + 20M ie, +20Y −20M

$$\text{New exposure time} = 10 \times \frac{1.04}{1.20} = 8.7 \text{ seconds}$$

9.9 Colour print evaluation by means of viewing filters. The test print P is viewed under light source L and viewing filters F held before the eyes E.

– the test print is compared with an array of prints of known incorrect colour balance (fig 9.10). If the test print has a distinctly 'cold' appearance and you are unsure whether this is due to blue or cyan or even a mixture of the two, comparing it with prints of known blue or cyan bias will settle the question and even indicate the amount of imbalance. A 'ring-around' set of colour prints in reproduced form will help for the first trials at colour printing, but it is much more useful to make your own set with your own printing conditions. Details of how to do this are given later.

Corrective filtration and the ideal print

By reference to ring-around sets, a laboratory-made print and the table of colour change effects for filter changes – and a process of trial and error – a good print will finally be achieved from your chosen negative. By now you should have a good idea of the routines of colour printing, be able to remember to do everything in a logical order, keep notes and establish your own working procedures.

It is assumed here that the processing of each colour print is an established routine too, and that unexpected colour changes do not occur because of variations there!

The *ideal print* you have now made may represent many hours of work and frustration. But besides familiarising you with the mechanics of colour printing, it gives you a quantity of data from which you may produce a ring-around set of colour prints for evaluation purposes, or set up and use a *colour negative analyser* for more automated colour printing.

This information includes details of the colour negative material and the lighting used for the photograph; enlarger details such as filters, lens, magnification and exposure time; print material information such as batch properties and finally processing information.

One of the skills of successful colour printing is keeping as many variables as possible under control, or at known values. Ideally, for different negatives, only magnification and the filter pack would be altered, requiring changes in exposure conditions.

It will soon be found that if you take similar subjects using the same colour negative material, exposed and processed according to the maker's instructions, then the filter pack for subsequent colour prints will not vary greatly for your enlarger. You will soon see by looking at your records of filter packs used successfully, that there is a mean value that can be used as the *starting filter pack* for printing unknown or previously unprinted negatives by trial and error.

Note that Kodak, Agfa, Durst, Beseler, De Vere and other manufacturers' filter value numbers do *not*, in general, correspond with one another in their effects on the print (fig 9.9).

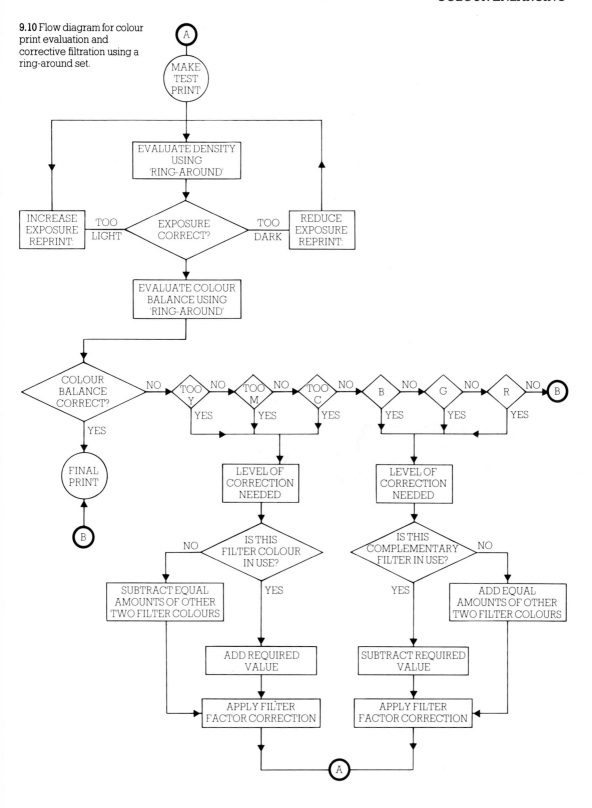

9.10 Flow diagram for colour print evaluation and corrective filtration using a ring-around set.

AGFA	20	40	60	80	100	120	140	160	180	200

DURST	10	20	30	40	50	60	70	80	90	100

KODAK	10	20	30	40	50	60	70	80	90	100	110	120	130

9.11 Approximate colour filter equivalents.

9.12 Colour printing data sheet.

Factors affecting print exposure

As already mentioned, the exposure latitude of colour paper is small, and print exposure must be correct for optimum colour reproduction. There is no possibility of manipulation in processing to allow for exposure errors, as there is in mono-chrome printing. The most common factor affecting accurate print exposure arises from changing the filter pack. Colour filters absorb light so that increasing the value of the *filter number* or density needs correspondingly more exposure to compensate. The exact filter factor depends both on the colour of the filter and its assigned value. Yellow filters have the lowest factors, magenta the next higher and cyan has the highest. This variation is related to the relative amounts of their primaries in the light from the enlarger lamp. Note that altering the yellow filter value over a range of 50 requires an alteration of only 10 per cent in exposure, which is within the exposure latitude of the paper. So for most small changes this filter factor may conveniently be ignored.

A change in magnification or degree of enlargement to improve composition or to give a larger print also requires an exposure adjustment. This calls for a further test print to evaluate, or use of the enlargement formula (page 21) or a printing exposure meter or analyser.

For small changes in exposure it is convenient to alter the original exposure times, but always think of changes in terms of percentages of those values. For large changes in exposure, where adjustment may be by 50 per cent or more, it is better to alter the lens diaphragm setting, remembering that a one stop change represents double or half the exposure. A fairly standard exposure time of, say, 20 sec allows for printing manipulations such as local exposure control. Yet it is not an inconveniently long time if many prints are to be

made. It also suits the colour balance conditions for the paper.

The three different types of emulsion in colour paper unfortunately respond differently to the length of exposures. This can cause unpredictable colour changes, loosely termed *reciprocity law failure effects* (RLF). This can be clearly seen by say, making a print requiring a 10 sec exposure and then stopping down the iris until a 100 sec exposure is needed. This usually gives a different colour balance and density. Likewise for a print needing a one sec exposure. Here again, it is best to open up the iris. To avoid RLF changes, do not make large alterations to moderate exposure times.

Finally, a change of enlarger lamp may require correction to print exposures as the new lamp will have different characteristics initially, even with tungsten halogen lamps. Another minor factor is a change of the batch of printing paper; the sensitivity of the new batch may differ significantly from the previous one. For details, see Chapter 6.

Printing records

It is vital to keep systematic records of all your colour printing. A suggested layout for a *record form* is given here and this may be copied out as needed and photocopied as required (Table 9.4). By recording results for each test, and its corrective measures, it is possible to accumulate experience quite rapidly. It is also possible to go back and trace possible errors, or even faults in the enlarger or processing. When a negative has to be reprinted, some starting data can save a great deal of time and printing paper, even if a new batch is to be used.

COLOUR PRINTING DATA SHEET

date................. negative/transparency reference number.................

subject matter...

film used.................. format size............. filter(s)...............

illuminant used......................... processing.........................

additional data...

enlarger............ type of filters............. lens used..................

colour print material.................. size.......... batch number...........

filter adjustment code, speed and other data from box.....................

processing chemistry code.................. processing equipment..............

temperature............ replenishment............. age........................

colour analyser.................. reference area....... type of reading........

program reference numbers...

other data...

test number	magnification or neg-to-easel distance	exposure time	aperture	filter pack			light intensity setting	result
				yellow	magenta	cyan		

Viewing colour prints

A colour print as viewed in the hand is a colour reproduction of the original scene or subject. As such, its *colour appearance* is significantly affected by a number of factors which can make the viewing and assessment of colour prints quite a critical operation. The major factors are: the illuminant, the surround, the vision of the observer and the print itself (fig 9.10). It may never have occurred to you that a colour print changes its colour balance as the viewing light is altered. This is easily demonstrated by viewing one in artificial light and then in daylight. However, colour adaptation of the eye soon may cause the print to be deemed acceptable in both circumstances. This problem of a shift in colour balance with illuminant cannot be solved completely but standardised light sources have been specified for purposes such as colour evaluation and colour matching. For example, British Standard BS 950 (1967) Part 2 suggests a colour temperature of 5000 K for the illuminant as well as the lighting level and colour of surround. A fluorescent tube such as the Philips Graphika 47 is a suitable if expensive light source.

For the average amateur colour printer, viewing test and final prints with the same light source is sensible and so is choosing the source by which the print will usually be viewed – so the choice may be tungsten lighting.

A second factor is the surround to the print. The colour, the relative sizes and brightnesses of print and surround can all affect the *apparent* colour balance and density of a colour print. There is no physical change just a complex series of interactions in the eye and brain which interprets what is seen. These are generally termed *simultaneous colour contrast* effects. To demonstrate this, place two identical prints on two different coloured pieces of paper and look at both together. Quite dramatic differences in the prints may be visible. The effect works even with black-and-white backgrounds. In fact, a neutral mid-grey background tone is best for print evaluation, as it will have little influence on the appearance and density of colours. A large sheet of grey card, such as a photogaphic mount, is quite suitable.

Finally, colour vision varies from person to person and a significant number of the population (some eight per cent – mainly males) have defective colour vision, often incorrectly called *colour blindness*. This usually has more to do with confusing, or failing to discriminate between colours rather than not being able to see a colour at all.

9.13 Variables influencing colour appearance for colour print evaluation.

The commonest conditions are confusion between red and green, called *deuteranopia*, and much reduced discrimination of red, called *protanopia*. Usually, such people become aware of these conditions through colour vision tests made at school and elsewhere. Colour defectives can learn to colour print correctly as they match a print to their perception of the subject. Disagreement may arise when discussing colour balance with another person. However, even people with normal colour vision cannot always agree with someone else on a 'correct' colour balance as there is the factor of *colour preference*, especially where a person prefers a 'cool' or a 'warm' balance to a colour print, neither of which may be strictly correct.

Making ring-around prints

Without doubt, one of the most useful aids in colour printing is a ring-around set of prints. This matrix, or array of prints varies in a known way and degree from a print with an 'ideal' or 'perfect' colour balance (fig 9.11). Such a set allows prints to be evaluated by direct comparison and shows the effect of specific changes in filter value, and interpolation between values (fig 9.12). Producing a set for the first time is most instructive. The procedure is normally as follows:

1 Select a representative negative, or a specially made *master negative*, that gives a good print.
2 By trial and error, produce the best possible print from it in terms of colour balance and density and take this as the *ideal print*. Note the filter pack and exposure details carefully.
3 Take this filter pack and add or subtract filter

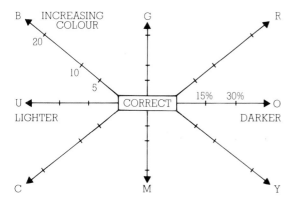

9.14 Structure of a ring-around print array for colour print assessment.

values singly or in pairs to produce results which have colour casts in the three primary colours blue, green and red and in the three complementary colours yellow, magenta and cyan. This can usually be done by changing only the yellow and magenta filters (see fig 9.13). It is sufficient to pro-

9.15 Sample ring-around print calculations.

duce changes equivalent to filtrations of 10 and 20, but 5 could be useful as well if your particular enlarger produces a marked change in colour balance with so little alteration. Values of 15 or more than 20 can be estimated from the arrary.

4 Calculate the necessary exposure changes to allow for the different filter factors of the altered filter packs.

5 Now, keeping the filter pack as for the ideal print, vary only the exposure time in increments of + and − 15 and 30 per cent and make this set of prints to add to the array to demonstrate the effect of incorrect exposure.

6 Expose and process the whole set of prints in a single printing and processing session, endeavouring to keep the processing conditions standardised.

7 Carefully identify each print with its filter variation, exposure change and colour balance. A test print which resembles one in this ring-around can usually be corrected by applying a filter change in the reverse direction to remove the unwanted colour cast. For example, if a test print matches the ring-around print which has a 10 cyan imbalance (ie the filter change from the ideal was 10

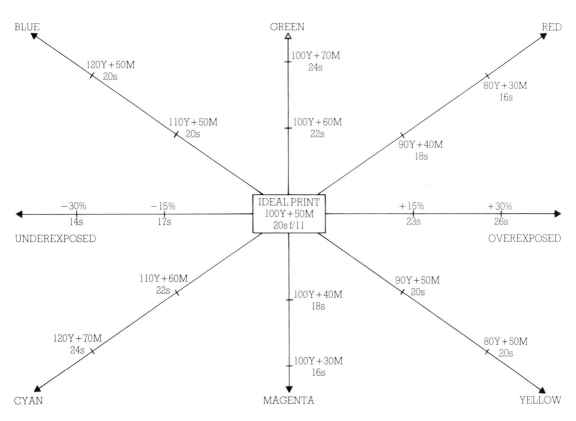

in both yellow and magenta, and gave a cyan print) then to correct the test print subtract a 10 yellow and a 10 magenta from its filter pack. An example is shown in the figure.

By the nature of things, a print viewed in isolation may be judged as correct and used as the ideal print or origin of a ring-around set. But when the completed array is viewed, one of the deliberately 'incorrect' prints may seem better than the ideal one! So you may have to repeat and recalculate the array on this basis.

Using a colour negative analyser

If you have a systematic approach, and a view to saving time and money, a colour negative analyser is recommended. The detailed functions and operation of this instrument are explained in Chapter 4. Do not use an analyser until you have gained some experience by trial-and-error methods and have attempted to produce a ring-around set of prints. This procedure is essential for setting up an analyser successfully.

Manipulating colour

Once you have understood and mastered the basic techniques of colour printing you can explore the possibilities for manipulating colour, whether to adjust colour balance of prints to suit your taste or to produce abstractions from images other than conventional colour negatives.

A detailed discussion of such techniques is not possible here but they have been thoroughly explained in the companion volume *Colour Printing in Practice.*

Printing from colour slides

The production of a colour print from a colour slide or a colour transparency is generally termed 'positive-positive' or 'pos-pos' colour printing. This refers to cases where the colour original (the colour slide) in the enlarger has correct tone and colour rendering, producing in a single step a print that is a reasonable facsimile.

Colour print material of quite different structural composition and processing is required (Chapter 6). If a colour slide is printed on to conventional neg-pos paper as described earlier in this chapter, the result will be a high contrast print but with the tones reversed and colours in complementary hues. (This is however, a printing trick with some creative potential.)

There are at present three different types of

material for pos-pos printing as described in detail in Chapter 6, each producing colour dye images either by chromogenic development, dye destruction (silver dye bleach) or by dye diffusion (self-developing or diffusion transfer reversal). While these differ enormously in their structure and processing, exposure and print assessment take place in a virtually identical way. So pos-pos printing can be discussed in general terms, noting a few crucial differences.

The apparatus required and the initial check procedures previously described all apply to pos-pos printing with one important exception. No safelight is used, all handling is in total darkness. The same processing apparatus can be used for the chromogenic development and dye destruction processes. Kodak Ektaflex materials require a special machine for lamination but Agfachrome materials can be processed in a simple developing dish.

The colour slide is put into the enlarger carrier. Here there are possible snags, for the carrier may not be able to hold a mounted slide or close correctly. So you may have to remove the transparency from its mount. This is a good idea anyway, especially with glazed mounts as there are four additional surfaces which may be dusty, producing black spots on prints which are difficult to remove or retouch out. The transparency should be carefully dusted and cleaned as necessary. Card-mounts are usually destroyed in order to get at the slide. Uncut transparencies in a strip are the easiest to deal with.

The orientation of the transparency in the carrier depends on the printing material being used (fig 9.3). For chromogenic and dye-destruction materials such as Ektachrome paper and Cibachrome respectively, the conventional orientation is used with the *emulsion side down*, that is, the dull side towards the lens or baseboard. The projected image is seen correctly orientated on the baseboard.

For printing on to dye diffusion materials such as Kodak Ektaflex PCT or Agfachrome Speed, the transparency must be inserted with the *emulsion side up*, so that the projected image is seen laterally reversed on the baseboard. Ektaflex has a lamination and image transfer stage which gives another lateral reversal to correct the final image in the print. Agfachrome Speed is exposed through its rear surface and the final images are seen correctly orientated when viewed from the front.

Exposure of reversal materials

The first test print may be made without any colour filtration, using an aperture of, say, *f*/16 and giving a four-step exposure time series of, say, 3, 6, 12 and 24 sec. Alternatively, the suggested starting filter pack for the material may be used. This data is supplied with each pack of material and is just a guide. Note that the suggestions will vary depending on the type of colour film used in the camera to make the colour transparency, so Kodachrome will need a different filter pack from, say, Agfachrome or Fujichrome. The suggested filter pack is usually of small filter values, and typically with Y + C or M + C rather than the Y + M combinations recommended for neg-pos printing.

After processing you will immediately notice several things. An unexposed region such as the border of the test print (protected by the blades of the masking frame) records not as white but as a high density black. The considerably greater exposure latitude of these materials is evident from the fact that one of the differently timed test exposures will probably be correct or very nearly so, while those adjacent to it, with double or half the exposure will not be seriously over- or underexposed. This feature is due to the inherently low contrast of a material which is designed to record the long tonal scale of a transparency. There will also be some disappointment at the much more muted colours in the print compared with those in the transparency. This is a consequence of reproduction by dyes on a paper base viewed by reflected light.

The corrective actions for colour balance and print density are quite different to those for neg-pos printing (see accompanying table) so any hard won experience in that area must be disregarded for the moment. Because these are reversal materials, an *increase* or a *decrease* in exposure level or time will result in a *lighter* or *darker* print respectively. So if your first test print shows an image that is still too dark, then exposure time for the next test print should be *increased* still further. Quite large changes in exposure level (of the order of 50 per cent) should be used initially, bearing in mind the great exposure latitude of the material.

To adjust colour balance, a much more logical and simple change is made to the filtration, compared with neg-pos routines. If the test print is too yellow, then yellow filtration (if present in the pack used) should be reduced. If there is no yellow filtration or an inadequate amount, then blue filtration may be added to cancel the yellow cast.

This is done by adding magenta and cyan filters to the pack in equal amounts.

For example, if a test print with filtration 50Y + 20C was to be corrected by the removal of 30Y, then the new filtration would be 20Y + 20C. But if the filtration had been say 10M + 10C then an equivalent to the removal of 30Y is the addition of 30M + 30C (equivalent to 30 Blue) giving a new filtration of 40M + 50C. Similarly, for an initial filtration of 10Y + 20C, a 30Y equivalent correction would result in 20M + 40C.

Once again, compared with neg-pos printing, filter changes need to be somewhat greater to produce noticeable colour shifts.

It would be a useful exercise to produce a ring-around set of colour prints for the pos-pos materials you are working with, and a very helpful visual aid for subsequent printing.

One great advantage of pos-pos colour printing compared with neg-pos systems is that the accuracy and acceptability of the colour print can always be determined by direct comparison with the colour slide. Colour reproduction can, in some instances, actually be improved by using the printing filters to remove an overall colour cast that was present in the original slide. So that a slide with an overall green appearance due, say to exposure to fluorescent lighting, may be successfully corrected by additional magenta filtration at the printing stage.

10 PROCESSING COLOUR PRINTS

The dyes in colour print material are formed in their appropriate layers according to the colour sensitivity of those layers and the exposure they receive. Their density of strength is either *proportional* or *inversely proportional* to exposure (Chapters 6 and 9, and fig 10.1). Various means are used to form the dye images, depending on the material. But all have in common a number of stages of chemical processing involving chemical baths and water washes. The functions of the main processing solutions are as follows:

Chemistry of colour processing

First Developer: this is a near-conventional form of high energy print developer which produces a silver image only. It is used as the first stage in some colour reversal processes for pos-pos printing. It may contain small but critical quantities of compounds to give clean highlights or act as catalysts for subsequent bleaching. Processing conditions are critical and must be adhered to carefully.

Colour Developer: This is a high energy developer that is highly alkaline and uses a special developing agent. It produces a conventional silver image with a reversal of tones but in addition the oxidised colour developing agent reacts with suitable colour couplers dispersed in each emulsion layer to form the appropriate image dyes in situ. A heavy deposit of silver produces, in turn, a dense dye image associated with it.

Exposed silver halide (latent image)	+ Colour developing agent (in developer)	→ Metallic silver (image)	+ Oxidised developing agent (in solution)
Oxidised developing agent (in solution)	+ Colour coupler (in emulsion)	→ Image dye (in emulsion)	

For this *chromogenic* process to take place, the developer is highly alkaline, but only contains a minimum of preservative which would otherwise react with the oxidised developing agent to prevent dye formation. Consequently, the colour developer has a limited life in a dish or tank without protection from aerial oxidation which reduces the activity of the developer.

For *negative* working materials, both negative silver and negative dye images are produced from the latent image given by exposure in printing.

For *positive* working materials, positive silver and positive dye images are produced from the residual silver halides left after the first development. There is no fixation stage, and either fogging to light or chemical fogging must be used for colour development to be possible.

To remove the superfluous silver images from colour development and leave only transparent dye images, the silver is bleached out at a later stage. This can be a one-or two-stage process:

Bleach: This traditional solution containing potassium ferricyanide and potassium bromide converts a black metallic silver image back into pale yellow silver bromide. The loss of visual contrast gives rise to the term 'bleach'. It is really a *rehalogenising* process. After washing, the silver bromide may be removed completely by fixing with sodium thiosulphate, as in conventional monochrome materials.

Fixer: This converts silver bromide into water-soluble compounds. Usually, a rapid fixer is used. Note that the two-solution bleach and fixer baths form the traditional *Farmer's Reducer.* They cannot be combined in one solution in this form as they would rapidly react with each other and render the solution useless.

Bleach-fix or Blix: This is a reformulated combination of bleach and fixing actions in one solution designed to facilitate processing and reduce the number of solutions required. It is normally opaque red and employs a complex organic iron salt. It is also very expensive and is highly active and corrosive.

Another of its roles is as stop bath following development.

Stabilizer: this is occasionally used as a final solution to acidify the print emulsion and thereby improve long-term dye stability. It may also contain formaldehyde to harden the emulsion and a wetting agent to promote drying.

Silver dye bleach: This is a solution unique to Cibachrome materials and has the property of bleaching the uniform dye layers of the material only in the presence of the negative silver images from the first development stage, aided by a catalyst – hence giving positive dye images. The

Full colour print

10.1 The individual dye layers forming the image in a colour print.

Yellow dye image

Magenta dye image

Cyan dye image

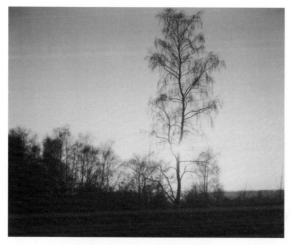

67 Subjects that do not have reference colours, such as this sunset, can be satisfactorily printed to a range of colour balances – the final choice is a personal one. This reproduction is from a reversal colour print.

68-70 These examples of colour posterisation were obtained from the same set of lith positives and negatives. A combination of artwork and photographs was used to obtain the original lith separations. (See text for procedure.)

71-75 These prints were all made by printing black-and-white negatives on to negative colour paper. 'Narrow-cut' filters were used to obtain strong colours, and were (in order): green (Wratten 58), cyan (44), red (25), yellow (12), and yellow again for the door. (See text for full details.)

76 Many combinations of derivative printing techniques are possible – each person should discover his own variations. This print was obtained by firstly making a sabattier positive from the original black-and-white negative using lith film and then printing this 'positive' on to negative colour paper. The colour filter pack was set at 0Y 20M 0C.

77 The original from which this print was derived was a colour slide. The first step involved copying the 35mm slide on to slide film. This was then processed in the normal manner except that the room light was turned on for about one sec half-way through the first development. The resulting sabattiered slide was printed on to Cibachrome paper and the balance adjusted to give a neutral rendering of the cross

78 A fibre-based black-and white print was sepia toned to give this result. The chlorobromide print was first rehalogenated (rehalogenised) in a ferricyanide bleach until the image had almost disappeared, and this was followed by a short but efficient wash. Finally, the bleached image was placed in a sepia toner for about 3 min, washed, then dried.

79-82 The brown image is another example of sepia toning, but note how this bromide print differs from the chlorobromide print of the seagull. The green image was achieved by copper toning followed by immersion in a solution of ferric chloride. Copper toning, followed by yellow dye, produced the yellow print and the greenish print resulted from iron toning.

silver is also converted to silver bromide at the same time for later removal by conventional fixing.

Activator: A highly alkaline solution which contains no developing agent; it cannot act as a developing solution, as such. But it is used with various dye-release type materials to initiate the development of the latent images by the developing agents incorporated in the emulsion layers themselves. This action also serves to release or anchor dyes.

Replenisher and starter: Some solutions are sold in a modified form for replenishing an 'initial' bath that has been in use for a while. Often, in larger sizes of chemical kits *only* the replenisher-type solutions are supplied. These may be converted into the 'initial' solutions by adding small quantities of *starter* solution – a liquid containing chemicals to reduce the activity of the replenisher solution so as to make it suitable for initial use. In a system using replenishment, the quantity of replenisher required is far greater than the volumes of initial solution.

Chemical mixing

It is very important to prepare the processing solutions exactly according to the detailed instructions included with each package.

Most solutions now come as concentrates rather than as a number of separate packets of powdered chemicals. These concentrates are either diluted with water at between 20°C and 30°C to a final volume or, when more than one component is required to make up a solution, they are added in the correct order to water at a specified temperature, stirred until dissolved and then made up to a final volume. Some solutions are deeply coloured. To keep air out of the solution, excessive stirring is not advised. Give a final stir after making up to final volume to ensure a homogeneous solution.

Store in stoppered bottles, clearly labelled with the contents and the date the solution was made up. Avoid contamination by cleaning each utensil after use.

Substitute chemistry

It is sensible to start colour print processing with a kit of processing chemicals as made and specified by the manufacturer of the print material. However, alternative chemical kits are sold for most processes and may offer distinct price savings, fewer baths or even just a more convenient total volume of solutions. Whilst most of these substitute kits are quite satisfactory, it is sensible to conduct some comparison tests with the specified chemicals to convince yourself that replacement will give no problems.

Various chemical formulae exist for the solutions involved in colour paper processing, but few people these days wish to make up their own 'brews' for that purpose. In addition, some of the chemicals are costly and difficult to purchase.

Solution properties and capacities

Compared with black-and-white, many colour processing solutions, once made up to working strength, have a rather short shelf life, even when kept in full, sealed glass bottles. Partly used solutions which have been used to process materials have an even further reduced life. These comments apply particularly to colour developers.

Because of the costs involved, it is tempting to extract the maximum use out of colour chemicals. But print processing capacity may be exceeded all too easily, even allowing for the generous safety margin included in the manufacturer's instructions. This could result in processing faults.

Keep a note of the recommended storage lives, and processing capacities in terms of the approximate area of paper for each solution involved.

It is sometimes recommended that a solution, particularly costly bleach-fix, be retained (even from throw-away systems) for limited re-use in order to extract maximum processing capacity. However, many processing faults or poor results are traceable to the use of exhausted or stale solutions. Note also that some chemical kits are sold in versions that vary slightly according to the intended method of processing – ie, in a small tank with throw-away solutions or in a large tank with solution replenishment, or, again, in a large rotary discard machine. Slightly different processing times may be recommended too.

Basic processing stages

Irrespective of the large variety of materials, processing systems and kits of chemicals on sale, it is possible to list the basic processing stages and solutions required for the major types of print materials. These are given on page 130. Where appropriate, typical specific processing cycles are indicated in the accompanying tables for currently available materials.

Note the wide range of specified temperatures

for the various solutions and the tight or relaxed tolerances depending on how critical the particular stage may be. The processing times too, may be critical and usually include a 20 sec *draining time* before transfer of the material to the next solution or before the next solution is added to a sealed tank.

Negative working paper:

Colour developer	Colour developer
Bleach-fix	Bleach-fix
Wash	Cold water wash
Dry	Stabilizer
	Dry

The alternative procedures given depend on whether a warm or cold water washing stage is used.

Positive working paper (chromogenic)
First developer
(reversal stage)
Colour developer
Bleach-fix
Wash
Dry

The reversal stage may involve re-exposure to room light or use a chemical fogging agent in the colour developer to cut down on the number of stages and manipulations involved.

Positive working paper (silver dye bleach):
Developer
Silver dye bleach
Fixer
Wash
Dry

Positive working paper (dye release)
Activator
(wash)
Dry

Print processing using a drum

Most amateurs who do their own colour print processing use the cylindrical plastic processing drum. The simplest arrangement is a sealed drum which takes a single sheet of paper and is then rolled on a bench top for agitation when the processing solutions are introduced from the light-trapped funnel at one end (fig 10.2). Far more convenient is the use of a *motorised base* or a handle or motor to rotate the drum in a water bath to maintain temperatures. With this type of unit, the procedure would be as follows:

Before use, check that all the chemical containers are clean and dry with no traces of chemical contamination. Check the drum likewise and also that the end lid fits securely and that the internal paper holders are present and intact. Fill the water bath to the correct level, switch on the immersion heater and allow the bath to come up to temperature. The critical temperatures involved, especially for developers, are achieved by ensuring that all solutions are at the correct temperature, kept there in readiness and that the drum is preheated by the water bath outside and by *tempering water* inside, if necessary.

Alternatively, a 'drift-by' temperature control system may be used. If by testing with quantities of water put into the drum, it is found that chemicals are, say 1°C above the correct value when added and 1°C below when discarded, then the steady downward drift in temperature will, during the processing time, give an *average* temperature that is correct.

Another method that can be used if temperatures do tend to vary by a few degrees, is to use a published *nomograph* for development times adjusted upwards or downwards according to the

(a) (b) (c)

(d) (e) (f)

10.2 Developing colour prints using a drum.
A Loading paper in dark, **B** Presoak water, **C** Agitation using a motor base or by rolling, **D** Pour out presoak water, **E** First solution, **F** Removal of print after processing.

temperature variations. It is very important to calibrate or check upon your working methods in this way and ensure that you are capable of getting *repeatable results,* otherwise all else is pointless.

The drum should be carefully *levelled* with the aid of a spirit level set inside it when in its working position. If it is not correctly horizontal then processing faults could arise due to uneven coverage of the paper by the processing solutions. Chemicals are specified in minimal quantities to *just* give even coverage and so process the maximum number of prints per kit.

Be certain that your processing chemicals are correct for the printing material, especially if you do both neg-pos and pos-pos printing. Measure out the volumes required into individual beakers and put them in the water bath to bring them to the correct temperature. Sometimes it is possible to stand the chemical storage bottles themselves in the water bath provided for the processing drum.

Processing drums are available for paper sizes ranging from 20.3 x 25.4 cm to 50.8 x 61 cm (8 x 10 in to 20 x 24 in) and which take volumes of chemicals from about 50 to 350 ml. Next, check that your processing timer is operational and, if clockwork, that the spring is fully wound. Test that the drum revolves freely.

A visual check that all is in place, a final check on temperatures with the thermometer and all is ready for processing.

1 Make sure that your hands are clean and dry.
2 Switch out the room light. Make the exposure(s).
3 Remove the exposed paper from its masking frame after exposure or from its storage box and load the sheet(s) into the drum, emulsion side out, making sure it will not fall out of the paper retainers. Put on the end lid securely. Check that any other paper is all covered up and then switch the room light on again.
4 Put the drum in the water bath, add presoak water if required, start the agitation and continue for the presoak time.
5 Pour out the presoak water and drain the drum. Reset the timer to zero, pour in the first processing solution, start the timer and rotate the drum. Stop agitation with 20 sec remaining, drain the solution and add the next one, starting the timer again. Repeat this procedure until the processing and washing cycles are completed. Remove the paper print carefully and dry as recommended.
6 Clean the drum and its component parts

thoroughly, well away from the water bath if possible, and dry with paper towels or a clean, uncontaminated cloth. Allow to dry completely before starting the next processing run. A second, or even a third drum to use while this is taking place is a great help.
7 Check that there are no splashes or deposits of used chemicals on the equipment or bench.

These routines are used successfully for neg-pos prints and pos-pos materials, including Cibachrome.

Print processing using deep tanks
The tanks full of processing solutions are usually standing in a water jacket equipped with an immersion heater, thermostat and impeller to circulate the water. Before use, switch on the heater and allow the tanks to come up to temperature. Often such *tank lines* can be left on permanently with little ill effect.

1 Remove the tank lids and the floating lids on the solutions, stir the solutions to check that there are no foreign bodies and no precipitation which could indicate chemical breakdown. Add any quantities of replenisher necessary for the aging of the solutions or for the material processed in the previous processing run. The technique is to remove a volume of solution from the tank, add the calculated quantity of replenisher solution and then top up to the correct level using the solution removed, discarding any left over. The solution, when replenished, should be stirred gently.
2 Check the solution temperatures and the functioning of the process timer. Set it to zero.
3 Make sure the paper holders or hangers are clean and dry. Check also that the processing tanks are in the correct order, working either left to right or right to left depending on personal preference.
4 Load the paper into the holders in the dark (fig 10.4), locate the holder(s) above the developer tank, insert into the solution, start the timer and give the initial agitation, as recommended. This may mean about 15 sec of vigorous agitation followed by a 5 sec cycle every 30 sec for the remainder of the time. Before the end of the immersion time, remove the holders from the solution and allow them to drain for the time specified and then transfer them to the next tank in the sequence. Restart the timer if necessary. The room light may be switched on at a specified point in the processing sequence making the remainder

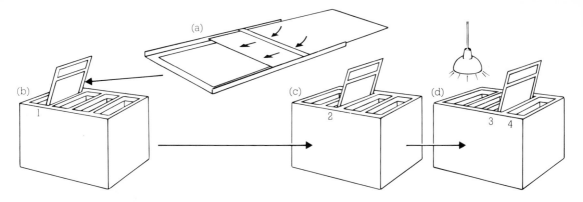

(a) (b) (c) (d)
1 2 3 4

of the processing run much easier. Usually this stage is reached when the print has been in the bleach-fix for about 30 sec.

5 Make sure that no stray drips or splashes cause chemical contamination. Preferably keep the tank lid on the developer solution at all times, except when actually in use.

6 After the final bath or wash, carefully remove the prints from the holders and dry as specified. Clean and dry the holders carefully, especially if they are of the channel design type.

7 Note the amount of paper processed (in the log book for the solutions) and add replenishers to the tanks if another run is to be made.

8 Check the solution temperatures at intervals also. Occasional filtering of the solutions using a filter funnel and a piece of good quality cotton wool will remove suspended matter. Throw away the cotton wool after filtration, do not squeeze it out into the solution, as is often done in error!

All forms of print material other than Kodak Ektaflex PCT materials which require a lamination stage, can be successfully processed in this way using tank lines. Several prints may be processed together with identical treatment and time saving compared with using a drum processor.

Using a roller transport processor
Small processing machines, such as those marketed by Durst and other manufacturers, may be used for processing prints on an almost continuous basis.

The procedures are even simpler than those described above.

1 Ensure that the machine is correctly levelled on the bench top and that the soft rollers used to transport the paper are all functioning. Fill the machine compartments or tanks with the correct volumes of the necessary processing chemicals in the correct sequence. Usually only two will be re-

10.3 Developing colour prints in a tank line. **A** Loading paper in holder, **B** develop in tank 1, **C** Stop bath in tank 2, **D** Bleach-fix in tank 3. Lights may go on. Wash stage is in tank 4.

10.4 An Ektaflex processing machine provides the correct sequence of coating and lamination automatically without need for temperature control or replenishment.

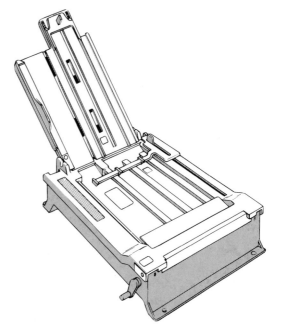

quired, being colour developer and bleach-fix only. These chemicals are not replenished, but used to capacity by processing a maximum number of sheets of paper. Then the exhausted chemicals are thrown away and fresh ones put in the machine. So,. if previously used, check your processing log to see how many more sheets of paper can be processed before the chemicals are dumped or discarded.

2 Switch on the machine, which normally incorporates its own heating system, and after a suitable time, check that the solution temperatures are correct and stable. The initial processing of an old

EXPOSE

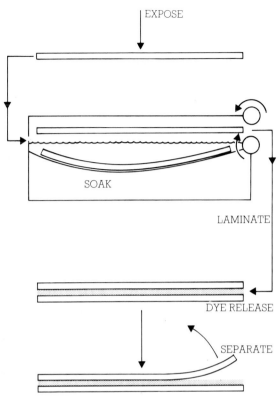

SOAK

LAMINATE

DYE RELEASE

SEPARATE

10.5 Processing of Ektaflex PCT materials.

machine and almost certainly both prints would be unusable.

5 Note the starting time of processing and check that the print emerges from the other end of the machine after the known process time, typically, 10-12 min. If not, expect trouble and take the top off the machine to look in the tanks or between the rollers for your missing print! The print will emerge still wet and may even need washing in a separate dish with water at a suitable temperature before the final drying stage.

6 Finally, note in the processing log book the paper size and the number of sheets processed.

Processing faults

Occasionally a print may not appear right, even though there has been no obviously incorrect filtration at the printing stage. This may be due to processing problems or faults. Often particles become embedded in the print surface, indicating that a water supply filter is required or that any replenished solutions need filtering or replacing. Another cause is the state of the rollers in a roller transport processing machine.

White spots or lines on the print result from dust or hairs on the negative. Alternatively for pos-pos prints the same causes give black lines or spots.

The sensitivity of materials to marking due to fingertip contact has already been mentioned.

Accidental fogging of the paper prior to processing usually shows itself as reddish-orange streaks on neg-pos paper and as light streaks on pos-pos paper. When correctly processed, neg-pos paper will have a clean white border without stain or colorations. This border white can be compared with the white base of the paper on the reverse side. It will not be as pure a white, even for a faultlessly processed print, but should still be acceptable.

A cyan stain on the whites is a sure sign of developer contamination, usually by residual stabilizer or bleach fix in a processing drum.

A magenta stain may be due to inadequate washing or to using wash water at too high a temperature.

If the border is a dull grey the paper may be old, stale or have been stored incorrectly. Another cause, especially if a pink tinge is visible, is old or exhausted chemicals.

Occasionally, a weak acetic acid stop bath used between the colour developer and bleach-fix stages plus a short water rinse will remove slight persistent chemical staining.

sheet of paper or of stale paper is sometimes helpful as this will give a positive check of the functioning of the machine and also serve to remove any deposits or particles on the rollers which could embed themselves in the emulsion of subsequent prints and mar the results. Such sheets of paper are usually called *clean-up sheets*.

3 When all is ready, switch out the room light, remove the exposed material from the masking frame after exposure or from its light-tight storage and insert the first sheet of paper into the entry slot of the machine with its emulsion side down. Make sure that the transport rollers have gripped the leading edge of the sheet and are transporting the paper correctly. Make sure that you know the minimum size sheet of paper that can be safely processed without getting lost in the machine. (This can happen if the sheet is not gripped properly by the rollers when being transferred from one bath to the next.) Put the light-tight cover back on to the paper feed box.

4 If more than one sheet of paper is to be processed, allow a time interval of say 30 sec before inserting the next sheet, otherwise two successive sheets of paper may overlap in the machine and may jam. This could possibly damage the

11 BEYOND THE 'STRAIGHT' PRINT

The printing stage offers the opportunity to change the 'straight' print into something unique. There are a number of techniques which will enable you to do this; some may take a matter of hours to achieve their effect, while others need several days of careful work including several different production stages before the final print is made.

These techniques will be discussed one at a time in this chapter, giving the procedure for black-and-white first, and then colour for each. However, they may be intermixed and used together as much as you like. As you become familiar with them so your confidence will grow.

The results of some techniques are more predictable than others, so remember to make detailed notes as you go along. There is nothing more frustrating than producing an outstanding piece of work that can never be repeated because the happy accident that made it possible was not methodically recorded.

Misprinting the black-and-white negative

Elsewhere in this book we have discussed the superb effects to be gained from carefully printing to reproduce a subject in a full range of tones. We will now consider producing equally stunning results by doing just the opposite – eliminating much of the tonal scale to emphasise the subject's form and content.

Of course, it is possible to produce an image distorted in this way by making appropriate camera exposure and film development adjustments while you are actually photographing the scene. But, generally speaking, most of your ideas for altering the image will start to come as you study the contact prints. Also, recording the whole tonal range of the scene gives you so much more scope; this book will teach you techniques for eliminating subject tone and detail. *Adding* these qualities by retouching is, however, a highly skilled and specialised retouching art.

The simplest method of distorting tonal scale is to over- or underprint the negative. Look at the contact sheet or a 'straight' print and consider whether eliminating the shadow or highlight details would improve the image.

Overprinting the negative (fig 11.1) means that the darker areas of the scene become more intense until they reach maximum black and, depending on how much you overprint, some darker mid-tones may also appear black. To ensure that you obtain clean whites on your overexposed print, use a higher contrast paper, ie grades 3, 4 or 5, as overprinting means you are only using part of the available negative density range.

Suitable subjects for this technique include

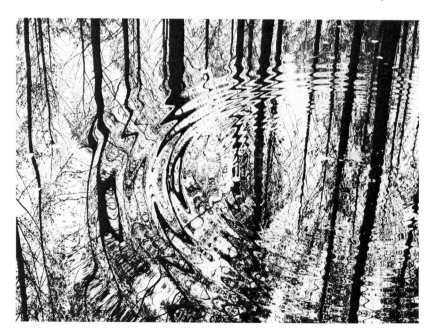

83 High contrast prints generally produce 'graphic' images and can be obtained by photographing high contrast subjects, increasing film development, or printing on high paper grades – often a combination of these is used. In this example, a normal contrast negative was printed on grade 5 paper.

dazzling highlights on water and the effects of bright sunlight as well as any backlit scene where the highlights could be emphasised to good effect. The final print will often appear as if the photograph was taken at dusk, or even at night.

The reverse technique is *underprinting* (fig 11.1), which lightens the overall tone of the print, burning out the highlights and producing grey rather than black shadows. Again, print on higher contrast grades of paper. Underprinting is most suitable for soft and delicate images, for example a portrait of a mother and newborn baby.

High contrast prints

Tone elimination, or the removal of all or most mid-tones from a scene, produces a stark, truly black-and-white effect, which is very suitable for posters and other graphic work which needs to be arresting. The technique is as follows:

1 Enlarge the negative image on to high contrast film (usually 'lith' film). This gives a fairly high contrast positive image.
2 Project this image on to lith film, to create a high contrast negative.
3 Print this negative on to paper.

At step 1, enlarge the original continuous tone negative up to the maximum your enlarger will allow, for example, 35mm up to about 6 x 4cm (2¼ x 1½in) if you have a 6 x 6cm (2¼ x 2¼in) format enlarger. The ideal enlarger for this type of work is 12.7 x 10.2cm (5 x 4in) format. But if yours only takes the 35mm format, it is still better to use it to produce a same-size positive rather than by contact printing, as by using the latter method you will almost certainly get dust marks on the positive. Step 1 is also the time to crop and adjust local densities, although such a small enlargement would make burning-in or dodging difficult. The printing exposure for step 1 must be controlled in the same way as when printing on paper if the positive is to retain sufficient image detail.

Step 2 gives you a same-size, high contrast negative and, again, project this rather than contact print. Ensure accurate exposure by making test strips.

All contrast grades of paper give similar results when printing high contrast negatives; work out the necessary exposure by the length of time needed to produce maximum black. If you overexpose too much the image will 'bleed', causing the edges to blur, but a slight overexposure does no harm.

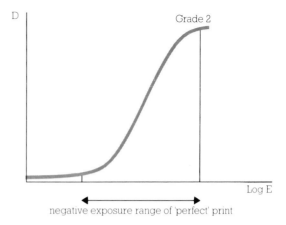

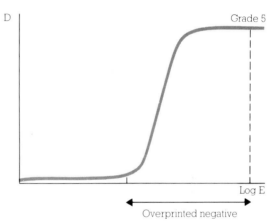

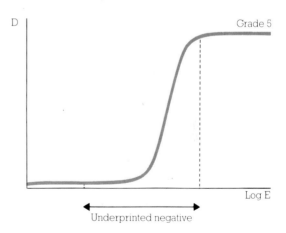

11.1 The top diagram shows a negative exposed on grade 2 paper to give a full range of image tones. When overprinting on to a harder grade of paper (eg. grade 5), more subject tones become black and the print has higher contrast (centre diagram). Underprinting the same negative (bottom diagram) on grade 5 forces many lighter tones to be printed as white.

Lith materials

Lith films are used by lithographic printers to make the large film negatives and positives used to produce printing plates for the presses. To maximum contrast from lith films, develop them in a solution of lith developer which you make up from two stock solutions just before you need it. Lith developers can only be used for about two hours after they have been made up, as they then lose activity.

The very high contrast image produced by lith developers is due to 'infectious' development, in which the by products of an area which is developing slowly become catalysts, increasing the development rate. The developer must not be over-agitated as this will remove these by-products from the developing site before they have fully done their work. You can use a 'still bath' technique which involves vigorous agitation for about 15 sec followed by sporadic agitation, thus ensuring maximum contrast with overall even development.

The majority of lith films can be handled in red safelighting, as they have orthochromatic (blue + green) sensitivity only. Ideally, use an enlarger timer as printing exposures are generally very short. Set the enlarging lens at its minimum aperture but never go to below the last marked stop as this will increase light diffraction, leading to loss of definition in the image.

Another high contrast material is line film, although it does not give as high contrast as lith. Line films are developed in very high contrast developers such as Kodak D-19; these are relatively stable, do not involve 'infectious' development and can be replenished. However, if used only occasionally, lith films are more useful than line, but a few high contrast films, such as Agfa Rapidoprint, can act as lith or line film, depending on the developer in which they are processed.

Working with lith materials

Read the film manufacturer's instructions carefully, noting the recommended exposures and processing methods. There are, however, a few general rules on working practice which will help

84-85 The original 35mm negative was enlarged on lith film and 'sabattiered' to give a predominantly positive image; printing this positive gave the left hand print. The positive sabattiered image was projected on to ortho tone film and the resulting 'negative' was printed to give the right hand picture.

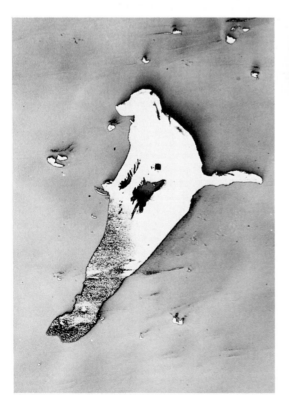

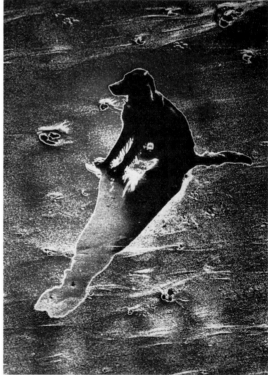

you get the best results from whichever lith materials you choose:

1 Sheet film is the material to choose for most of the processes discussed later in this chapter. It lies flat more readily than 35mm film and is more convenient to process but it is expensive so cut it up to make test strips. For the final exposure you may be better off buying the larger sizes and then cutting them down to the largest film format your enlarger can take.

2 Consult the manufacturer's recommendations for handling the film under safelights (normally red) but do not hold it in front of safelights for more than a second or two; it is more sensitive than paper.

3 Set the easel for wide borders surrounding the projected image, so that the lith image can be positioned in the middle of the film carrier when it is being enlarged later.

4 Put the film into a small dish (about 18 x 13cm or 7 x 5in in size) of freshly made-up developer which is at the right temperature and dilution. Agitate as recommended, or you could use the still bath technique, in which 15 sec of continuous agitation is followed by one gentle rock every 30 sec, for some applications.

5 Stop development sharply by using a stop bath. Then fix the film for twice the clearing time (the period taken for the milky appearance of the film to clear) which should mean a total of about 5 min for slow fixers (about 2 min for rapid ammonium thiosulphate formulations).

6 Use a wetting agent before carefully drying the film. Ensure that all equipment is kept clean, as dish processing can produce scuff marks on the film.

7 Small clear spots called 'pinholes' may appear on developed lith film. To avoid them as far as possible, do not underexpose the film or develop for less than the recommended time. In most cases these pinholes can be spotted out with blocking out fluid – a brown paste which is also known as photo-opaque.

Bas relief

Changing the lines and shapes of the image to modify or even transform the original scene can, as we have seen, be an unpredictable process. So be flexible; if things turn out rather differently from what you had imagined or hoped for, improvise. Your initial mistake could be the beginning of your most exciting work, so remember to keep detailed notes.

Bas relief is a simple technique which produces a pseudo three-dimensional image rather like a relief painting, which can be intensified at will. The basic procedure, although there are a few small variations, is as follows:

1 Contact print the black-and-white negative on to lith film, and then process it to give a high contrast positive.

2 Sandwich the original black-and-white negative and the high contrast positive together, with their emulsions touching. They must be slightly misaligned, and to ensure this it is best to place them on a light box where you can judge the amount of image distortion. When you have the desired adjustment, tape them together along one edge.

3 Enlarge this sandwich on to photographic paper and print it.

4 This first print will tell you what adjustments to printing exposure, grade of paper and degree of misalignment are necessary for improvement.

Step 1 requires extreme care as with all contact printing if your work is not to be spoilt by dust marks. Ideally, use a compressed air can to make sure that every speck of dust has been removed. Generally speaking, it is best to aim to produce a fairly light positive image. At step 3, if it is difficult to obtain good contact between the two films, use a glass film carrier, which, too, must be kept absolutely clean. Stop the enlarging lens down as far as possible (still giving reasonable exposure times) to ensure sufficient depth of focus for a guarantee of sharpness even if the two films are slightly separated.

This is the basic process, but instead of lith film you could use a lower contrast material such as Kodak Gravure Positive, which must be handled in orange safelight; this produces a softer positive which is appropriate for more delicate subjects. Or, you can contact print the lith positive against another sheet of lith film. The high contrast negative thus produced is sandwiched together with the lith positive, slightly out of register, to produce a high contrast bas relief photograph.

A bas relief print appears 'positive' when the sandwich positive film is weaker then the original negative, or any second generation negative. However, the final print can be made strongly 'negative' if you produce a reasonably dense positive, or produce a weak negative from the positive and then sandwich these two together and print.

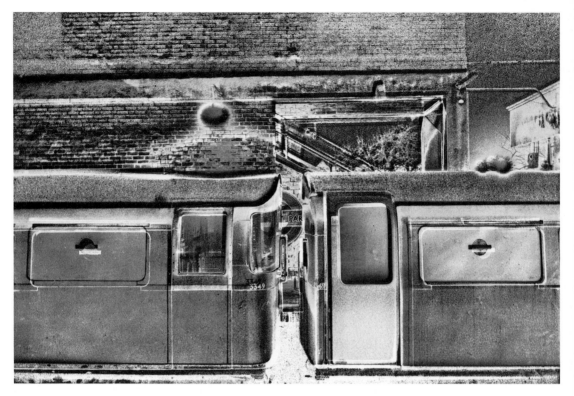

86 A bas relief print. The original black-and-white negative was enlarged on line film to give a fairly high contrast positive, which was then contact printed on to the same material to give a light, high contrast negative. The darker positive was sandwiched, slightly out of register, with the light positive and printed to give the bas relief print.

Your choice of subject for a bas relief print should ideally be unfussy, with clear outlines. Keep the degree of misalignment of the films small, so that thin shadow lines surround the subject.

Sabattier process

This process is sometimes mistakenly described as solarisation. It is used to produce delicate lines based on and around the subject, somewhat reminiscent of a contour map, a bold original effect that is well worth trying. However, the results are unpredictable as the process can be difficult to control, but if you follow the simple rules given below you will obtain some very pleasing results.

The success of the operation hinges on the light being turned on while the materials are in the developer, and on the development which follows this deliberate fogging. The line pattern develops from chemicals building up at contrasting image boundaries.

Attempting the sabattier effect on film exposed in the camera is not recommended. Rather, project the processed negative on to sheet film in the darkroom. There is little point in fogging photographic paper during development as the sabattier print produced this way will be too dark to be of interest. Using film enables you to transfer sabattier images on to other sheets of film.

Sabattier process – step-by-step

1 'Enlarge' the black-and-white negative on to lith film, to the largest size possible for your enlarger film carrier; a 35mm negative should be projected up to about 55 x 37mm, with a small safety margin, if yours is a 6 x 6cm enlarger.

2 Make a test strip to decide the correct exposure for producing this film positive. As a guide, stop your lens down to f/16 and experiment with exposures of 1, 2, 4, 8 and 16 sec, using lith developer for these tests.

3 Expose a strip of lith film using the correct time found at step 2, and develop with constant agitation until a clear image just appears. This will take half the recommended development time, or about ½-1 min. Cease agitation and, when the film

is stationary, switch on a hand torch (flashlight) for about 5 sec, moving it constantly at about 30cm (1ft) over the film. Keep the light moving or the results will be uneven. If the lamp has a 'hot spot' of illumination place a tissue over the light to diffuse this. Leave the film to develop *undisturbed* for about a minute.

4 Quickly move the film to the stop bath and then to the fixer. When it is clear, hold the film up to a bright light and examine it for sabattier lines. Remember, the image will be very dark at this stage.

5 If, however, it is so dark that you cannot detect any sabattier lines, repeat the process with a fogging exposure of about one sec. If the image has few, or no lines and a low density margin around the image, the fogging exposure was too short. Correct this by increasing the fogging time to about 15 sec, or use a stronger light source (page 27).

6 Continue testing until you are satisfied, then expose a full sheet of film.

7 The film will be too dark for printing, so project it, same size, on to a sheet of continuous tone copy film, such a Kodak Gravure Positive. Produce an image of sufficient density to be printed.

8 Print the negative/positive thus produced in the normal manner.

87 The original 35mm negative was enlarged on line film and sabattiered during processing. The resulting 'positive' was too dense to print and so was projected at 1:1 on to a sheet of ortho tone film to give a negative; the latter was printed to give the print shown here.

Some sabattier variations

The above is the basic process; there are many variations. For example, the film/developer combination can be varied considerably, provided that it is a fairly 'active' system giving sufficiently high contrast. Experiment with developing lith, line and copy films in 'active' solutions such as lith, line film and paper developers.

Fogging lights provide another area for experiment. You can, for example, try using room lights. But if you do, make sure it is with a pull cord; *operating switches with wet hands is potentially lethal.* Or, a portable flash gun can be used as a light source. It is best to use an automatic type which gives you more control. Again, *do not use with wet hands.*

You might also like to try making 'multiple' sabattier images. Project the sabattier film on to another sheet of film and then sabattier this image.

Double, triple or quadruple images produced in this way are very striking.

Posterisation

Photographs produced by this method look like posters, with large areas of individual tones. This is achieved by converting a continuous tone image into a number – usually three or four – of distinct tones, such as white, mid-grey and black.

This technique is most striking when applied to bold simple shapes with minimal fine detail. Almost any original continuous tone image including colour negatives and slides, colour and black-and-white prints, can be used to make a black-and-white posterisation.

The method described below uses a black-and-white negative as the original; other methods are shown in fig 11.3. There are a number of ways in which a black-and-white negative can be posterised. The following (fig 11.2) will produce a successful three-tone posterisation:

1 Place the negative in the enlarger to project an image which is the same size as the largest film format possible with your enlarger. For example, for a 35mm enlarger this could be 36 x 24mm and for a 120 enlarger it is 6 x 6cm at least, and perhaps as much as 6 x 9cm.

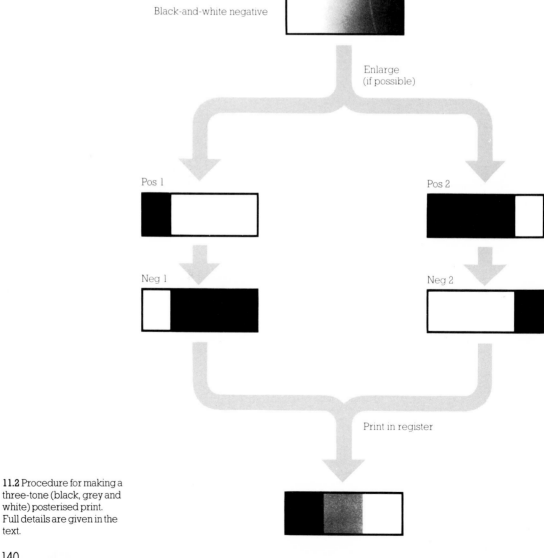

Black-and-white negative

Enlarge
(if possible)

Pos 1

Pos 2

Neg 1

Neg 2

Print in register

11.2 Procedure for making a three-tone (black, grey and white) posterised print. Full details are given in the text.

88-90 Posterised print. The original negative was enlarged using two different exposure times, on to lith film to give a lighter and a darker positive. These were then contact printed on to lith film to give high contrast negatives. The heavier negative, when printed, gave the black image, the lighter negative (at reduced exposure) gave the grey, and the combination gave the final print.

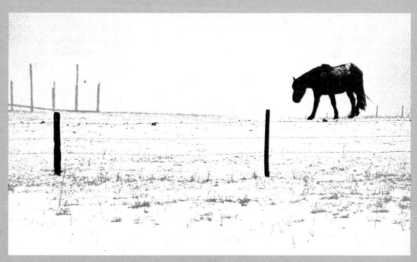

11.3 Alternative routes to producing a three-toned posterised print.

A Colour slide must first be converted to a black-and-white continuous tone negative by projecting on to *panchromatic* film–for the remaining steps follow fig **11.2**.

B colour negatives can be projected on to *panchromatic* lith film to give lith positives directly, which are then used to give two lith negatives for printing.

C Alternatively, a colour negative can be projected on to *panchromatic* black-and-white film to give a continuous tone positive, which is then used to generate two lith negatives for printing.

A

Colour slide

Enlarge (if possible)

Black-and-white negative

B

Colour negative

Enlarge (if possible)

Pos 1

Pos 2

C

Colour negative

Enlarge (if possible)

Black-and-white positive

Neg 1

Neg 2

The ideal enlarger for this type of work is 4 x 5in because of the extra ease of achieving high quality results (registration, minimum enlargement) and the wide availability of films for that format. You can, if you wish, crop the image at this stage, if you are certain where you want the boundaries on the final print, but it is wiser to retain as much of the image as possible, and make this decision when the process is complete.

2 Place a sheet of lith film in the print easel and stop the lens down to the minimum aperture. Make a test strip exposure; such multiples as 1, 2, 4, 8 and 16 sec are recommended as a guide.

3 Choose two exposure times from the test strip and produce two film positives which are fairly distinct from each other. For a three-tone posterisation, the lighter positive will indicate the black parts of the final posterised print, while the darker positive shows the white areas of the final print. The mid-grey tone of the final print will come from any remaining areas (fig 11.3).

4 Project the two positives on to lith film to produce two high-contrast negatives which *must* be of the same magnification. It is essential that the enlarger is not adjusted except for fine focusing, during this step.

5 Place the darker of the high contrast negatives in the enlarger and project to give the full print size. Make a test strip in the usual manner, using a small lens aperture. This will indicate the correct exposure times to produce a mid-grey and a maximum black.

6 Expose a full sheet of paper for the time ascertained above to give maximum black.

7 Replace the darker negative in the enlarger with the lighter one, without moving the enlarger or the paper. Using the registration techniques described below, ensure that the lighter negative is correctly aligned, and give the paper another shorter exposure to produce a mid-grey. You should not need to focus this second negative because of the small printing aperture and therefore the large depth of focus, but if you have to re-focus each negative because of unsharp results do it as quickly as you can at full aperture through a red filter.

8 The three tones of the posterised print should now be examined carefully, and adjustments made to printing exposures if tones need to be lightened or darkened, or alignment needs to be refined.

Careful control is vital at each stage and good registration of the two printing exposures is also crucial. As you become more confident, you will be able to visualise in advance how the original scene will convert into a successful posterisation.

Registration of images

To ensure exact registration use a registration punch, a registration board and a film carrier with matching registration pins, all of which can be purchased or made at home. If you decide to do it yourself, the simplest system is as follows. Using a paper punch, make two clear holes in the film, about 7cm (2¾in) from each other. Take a spare, preferably larger format, enlarger film carrier, and adapt it to take two round pins 7cm apart. Then secure two round pins to a flat board, which will hold the film during exposure. Mark this board with the useful image area and ensure that it can be fixed to the baseboard.

It is more difficult to register 35mm film accurately because of the greater degree of enlargement. However, it is worthwhile trying to adapt the pin registration of a 35mm film editor to achieve this.

Alternatively, you can use a visual marking system which is carried through each stage of production. For example, use the four corners of the original negative as your markers, by ensuring that these corners are all within the projected image at every stage of the process. For 35mm work you would need to reduce the image slightly, so that the two 35mm images could fit easily inside the 36 x 24mm format. The remaining production stages could be at same-size reproduction.

When you are ready to make the final double exposure on paper, mark the four corners of the paper. Using a red filter under the enlarging lens, align each negative in turn at full aperture, working as quickly as you can to prevent print-through.

Four-tone posterisations

A four-tone posterisation comprising black, white and two greys will require three positives to be produced from the original continuous tone negative (fig 11.4). As we have already noted, the lightest positive indicates the final blacks, the darkest positive will show the whites, and to anticipate the two greys the middle positive must be compared against the other two to judge their tonal differences. Produce three high-contrast negatives from the three positives and then print them in register. The darkest negative is exposed

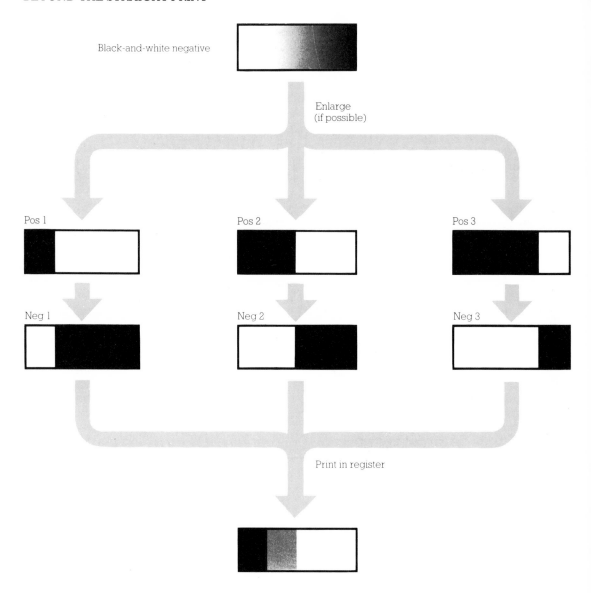

Black-and-white negative

Enlarge
(if possible)

Pos 1 Pos 2 Pos 3

Neg 1 Neg 2 Neg 3

Print in register

11.4 Procedure for making a four-tone (black, dark grey, light grey, white) posterised print. For complete details see the text.

to produce black, the middle negative will give dark grey and the lightest is exposed to produce light grey. Unexposed areas produce white.

A five-tone posterisation can be made by producing four positives and four subsequent negatives for printing, but as the resulting print will look almost exactly like a continuous tone print made from the original negative, there seems very little point!

The intermediate positives should not be disposed of as you can use them to produce other print modifications, for example bas relief and colour posterisations (page 155).

Combining several images

The combination of several images on one sheet of photographic paper is called *montaging*. It is a long process to create these dream-like images, whether you plan ahead and photograph your chosen subjects accordingly or choose the component images from your existing work. Look at the work of Jerry Uelsmann to see some of the most exciting uses of montage photography.

There are three main procedures which can be

used to create a montage photograph, namely sandwich printing, multiple printing and collage. None of these techniques is superior to the others; the method you choose should depend on the subject and its environment.

Sandwich printing

Two negatives are sandwiched together and then projected, perhaps with the aid of a glass carrier to keep them together. To position the two images correctly, line them up on top of a light box and,

91 Several front and side portraits were taken against a black background, and in every case a large amount of space was allowed around the subject. From the contact prints, two 6 x 6cm negatives were selected, sandwiched together and printed using a glass film carrier. The enlarging lens was stopped down to *f*/22.

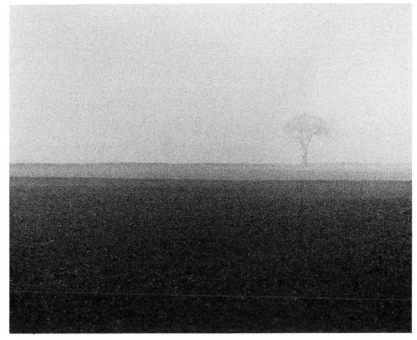

92 The original misty scene was very low in contrast, and so the film was given extended development to increase the density range of the negative. The resulting grainy negative was printed on grade 5 paper to give this moody image.

when they are correctly aligned, tape them together at one edge. The two emulsions should be kept as close together as possible, and in normal orientation. This means that the two negatives will be separated by one thickness of film base. If one image is 'flopped' (laterally reversed) the two should be sandwiched emulsion to emulsion.

This technique is most appropriate for negatives with large clear areas, providing space for the details of the second image, which result from subjects surrounded by dark tones. To complete the sandwich you may decide to photograph the second subject against a black background, adjusting the object's size on the negative to ensure that it fits into the space provided by the first image.

If the size relationship of the two subjects' negatives is awkward, produce a duplicate negative via a film positive of one, at a different, more suitable magnification.

Instead of combining two negatives, you might decide to sandwich a negative and a positive, the size of which has been adjusted, as appropriate. Whether the final montage to result from this type of sandwich appears predominantly negative or positive depends on which image is the most dense. Again, you can produce high contrast montage photographs by sandwiching together high contrast (lith) negatives of positives (page 137) produced from the original continuous tone negative.

You can take it one step further and sandwich three films together. Use a glass carrier to keep the three in contact, and stop the enlarging lens down to its minimum aperture to make sure that all the images remain sharp, as at least one film will become separated from the rest by one or two layers of film base.

Multiple printing

This technique creates the montage through the projection of a number of images on to a single sheet of photographic paper. The number and choice of images you decide to project is limitless, but you will achieve the best results if the selection is not entirely random. Plan it carefully, creating space and considering all your existing work for possible inclusion, as well as photographing specifically for the montage.

Ideal subjects for this technique are surrounded by lighter tones (dark areas of negatives), where there is less risk of printing one set of interesting details over another. If you decide to photograph

a subject specially for the montage, set it against a white background and try to make the lighting match that of the other images to be included.

Multiple printing is only successful if the various subjects and their treatments appear related. So be careful to match image grain and definition as well as lighting. All the images should at least appear to have been photographed on the same film and format and under the same lighting conditions.

This technique requires planning and organisation, and a fairly clear idea of how the final print should look. A useful technique is to draw round the outlines of the images you intend to use by projecting them on to ordinary paper. It is also essential to keep detailed notes of exposures, degrees of enlargement, any shading or burning-in that is done, paper grades used, and so on.

Multiple printing – step-by-step

To print two negatives on to a single sheet of paper:

1 Place the first negative in the enlarger and adjust the size until it matches the dimensions in your sketch.

2 Determine the correct printing exposure and the correct paper grade to give a good quality print. Make detailed notes of the exposure time, lens aperture, column height and any burning-in or dodging.

3 Replace the first negative with the second and repeat steps 1 and 2.

4 Expose the second negative to the photographic paper. With the paper still in position, move the easel away from the enlarger light. Replace the second negative with the first.

5 Use your sketch as a reference to align the first negative correctly, ready for exposing. Bring the easel and the paper back and place them in the correct position in relation to the first image, using the enlarger's red filter to protect the paper. Expose the first negative.

6 Examine the double-exposed print carefully. Correct either or both exposures as necessary.

93 A dramatic print achieved by using a red filter on a stormy day, and by giving extra printing exposure to further darken the sky. The area around the ship was lightened by dodging. A slightly less dark effect could be achieved by using an orange filter instead of red but, in practice, control in printing allows greater change of density than the difference between the two filters.

You might find that the two negatives do not print equally well on the same grade of paper. If this is the case, make a 'duplicate' but slightly different negative (ie, higher or lower contrast) of one of the two, which will then print satisfactorily on the grade of paper you have chosen. Or, more simply, use a variable contrast grade of paper and change the printing filter to suit each exposure.

The only real difference between printing two negatives on a single sheet of paper and printing more than two is obvious – it takes longer. So, if you intend to multiple-print fairly often, an extra enlarger would be a useful buy, as each negative can then be left in its enlarger at the correct adjustment and ready for exposure. All you have to do then is transfer the paper easel from one enlarger to the other.

Other variations on the multiple-printing theme that you might like to try include printing positives, negatives and positives, and high contrast (lith) negatives and/or positives. With lith film images you can 'edit' the subject by blocking out part of it by painting blocking-out fluid on to the non-emulsion side of the film.

Collage techniques

Collage is the method by which numbers of individual photographs are cut out and pasted together. The great advantage of this technique is its versatility, allowing you to perfect each component image, reprint and move the images around at will. You can also incorporate other non-photographic skills you may have, such as painting, into the collage.

Any type of photographic paper may be used, but ideally art or at least matt papers such as Kentmere Art are the most suitable, as they are easier to cut and paste up on, and are ideal for retouching.

When pasting-up, use a type of adhesive that allows you to stick a photograph down in one position and then peel it off and stick it down again somewhere else on the sheet. Most adhesives contain volatile solvents, so always work in well-ventilated areas.

To give your final composition a professional finish and ensure that it does not look like a paste-up, re-photograph it to produce a copy negative. If at all possible, use a film designed for copy work, such as Kodak Gravure Positive, although these films are normally only available from suppliers of professional materials. Pan camera film gives satisfactory results if it is developed to a

higher contrast than usual. Use slow pan film to conserve image quality, and develop to a gamma of about 1.0.

Printing black-and-white negatives on colour paper

If you decide to try printing black-and-white negatives on to colour paper, and you already have colour printing facilities, you may well find that these provide a simpler and more flexible way than toning (see Chapter 12).

To print a continuous tone black-and-white negative on to 'negative' colour paper, such as Ektacolor, follow this basic procedure:

1 Compose and focus the black-and-white negative on the paper easel. Stop the lens down by three stops, as a guide, from maximum aperture.
2 Set the filter pack or colour head to 0Y 0M 0C; expose a small test strip at 5, 10, 20 and 40 sec.
3 Expose more test strips, or other corners of the same sheet of colour paper, at the same exposure times, but use the widest range of colour filter settings. As a guide, you might try 120-00-00 (Y-M-C), 00-120-00, 00-00-120, 120-120-00, 120-00-120, and 00-120-120. Make detailed notes.
4 Process the colour paper in your normal manner.
5 Examine the results, bearing in mind that for 'negative' colour paper longer times will produce darker images, and printed colours are complementary to the filter colours. For example, a setting of 120Y 120M 00C (red) produces a cyan print.

If you want more saturated (purer) colours, use narrow-cut filters below the enlarging lens; for example, Wratten 47 (blue), 58 (green), 25 (red), 12 (yellow), 32 (magenta) and 44 (cyan). To obtain less saturated colours, find the colour filter pack for a neutral print and vary this slightly. Produce test strips accordingly, and keep them for other times when you want to print black-and-white negatives in colour.

With an *additive colour enlarger* you follow basically the same procedure. However, you are likely to obtain a wider spectrum of colour, particularly if you can turn the three colour channels on and off independently. There are some further alternatives, for example:

1 Continuous tone black-and-white positives on to negative colour paper, giving monochrome negative prints.
2 Black-and-white continuous tone negatives or

94 Very careful burning in was needed to give the fish just enough detail without overdoing it and producing a muddy look. The face was slightly lightened by dodging.

95 The high contrast surroundings of the backlit water help to isolate the main subject. In addition, the centre area was dodged slightly to retain the viewer's attention.

96 Simple everyday objects often make good photographic subjects, especially if the lighting can contribute to the composition. A hard grade of paper was used to emphasise the wall texture. No local density control was needed.

97 The combination of a slow shutter speed (about 1/30 sec) and panning right to left during exposure has given a feeling of movement. A hard grade of paper was used to accentuate the strong compositional shapes of the umbrellas.

positives on to reversal colour papers, for example, Cibachrome or Ektaflex, giving monochrome negative and positive prints.

3 Lith negatives or positives on either negative or reversal colour papers, giving high contrast monochrome prints.

4 Sabattier negatives or positives on colour paper.

Sandwich printing – colour negatives

Many of the procedures which we have already discussed for black-and-white sandwich printing are equally applicable to colour films. The most important points to remember are:

1 It is only really practical to sandwich no more than two pieces of film together; a thick sandwich involving many negatives or slides will project an unsharp image due to the limited depth of focus. Always use a small aperture, such as *f*/16 or smaller.

2 You cannot alter the relative sizes of the two images unless you are prepared to attempt the difficult task of making enlarged/reduced colour internegatives or positives.

3 To make sure the sandwiched films remain in close contact, it is best to use a glass film carrier. However, a major problem with these carriers is the very great care necessary to ensure that the negatives or slides and the glass remain very clean. Even the faintest mark will show up on the final print and could mean tedious retouching, which is even more difficult for colour work.

4 As mentioned in step 1, a small enlarger aperture must be used; this means that enlarging times are likely to be longish. It also means that the slower-speed papers, for example Cibachrome, and very dark film sandwiches, are impractical and not recommended.

Examine your contact prints very closely, and choose combinations of images that you think will create exciting montages. You must choose colour negatives which are generally light-toned, otherwise important subject detail will not print through the sandwich. The ideal subject, therefore, has been photographed against a dark background or environment.

If you decide to photograph subjects specially for use in the montage, try to estimate relative sizes and keep them in mind as you work. You might decide to leave a 'hole' in one photograph,

into which the main subject area of the second negative may be superimposed. After you have selected the subjects or photographs to be used in your sandwich, print and process the negatives as usual.

Sandwich printing – colour slides

The simplicity of producing interesting effects by placing slides on top of one another on a light box has great appeal. However, the snag is that your possibilities are somewhat limited by the slower speeds of reversal papers and the fact that you must stop the enlarger lens down to small apertures. Remember that for this technique subjects which have been photographed against light backgrounds generally work best. But do not let these restrictions put you off; read the section on making duplicate slides and negatives at the end of this chapter (see page 156).

Printing and processing for this technique is the same as for printing an individual slide, except that you must use smaller enlarger lens apertures (such as *f*/16) or less). You can print your slide sandwich on to negative colour paper which will produce a fairly high contrast negative-colour image. For this technique exposure times should not be too unmanageable.

You can also try sandwiching a colour negative and a colour slide together, although the effect would have to be carefully 'previsualised' to give worthwhile results. This type of sandwich, if printed on to negative colour paper, would give an image with a normal positive colour image (derived from the colour negative) combined with a high contrast negative-colour image (from the slide). But positive colour paper is less likely to produce a satisfactory result because of the slow speed and lower image contrast.

Sandwich printing – black-and-white with colour film

Sandwiching a black-and-white negative, or positive, with a colour negative or slide creates endless possibilities for exciting images. You can easily change the relative sizes of the colour and black-and-white images – it is easy to alter the size of black-and-white images by enlarging or reducing on to black-and-white film. It is also a very easy matter to get rid of any unwanted detail from the black-and-white image; you simply use blocking-out fluid (see page 137) on any intermediate negatives or positives. It is easier to do this if you are working on larger film formats.

Multiple printing – colour paper

Although making several exposures on a single sheet of colour paper may appear very complicated, with a little planning it is possible to achieve some very exciting results. The essential technique is much the same as that described for black-and-white multiple printing.

While you are studying the colour contact prints produced from your colour negatives, you may well visualise these images in exciting combinations. Using multiple printing will enable you to vary the degree of enlargement of each negative, which means that a small portion of one negative could be printed at any magnification into an area of another picture.

This technique usually works best when the chosen subjects are uncluttered in design and photographed against generally light surrounds. The lighter areas of the original scene record as dark on the negative, and will therefore pass very little light from the enlarger on to the colour paper.

Multiple printing of colour negatives is done by the following steps:

1 Examine your contact prints very closely; try to imagine how and which images could best be combined. Remember that dark areas of the contact print tend to mask anything printed on to these areas from a second negative. The only way to avoid the need for 'blocking-out' is by use of dodging techniques, described below.

2 Assuming that you are only using two colour negatives, print each as usual on to separate sheets of colour paper. Make detailed notes of this operation, including filter pack, exposure time and lens aperture, enlarger head position (most enlarger columns have a calibrated vertical scale).

3 After processing these trial prints, study them carefully and decide which, if any, adjustments are necessary for the double exposure on one sheet of colour paper. It can be of help to superimpose the two prints on top of one another on a light box to see clearly how they will match up. You might also at this stage consider holding back ('dodging') some areas of one negative so that details from the other will not be obscured.

4 Make an initial double-exposure print, using half the exposure times of the separate prints. *Do not* move the colour paper from its easel. To make sure the two images are registered exactly, mark the enlarger baseboard with tape or dark pencil for the two positions of the paper easel. Safelight-

ing should be the brightest possible without causing paper fogging, so that you can see exactly what you are doing. Also, give yourself time to adapt to the safelights. Remember that if you switch on the room lights too often this will cause loss of dark adaptation.

5 Process then examine your first double-exposure print. Make any necessary exposure or filter pack adjustments to the next print, and carry on with perhaps several more experimental prints until you produce the 'perfect' print.

A great deal of patience is needed to produce the 'perfect' print, but it is worth while persevering. Again, you *must* make carefully detailed notes of your work. It only takes a second or two to do, and becomes instinctive after a while.

Multiple printing – colour slides

The technique for exposing several colour slides on to the one sheet of positive colour paper (eg Cibachrome) is very similar to the method described above. There is, however, one major difference – the light areas of one subject must be prevented from burning-out the detail in the second or subsequent slide. So, ideal subjects for this process are those which have been photographed against dark surroundings. Alternatively you can hold back the lighter subject areas during exposure.

Previsualising your montages, either before camera exposure or printing, is most important. Take time to examine your slides carefully on a light box; you may save yourself many frustrating and unproductive hours in the darkroom.

As you gain confidence and attempt more abstract images, you may want to experiment with other multiple printing techniques;

Colour slides and colour negatives. This combination of colour negative(s) and slide(s) can be printed on to negative or positive colour paper, but you will need to make a number of tests before you produce a satisfactory print. As with the techniques we have been discussing, it is best to print film with large areas of high density, thus preventing burning-out in any image areas.

Black-and-white negatives and/or positives. Multiple printing of black-and-white negatives and positives on to a single sheet of paper gives you many possible combinations. You can print either negatives or positives or, perhaps, a combination of both. Again, the black-and-white images could be used with either colour negatives or

colour slides, or high contrast black-and-white (lith) images. Try all these various permutations on negative or positive colour paper. When using lith images you can block-out areas of the picture with fluid, particularly if the images are on film sizes larger than 35mm.

Sabattier technique in colour

The essential procedure here is similar to that for black-and-white, as described on page 138. This method should give you a partially reverse image which is dark, with white lines around the contours of the subject. These lines are produced by the migration of development-retarding chemicals across the image boundaries. Therefore, no agitation should be given in the second half of the development.

The sabattier technique done directly on to colour paper is unlikely to produce as pleasing results as using film for the intermediate step (page 153). However, it does give you a good and cheap introduction to the process.

Step-by-step procedure for the technique is as follows:

1 Choose the correct filter pack and exposure to give a *reasonable* colour print from the selected colour negative or slide. Remember that the final print will not consist of true colours, so a perfectly colour-balanced print is not really necessary. It is most convenient to work with dishes (trays) or a small tank processor, which simplifies the fogging stage. If you use dishes, choose the lowest processing temperature possible, as you will find this easiest to maintain.
2 Expose a print as in step 1, develop for half the recommended time, stop agitation.
3 As soon as the print is stationary, make a test strip exposure as usual (page 89) but with the use of the fogging light. As a guide, try a fogging exposure of 2, 5, 10 and 20 sec with a torch (flashlight) held at about 30cm (1ft) above the print. Diffuse the light with a tissue and move it during the exposure to prevent uneven fogging.
4 Proceed with the development, without agitation, for the full recommended time.
5 Continue the remainder of the process as usual.
6 Examine the processed print carefully. If it is totally dark, the fogging exposure needs to be reduced by using a weaker light. Or, you can increase the distance between the paper and the light. If, on the other hand, the print shows little fogging effect, use a brighter light source and/or

move it closer to the paper to increase the fogging exposure.

You will need to practise and experiment with this technique before you start to see satisfactory results, so remember to take detailed notes. Try several different paper/chemical combinations as the effects obtained can vary considerably. Also try different re-exposure light sources such as electronic flash (an automatic gun gives you most control) and lamps covered with coloured gels. Always ensure that electrical equipment is kept well away from water – the combination can be lethal.

It is easier to use black-and-white film than colour when experimenting with sabattier effects; monochrome film is also very versatile for this type of work. See page 138 for practical details on how to obtain the sabattier film negative/positive.

This positive/negative forms the starting point for colour printing, and gives you great scope for experiment. For example, it may be printed to give a monochrome colour print on negative or positive colour paper; it can be multiple-printed with its original colour film; sandwiched with the original colour film or another subject and sabattiered again to give a 'double sabattier'. These are just a handful of suggestions; there are many other variations.

The high contrast film used in the process is generally orthochromatic, ie sensitive to blue and green, and insensitive to reds. It therefore reproduces all the reds of colour films as if they were dark tones. If you begin with a colour negative or slide, ortho film will in most cases give very acceptable results. If, however, you are not happy with what you are getting, try a panchromatic high contrast film such as Kodalith Pan (although this does involve working in total darkness and not with the red safelight that suits ortho films). Or, you can copy the original colour negative or slide on to pan film, producing a continuous tone film positive or negative and use this for the remainder of the process.

Sabattier – colour film

Whether the original camera film is black-and-white or colour, negative or positive, it can be copied on to negative or reversal colour film (see page 139), and the copy image 'sabattiered' during processing. For a colour negative the fogging sabattier exposure is carried out half-way through the colour development. For slide processing the

BEYOND THE STRAIGHT PRINT

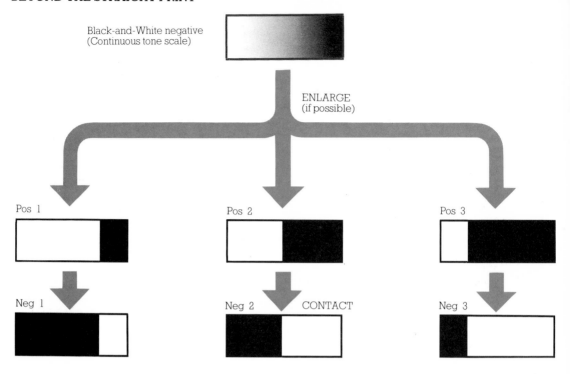

Black-and-White negative
(Continuous tone scale)

ENLARGE
(if possible)

Pos 1

Pos 2

Pos 3

Neg 1

Neg 2 CONTACT

Neg 3

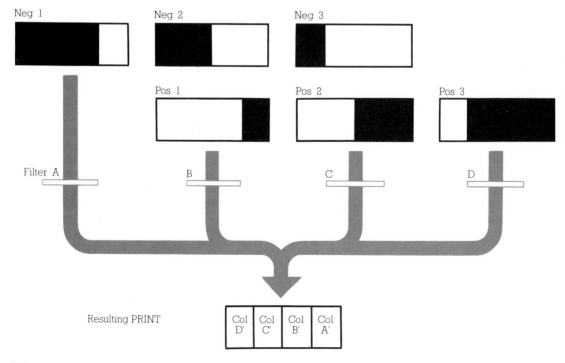

PRINT (4 exposures)

Neg 1

Neg 2

Neg 3

Pos 1

Pos 2

Pos 3

Filter A

B

C

D

Resulting PRINT

| Col D' | Col C' | Col B' | Col A' |

fogging exposure takes place mid-way through first (black-and-white) development. Agitate in the normal manner for the first half of development and then stop agitation for the second half.

You will need to be patient and to experiment before you satisfactory results. The variables are numerous, the most important being the colour and intensity of the exposing light and the film/process combination. So, be methodical and change only one variable at a time.

Colour posterisation
This technique produces a colour print in the style of a poster, consisting of large areas of (usually) four solid colours – although you can have more, or fewer than this. The procedure given here is for four-colour posterisation.

The original photograph is separated into four tones, which are then selectively printed as different colours. Although it is not a complicated technique, resembling that for black-and-white (page 140), very careful attention must be paid to several steps of the process. One area of difficulty could be the registration of the four colours, so before you start, read the section dealing with this on page 143 of this book.

The idea of deriving a multi-coloured print from a continuous-tone black-and-white image is rather intriguing. The multitude of tones in the original photograph convert into four distinct tones which are then printed separately through colour filters on to colour paper. Correct registration is vital, as four exposures are made on a single sheet. The following basic procedure (fig 11.5) for making a posterised print is recommended:

1 Choose a graphic image with a full tonal range from among your black-and-white contact prints, avoiding anything fussy or over-detailed.
2 Place the negative in the enlarger and project the image on to high contrast film, ideally 6 x 6cm or 4 x 5in lith film.
3 Following the procedure given on page 140, make three black-and-white film positives, one of which is fairly light in density, one fairly dark and the third of middling density. It is vitally important to produce good, evenly spaced 'tone-separation positives' at this stage.
4 When the tone-separation positives are dry, contact print each on to lith film to produce three 'tone-separation negatives'. The contact exposure is the same for each positive, and should be adequate to produce a maximum black when the film is processed in lith developer.

5 Enlarge the middle tone-separated negative on to either negative or positive colour paper, trying a variety of exposure times and filter packs to produce the four colours which appear in the final posterisation. If you want these to be very vivid, use either an additive colour enlarger, or narrow-cut filters below the enlarger lens. Fig 11.6 gives you a guide to the final colours. Remember to make detailed notes on the exposures and filters which produced your selected colours, and prepare to make the four separate exposures on to one sheet of colour paper.
6 Place the darkest separation negative in the enlarger and expose it through the selected colour filter(s) on to the colour paper placed in the easel.
7 Take the darkest negative out and replace it in the enlarger with a sandwich of the lightest positive and middle negative. Expose this through the chosen filter. Make sure that all exposures are in register (page 143).
8 Make your third exposure, a sandwich of the middle positive and lightest negative, using the third selected filter(s).
9 Make the fourth and final exposure, using the darkest positive.
10 Process the colour paper in the usual manner.
11 Examine the posterisation. Adjust the colours via exposure times and filters as you think necessary on the next print. You may also need to refine your registration technique.

As the colour of each of the four separate exposures is controlled independently, you can produce a wide range of different-coloured posterisations from one set of lith separations (one set consists of three negatives and three positives).

11.6 Table of colours for posterisation

	Resultant print colour	
Colour of exposing light	Negative colour paper (eg Ektacolor)	Positive colour paper (eg Cibachrome)
Blue (eg WR47)	Yellow	Blue
Green (eg WR58)	Magenta	Green
Red (eg WR25)	Cyan	Red
Yellow (eg WR12)	Blue	Yellow
Magenta (eg WR32)	Green	Magenta
Cyan (eg WR44)	Red	Cyan

Posterisation from colour negative or slide

To produce a posterised print from a colour negative or slide, the first step is to make a continuous black-and-white positive (negative). To do this, contact or enlarge the colour original to 6 x 6cm or 4 x 5in on to slow-speed *panchromatic* black-and-white film, working in total darkness. This gives a continuous-tone positive (negative) which is then contact printed on to ortho lith film. Three separation negatives (positives) are produced by three different exposures at different times on to three separate sheets of lith film. One of these three negatives (positives) should have a high overall density, one should be generally low in density and the third should be in the middle; the differences between the three should be about equal. Each of the three separation negatives (positives) is then contact printed on to ortho lith film, to give three separation positives (negatives). The same contact exposure time must be used in each case.

Following the instructions given above, print the set of lith separations (comprising three positives and three negatives derived from the original colour negative or slide) on to a single sheet of colour paper, in four exposures. There are no limitations to choice of the four colours to appear in the final posterisation; they can be as unlike the colours in the original image as you choose.

(For examples of these processes see pages 125-8.)

Copying slides and negatives

Many procedures discussed in this chapter can be greatly simplified by copying (duplicating) one or more of the intermediate steps. This is especially true for procedures that involve 'sandwiches' and printing very dark film, as it requires film sandwiches or multiple exposures to be converted to a single piece of film.

It is a simple process and convenient (especially if you already own a slide copier). You need only register the films or exposures once for copying, and for future printing simply print one copy negative or slide. You can also use this method to produce a posterised negative or slide.

It is vital that your film-copying apparatus, whether you purchase it or make it yourself, be accurate and efficient – pin registration must also be very precise. Make sure that all materials and equipment are kept very clean, as otherwise even the smallest blemish will appear, greatly enlarged, in your final print.

12 PRINT AFTERTREATMENT AND FINISHING

In common with all visual material, photographs need to be displayed carefully to bring out the true qualities of the image. Bad finishing and presentation of a print can mar the effect and, in extreme cases, cause the photograph to be ignored completely, or placed in the wrong context (environment). On the other hand, over-presentation may upstage the image. The viewer should be completely unaware of presentation – it is there purely to *enhance* the photograph.

This chapter covers post-darkroom techniques which can be used to improve the photograph, and shows you how best to present your work.

Chemical reduction of the image

Areas of black-and-white print which have been printed too dark may be effectively lightened by carefully applying a chemical reducer to the area. To make minor tonal adjustments, first make up a fresh solution of Farmer's Reducer (fig 12.1), testing its activity on a spare print. Make sure that the reducer does not work too quickly otherwise you might find it difficult to control.

12.1 Farmer's reducer

Stock solution A	
Water	250 ml
Potassium ferricyanide	37.5 g
Water to make	500 ml

Stock solution B	
Water	1 litre
Sodium thiosulphate	480 g
Water to make	2 litre

For use: 1 part A + 4 parts B + 27 parts water

Wash the print thoroughly and remove any excess water from its surface. Lay the print on the back of a processing tray or on a similar flat, smooth, surface and then brush or swab the Farmer's reducer on to the areas requiring attention. Make sure that the reducer stays where you want it and does not run into other areas of the print. Rinse the print surface with running water every minute or so to prevent yellow stains from forming.

If you are working on a large area and/or you want to remove heavy densities, Farmer's reducer is unsuitable. Instead, use an *iodide* reducer (fig 12.2) which can turn black into white

12.2 Iodide reducer

Stock reducing solution	
Water	100 ml
Potassium iodide	30 g
*Iodine (resublimed)	10 g
Water to make	200 ml

Stop and clearing bath	
Water	500 ml
Sodium thiosulphate	200 g
Water to make	1 litre

*Iodine is harmful and should be used with care.
For use: Dilute reducing solution 1 + 10 with water
 Clearing bath to be used undiluted.
1. Soak print in water; remove excess.
2. Apply reducer as needed.
3. Clear iodine stain produced in stop bath.
4. If further reduction needed, wash print and repeat process.
5. For removing dark spots, use reducer undiluted.

without any danger of staining.

For a large job, such as converting the grey background of a still-life subject to white, apply a special rubber solution to those areas of the picture which are not to be retouched. The rubber solution dries to form a protective mask, which means that the entire print can be immersed in reducer for as long as necessary to achieve the required effect. The print is then washed, and the rubber mask removed carefully with adhesive tape.

Colour of black-and-white prints

We have already discussed the way the colour of a black-and-white photograph can be varied with different combinations of photographic paper and developer, ranging from blue-blacks to brown-blacks (see page 72). This small range of tones can, in fact, be broadened by use of the following techniques, which can also be employed to bring in more saturated colours.

Chemical toning is a traditional method of converting the metallic silver image of a print to other, coloured chemicals, although the range of colours is limited by the fact that few reacting chemicals produce stable colours.

Photographic papers are available which have a conventional black-and-white emulsion coated on to a *coloured paper base*. These specialist papers are mainly used for exhibitions and posters.

A quick and versatile way to produce a coloured

monochrome photograph is simply to print a black-and-white negative on to a sheet of *colour paper* (page 148).

Below are some ideas to start you off on your own experiments with techniques and chemicals – the possibilities are very wide. If you would like to pursue this aspect more thoroughly, study some of the older photographic textbooks such as Ilford's former *Manual of Photography* (pre-1971 edition) or L. P. Clerc's *Photography: Theory and Practice.*

Sepia toning

Of the many published formulae for converting a black-and-white image of neutral tone into a coloured image, the most popular is sepia toning. We have already discussed how the conversion of the image to brownish silver sulphides or selenides will also bring image stability up to archival standards (page 103).

Ideally, sulphide toning should be carried out as a two-part process. The print is first soaked in a rehalogenising bleach (fig 12.3) to convert the silver image to silver halides, then rinsed for about one minute in running water and placed in the sulphide toner (eg, May & Baker Embesol, Kodak sepia toner). After toning, wash the print for 10 min and dry it as usual.

The exact shade of brown in the final print depends on the paper type, print developer and toner formulation as well as other factors, so experiment with several combinations. Generally speaking, the results gained from chlorobromide papers are more satisfying than those obtained with bromide emulsions, and fibre-based papers are more suitable than RC papers.

Make sure that the prints are correctly processed and washed very thoroughly before starting the toning process, otherwise any chemicals still remaining in the print will lead to stains. Some sulphide toners give off hydrogen sulphide fumes which fog photographic materials; they are also toxic and must be used in a well-ventilated area which is clear of photographic film and paper.

12.3 Rehalogenising (rehalogenating) bleach

Potassium ferricyanide (anhydrous)	40 g
Potassium bromide (anhydrous)	40 g
*Potassium oxalate	100 g
**Acetic acid (28 per cent)	20 ml
Water to make	1 litre

*Potassium oxalate is harmful and should be used with care.
**Made by mixing 3 parts glacial acetic acid to 8 parts water.

Metal toning

Many 'heavy' metals including cobalt, copper, iron, nickel and vanadium can form coloured metal complexes; a one- or two-bath process will convert the silver image of the processed black-and-white photograph to a coloured complex, although in most cases the resulting colour image is not permanent. The most stable images are made with the use of blue toners (iron) and red-brown toners (copper).

As with sepia toning, chlorobromide fibre-based papers are more suitable than resin-coated bromide papers, but you should experiment with many different paper types to find the effect that pleases you most. Before you start the toning process, check that your prints have been washed thoroughly, and that your processing trays are scrupulously clean, containing nothing that could contaminate your prints. Either make up your own toners or buy them ready-mixed and made up (such as Berg's toners), taking careful note of any manufacturers' health warnings.

Dyed image toning

The silver image can be converted into a form that acts as a *mordant*, holding dyes in the image areas but allowing them to be washed out of others. The image is then immersed in a 1 per cent acetic acid solution which also contains about 1 per cent or more of the selected dye. The dyed print is finally immersed for a short time in a weak solution of household bleach (sodium hypochlorite) to clean out the whites.

Images produced in this manner are not particularly stable, but if you store the prints in fairly dark conditions they should keep for several years. You can purchase dye kits for this type of work (such as Berg's colour conversion kit for black-and-white images, or Colorvir's kit). However, if you want to do it yourself, dyes that have proved to work successfully include fuchsine, malachite green, methylene blue, methyl violet and thioflavine.

Retouching black-and-white prints

Dust marks, small hairs and other blemishes must be removed before your prints are displayed, if

98 Although very careful dodging was used to lighten some of the shadow detail, the dried print still had over-dark areas. A very weak solution of Farmer's reducer was carefully applied to these areas of the dampened print, which was given a thorough wash before redrying.

the effect you have worked so hard to achieve is not to be completely lost under the viewer's critical gaze. It is very difficult to assess a photograph objectively when it is marked by blobs, smears and fingerprints; most people will not want to bother.

You can keep the amount of retouching you have to do to a minimum with clean working techniques. For example, cover your enlarger with plastic to keep the dust off, and clean your negatives with a blow brush or compressed air before you print.

For black-and-white photographs, images printed on to non-glossy surfaces are easiest to retouch, and prints on fibre-based papers are a little easier to work with than those on RC papers. Do not use black watercolour to retouch; the colour sits on the paper surface. Use photographic dye instead, as it is absorbed into the emulsion without leaving a mark on the print surface.

The method for retouching white marks is as follows:

1 Make sure the table or drawing board at which you will be working is comfortable and very well lit; an angled desk lamp is ideal.
2 Choose the most suitable dye (brown-black, neutral black or blue-black) to match the image colour of the photograph, and put a few drops of

the chosen dye on to an artist's palette or a glazed tile. Add water to the dye, testing on a spare print until you reach a stage where the diluted dye is giving a lighter tone than you need.
3 Use high quality red sable brush (size 0 for small spots and up to size 3 for larger areas) to collect the diluted dye and wipe the brush on a paper tissue until it is almost dry.
4 Dab on (don't stroke) the retouching dye, working from the centre of the white mark outwards. Work on several marks at once, returning to each to build up the density level. Do not go over the edge of the mark as this will leave a dark ring.

It is more difficult to remove black marks, which are caused by dust settling on the film during exposure. Save yourself the trouble by keeping your camera dust free, and clean the film chamber with a blow brush or compressed air can before loading. However, do not use a compressed air can on the mirror of an SLR camera as the propellants can affect the surface.

If black marks have appeared on the print, the following procedures provide a remedy:

1 If the print is not on glossy paper, you can scrape the black marks away with a sharp scalpel, although this needs practice.
2 Paint on a white opaque medium which has

99 Photographs that have 'busy' edges are usually best presented on a plain background of white or black. The crisp division between the print and its border help to form a 'window' through which the viewer can observe the scene.

100 The right side of this scene contained distracting background detail which drew attention away from the couple. An iodide reducer allowed this area to be taken back almost to white – the black line at the bottom right was left untouched to give a 'base' to the image.

been mixed with an appropriate amount of black dye to match the surrounding density. The retouching may have to be camouflaged by spraying the print with a sealant. This technique is not recommended for archival prints.

3 Use a reducer (page 157) to bleach out the black marks to white and retouch as described for white marks. Any mistake made using this process is very hard to put right, so work carefully with a steady hand.

Retouching colour prints

Because of the diffuse light sources used in most colour enlargers, the amount of retouching (if any) needed for a colour print is usually very small. However, if you know that retouching *is* necessary, perhaps because of a scratched negative or slide, you should print on matt or semi-matt paper since it is hard to retouch glossy surfaces.

The basic retouching technique for colour is the same as that described above for black-and-white prints, with the addition of the following:

1 The viewing light should preferably be of the correct colour temperature, ie daylight, or a colour-corrected fluorescent tube. If the print is to be viewed by tungsten illumination, then this may be used. For many applications, a mixture of daylight and say, a tungsten desk lamp is a good compromise.

2 A set of colour retouching dyes needs to be purchased; these are used (as with black-and-white) at dilutions which give lighter colours than the area being retouched. *Always* test the shade and density of colour on a spare print before applying the almost dry brush to the photograph.

3 Build up colour gradually in each area, using the stipple technique.

4 It is not practical to 'knife' colour prints; instead, apply white opaque mixed with the appropriate amount of selected dye. After retouching, spray with lacquer, which is available in all finishes, ie matt, semi-matt, and glossy.

Mounting prints

If a photograph is to be exhibited, it is generally necessary to mount it on card so that it can be pinned to a wall or board, and also to protect it. For archival mounting, the photograph *must* be mounted on special 100 per cent rag acid-free board, as the chemicals within ordinary boards attack the silver in a photograph.

Methods of mounting are:

Dry mounting The back of the print has a special shellac tissue tacked on to it with a tacking iron. This is then trimmed to size.

After pre-heating the mounting board in the mounting press (a large flat-bed heating press)

the print is placed on the board, and the corners of the shellac tissue are tacked on to the board. This combination of print, tissue and board is then sealed together in the mounting press, although you can use an ordinary domestic iron if you experiment first to find the right temperature setting. The correct temperature depends on the materials used, so follow the manufacturer's recommendations.

However, remember that RC prints must generally not be heated to above 90°C (200°F) or so, as the polyethylene coating will be damaged (Chapter 6). Spray adhesive can be used for quick mounting but is not suitable for permanent jobs as the solvent used may, over a long period, stain the print. It is available in pressurised cans.

Rubber-based adhesives are ideal for temporary display, as they allow the print to be removed and repositioned at will.

Mat mounting (fig 12.4) is particularly useful for archival work. The print is attached with linen tape to a board, and then covered with another board, which is hinged by tape to the first. The second board has a window cut out of it to reveal the photograph and prevents the framing glass from touching the print. If this happens, there is a danger that the photographic gelatin might adhere to the glass.

To surround a picture with a black or white line by mounting the print twice proceed as follows:

1 Tack dry mounting tissue on to the back of the print and trim the two to the size you want.
2 Position the print on black or white heavy paper as required, and tack the corners of the dry mounting tissue to the paper.
3 Tack another piece of dry mounting tissue to the back of the paper and trim to the width of surround you require.
4 Tack the corners of the second piece of dry mounting tissue to the black or white board, and place this 'double layer sandwich' in the dry mounting press.

Print presentation

It is surprising how often a good photograph is spoilt by thoughtless or careless presentation. Too many photographers plan the image painstakingly, control the film development and take hours over printing, only to ruin the whole effect by quickly mounting the final print on to the first piece of card that comes to hand.

Think carefully about the kind of surrounding material that would be best for your print. For example, a smallish print which is generally dark-toned around its edges attracts attention if it is surrounded by a large expanse of white. If, however, there are large areas of white within the print and reaching its edges, these will blend into the surround and be lost, unless the photographer chooses to 'enclose' the perimeter of the picture with a fine black line.

Alternatively, surrounding a photograph with black gives an enclosed, concentrated feel, as if observing a scene through a window; this effect is further heightened if the print is relatively small and the surround is large. The problem of white detail disappearing into a white surround applies equally to black detail and black surrounds.

In this case, either surround the print with a thin white line, or choose a different surround.

Grey-toned surrounds should be chosen with care; they can be very striking but can also flatten and dull the print. The only way to see which surround works best for your print is to put the unmounted photograph on, or against as many backgrounds as possible.

12.4 Mat mounting. The print is held to the bottom board by corners, simply made of acid-free card, which ensure the print is untouched. Special card cutters can be used to give the window an attractive angled cut. Only special acid-free card should be used for archival mounting.

finished print

Flush-mounting your print, by which you mount it on to card and then trim it to the borders of the picture so that there is no surround, is very straightforward but not always satisfactory. The snag is that you lose all control over how the print will be viewed, and it may be hung against a background which is far from complementary. This may not be a problem if you are happy with the background material being used for the exhibition, but you still have the worry of your picture being knocked about or damaged by pins. A print that is mounted inside a surround will come to no harm if the surround is damaged, and can simply be remounted or retrimmed.

Coloured mounts

Black-and-white photographs on a coloured ground can look very striking, but more often they look a mess. However, if you wish to use coloured mounts, keep to desaturated colours like cream and various browns and avoid very pure vivid colours. But, of course, patient experimentation with as many different surrounds as possible is the only way to find the perfect background for your print.

Remember, however, that the background and total presentation are intended to enhance the print – overpresentation will simply swamp it. Let the image be judged on its own qualities.

Colour prints are most simply presented when slipped inside a commercially made folder, with or without a flap. These are available in a wide range of colours, shapes and sizes to suit different moods and styles of subject. For example, warm colours such as gold, brown and red are usually perfect for weddings, portraits and other more gentle subjects. Strong colours such as yellows, blues and light vivid colours should be handled with care as they may clash with colours in the photograph or overwhelm them – the viewer will notice the surround but not the picture. But take the time to experiment, and don't forget that a simple black or white surround is often just right.

When considering the format of a picture the traditional rectangular 'portrait' (vertical) or 'landscape' (horizontal) formats are almost always found to be best, but there is no reason why you should not experiment with ovals or other more unusual shapes if they suit the subject. The simple slip-in mounts described above are generally not available for very large prints, for example 30.5 x 40.6cm (12 x 16in).

If your colour print is to be exhibited, the same rules apply as for black-and-white; do not let the surround you choose detract from it.

Showing your photographs

There would seem to be little point in producing photographs which no one ever sees, so investigate outlets, including camera clubs and societies, which provide opportunities for photographers to display their work.

A number of publishers are constantly looking for good, new, interesting photographs to reproduce, and it is up to you to find those most likely to be interested in your work. Study magazines and journals critically, noting the types of work they publish, and then contact the editor or art/picture editor if you feel this is the right place for your work to be seen. The most appropriate book publishers for your work can be discovered only by exhaustive research in your local library and bookshops. Note down the names of publishers whose approach and products appeal to you most, and then consult the trade directories for addresses and technical details.

Increasingly, banks, building societies, town halls, libraries, department stores and other institutions use some of their wall or window space for exhibitions. It is best to choose a particular theme if you want to exhibit in this way; subjects of local interest are always very popular.

Art galleries often exhibit photographs nowadays, although these displays are usually concerned with 'art photography'. However, the number of photographic galleries has been increasing in recent years, especially in major cities. If you have an idea for an exhibition, get in touch with one of these and arrange for them to see your portfolio. Most galleries operate under some pressure, with long waiting lists for exhibitions, but this need not be frustrating; if your idea for a show is accepted it simply gives you ample time to create the best display possible.

There are plenty of opportunities for getting your work seen, so seek them out. Displaying your work means that it will inevitably attract comment, and you may have to grow a tough skin. But criticism is just as valuable as compliments, if not more so, when given in a constructive spirit. Take all opinions into account but do not be swayed from your own ambitions and ideals. After all, a very important aspect of your photography is that it permits the rest of us to glimpse the world through your eyes.

BIBLIOGRAPHY

Photographic printing and enlarging is usually covered in very broad terms by most of the general books on photography and these can be a useful introduction to the subject. There are also a number of books which deal only with darkroom work; these range from the very elementary to some excellent interviews with 'master' printers. Judging by what is in print, these seem to be concerned mainly with American photographers.

Photographic magazines often carry articles on printing, especially during the winter months. They cover new products (eg. papers, enlargers, accessories, etc) and practical techniques.

For technical data on materials and equipment it is best to get in touch directly with the manufacturer, or consult the 'professional' journals, such as the British Journal of Photography.

To gain an appreciation of top quality printing you should visit photographic galleries as often as possible. Once you have seen the work of a master printer, such as Ansel Adams, John Blakemore, Eugene Smith, or Jerry Uelsmann, you have a standard at which you can aim.

The list below comprises books which have been of use to the authors. Although some may be out of print, your local library should be able to obtain them for you.

Agfacolor User Processing/Agfa-Gevaert
Colour as Seen and Photographed/Kodak
The Creation/Ernst Haas/Penguin
Creative Darkroom Techniques/Kodak
Creative Photography/Otto Croy/Focal Press
The English/Ian Berry/Penguin
Kodak Handbooks for the Professional Photographer/Kodak
Interviews with Master Photographers/James Danziger and Barnaby Conrad/Paddington Press
The Magic Image/Cecil Beaton and Gail Buckland/Little, Brown
The Photographic Illusion/Duane Michals/Morgan & Morgan
The World of Henri Cartier-Bresson/Thames & Hudson
and other books in the *'Photography in Practice'* series.

ACKNOWLEDGEMENTS

All photographs in this book are by Jack Taylor except the following:

Bob Irons 1, 19, 29, 44
Ken Kendall 68-70
Dee Kitson 83
Sidney Ray fig 6.6, 48-64, fig 10.

INDEX